AN IMPRESSIONIST LEGACY

THE COLLECTION OF SARA LEE CORPORATION

AN IMPRESSIONIST LEGACY

THE COLLECTION OF SARA LEE CORPORATION

TEXT BY

RICHARD R. BRETTELL

PHOTOGRAPHY BY

GEOFFREY CLEMENTS
AND DAVID FINN

ABBEVILLE PRESS · PUBLISHERS · NEW YORK

Founded in 1939, Sara Lee Corporation
is a global food and consumer products
company, headquartered in Chicago,
Illinois.

DESIGNER: ULRICH RUCHTI
DESIGN ASSOCIATE: MICHAEL SCHUBERT

THE CATALOGUE AND BIBLIOGRAPHIC
REFERENCES WERE COMPILED AND CHECKED
BY SUE TAYLOR AND STEPHANIE D'ALLESANDRO.

Printed by Imprimeries Réunies Lausanne S.A.,
Lausanne, Switzerland, 1986, 1987, 1990, 1993.

Fourth and expanded edition.

CONTENTS

PREFACE

For the last ten years of his life, I had the opportunity to know Nate Cummings intimately and from a unique perspective. During that time, as chief officer of Sara Lee Corporation, it was my lot to give direction to Nathan Cummings's most important business legacy.

Nate Cummings was a determined, tenacious, and highly successful business-man; and he was also a notable philanthropist. But Nate had another dimension: he was an enthusiastic art collector. He genuinely enjoyed buying art. He loved showing it to people who visited his apartment. He got so much pleasure loaning it to friends, companies and museums. He collected and shared his art for more than forty years. It was an important part of his life.

We at Sara Lee Corporation shall be grateful always that his vision and foresight have made it possible for us to work in an environment made so pleasant by some of the finest art of the past one hundred years.

The Sara Lee Corporation art collection is a tribute to our founder. As he was first and foremost a man of business, it is especially appropriate that this corporation should also have the honor of being the custodian of the legacy of Nathan Cummings the art collector.

John H. Bryan

INTRODUCTION

The remarkable paintings and sculpture that are reproduced in this volume are on permanent display at the Chicago headquarters offices of Sara Lee Corporation. They were designated by the chairman and chief executive officer, John Bryan, as a way of commemorating the remarkable achievements of the company's founder, Nathan Cummings, from whose personal collection they were acquired. The goal was to perpetuate the tradition of combining art and business which has been an integral part of the company's history.

Nathan Cummings's success as an entrepreneur was in part due to his openness to new ideas, his eagerness to learn about aspects of life that were unfamiliar to him, his capacity to make the most of his personal discoveries as a means of setting new directions for himself and the business, and his ability to act quickly and decisively to achieve his objectives. His success as an art collector was the result of the same basic characteristics.

A man of few pretensions, he enjoyed telling the story of how he first became interested in art. It showed how disarmingly candid he could be about what he didn't know, and how ready he was to embark on new ventures once somebody pointed the way. "I became interested in art," he explained, "about two or three years after we moved onto the twenty-first floor of the Drake Towers in Chicago. It was in the early 1940s, and I met an advertising man who convinced me that I should have a painting made of the view from my window. I thought it was a good idea and commissioned an artist, Aaron Bohrod, to do so. While he was working I enjoyed watching him paint, and we became good friends. When he was finished I said, 'Why don't you paint this scene at night as well, so I can have pictures from my window that show both night and day?' He did. I liked it. And soon after that I started to buy art."

A man who never did anything in half measures, Nathan Cummings started collecting on a grand scale, often acquiring a whole series of works by artists he liked. He judged the quality of the works the same way he judged the value of a company he wanted to acquire, "by the smell." He valued the opinion of outside experts, but trusted his own judgment even more. In time, his taste became educated and his judgment discriminating as he acquired examples of the very best from the artists he loved most.

For thirty-one years Nathan Cummings sent a Christmas card reproducing one of the masterpieces in his collection together with an original message expressing his personal philosophy about life and art. During the last ten years of his life the messages

were written by Nate's granddaughter Ruth and her husband, Steve Durchslag. Nate always chose the paintings to be reproduced, but Ruth and Steve found the words to express Nate's sentiment. I'm sure this joint creative effort gave Nate a great deal of pleasure. And for years, a hallmark of all companies that became part of what is today known as Sara Lee Corporation was the paintings that inevitably followed a merger. Cummings could make a deal as fast as anyone else in the business world, but one characteristic which distinguished him from his peers was his habit of following up a successful negotiation with a shipment of works of art from his collections as loans to the offices of each newly acquired company. Not everybody appreciated the idea, as when he gave paintings to the captains of all boats in the Booth Fisheries fleet. "These were rough, tough, seagoing guys," recalled Frank Holas, who subsequently became president of Booth. "We were the only floating art galleries in the North Atlantic. Our people wanted to know why they were getting these peculiar things. The answer was that was just the way Nate Cummings was."

The tenacity of Nathan Cummings as a collector of paintings and sculpture as well as of companies made him not only the builder of a giant corporation but also a great patron of the arts. The Nathan Cummings Art Gallery at Stanford University, the Nathan Cummings Collection of pre-Columbian works at The Metropolitan Museum of Art, and a number of outstanding gifts he made to The Art Institute of Chicago are fine monuments to his cultural patronage. But no less important are the superb paintings and sculpture which were part of his personal collection and which now grace the offices of the company he founded.

Late nineteenth-century and what might be called classical twentieth-century works of art were Nathan Cummings's favorites. He relished each one of his acquisitions with great joy, and after he moved to New York City a visit to his Waldorf Towers apartment where he kept his most valued treasures was always an aesthetic adventure. He was extraordinarily proud of the masterpieces he had in his collection and never tired of telling visitors about the background of each individual work.

In later years, the Henry Moore *Upright Motive* was the work of art a visitor first encountered in approaching the door to Nate Cummings's apartment. I mention this because in the late 1970s, when Henry Moore was in New York for a few days, Nate invited him to his apartment for a brief social visit. I happened to be present and remember the visit vividly as Moore moved from room to room and literally gasped at the quality of the works Nate had assembled. "This could be worthy of any museum collection," exclaimed Moore, who had a fine collection of paintings and sculpture in his own home in Much Hadham, England. "It is a marvellous choice of works." Nate

beamed at the compliment. He was proud of having met some of the great artists of his day—Picasso, Miró, Braque—and having someone like Henry Moore admire his collection was the mark of excellence he appreciated most.

Nathan Cummings died at the age of eighty-eight in 1985. Although he had been ailing in his last years, he never lost his ebullience about the wonder of great works of art. Just a few months before the end, I visited him in his apartment and found him incredibly excited about acquisitions I had never seen before. He was also extremely pleased that John Bryan had decided to purchase a selection of key works from the Cummings collection for permanent installation in the corporate headquarters. Nate recognized this as an ideal way to leave his mark on the company he built, and he was grateful that his successor welcomed the acquisition as a fitting expression of the personal and business philosophy of the company's founder.

The works of art reproduced in this book are not placed in historical sequence, but rather in a manner that enables readers to grasp a sense of the collection as a whole, very much as one would experience it while working in or visiting the offices of Sara Lee Corporation. By chance, the first painting in the book, *Bountiful Harvest*, by Camille Pissarro, happened to be Nathan Cummings's first acquisition. But thereafter, paintings and sculpture follow each other in an order that is intended to provide the most satisfying visual experience.

The purpose of the book is not only to provide a lasting record of the masterpieces in the Nathan Cummings collection, but also to serve as a demonstration of Cummings's conviction that art has a place in our working lives. By showing how the best of both worlds can be combined in one setting, the company is expressing its own continuing commitment to the highest values—not only in the art in its offices but also in its management philosophy and in the quality of its products—as the essential ingredient of its corporate character.

David Finn

THE COLLECTION

CAMILLE PISSARRO
BOUNTIFUL HARVEST, 1893

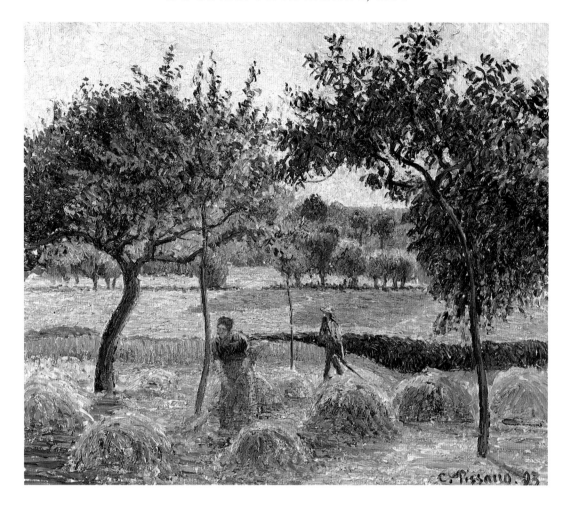

Bountiful Harvest exists almost as an oil sketch. Smaller than Pissarro's standard easel pictures, it was also more rapidly, indeed more easily painted. Pissarro selected a canvas with a prepared white ground, took it into the fields during the annual grain harvest at Eragny in August, and painted it in a single sitting. The movement of the figures and the play of light over the fields are observed and confidently recreated in paint. Pissarro had drawn and painted grain harvests for over thirty years when he turned again to the subject in 1893, and his experience shows. Because he had drawn and painted hayrakers literally hundreds of times already, his arms and wrists naturally evoked the correct hues and contours. In fact, one could almost claim that *because* Pissarro had been an Impressionist for nearly a generation before 1893, he had trained himself to transcribe his visual sensations with ease. Compared to this small oil sketch, his earlier paintings, although often of great quality, are as labored as their subjects. Here, the graceful ease and almost dancelike rhythms of the harvesters are virtually equivalent to the painter's "work."

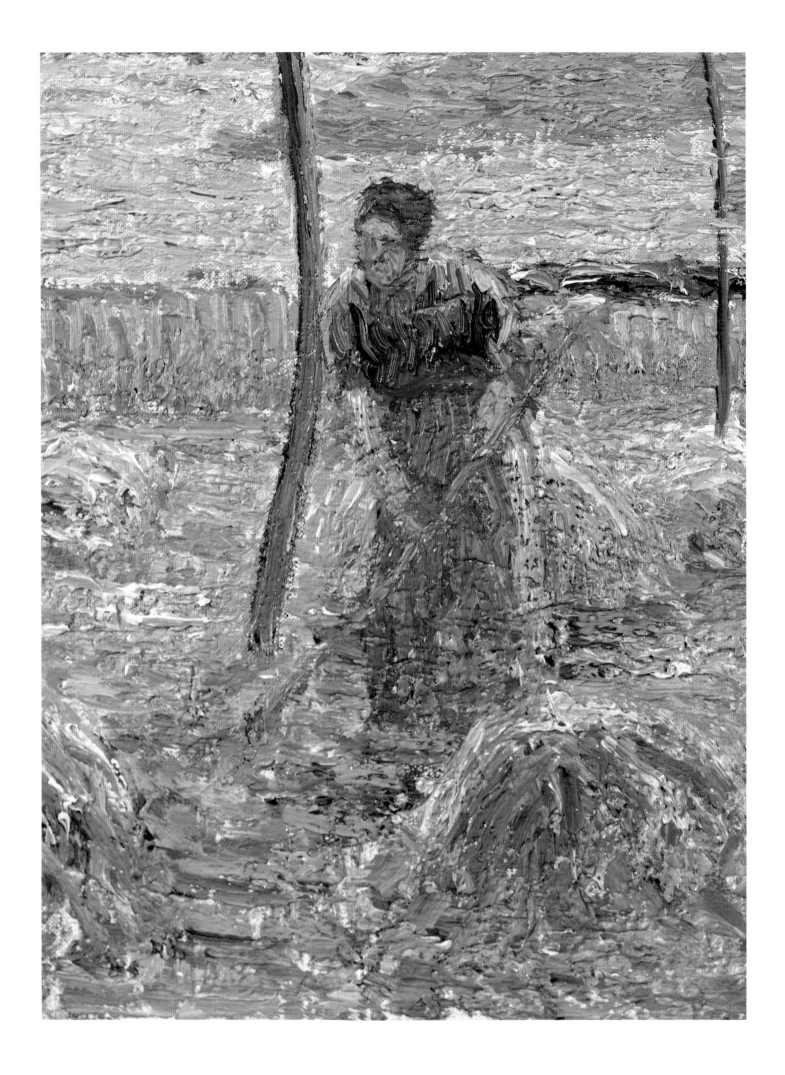

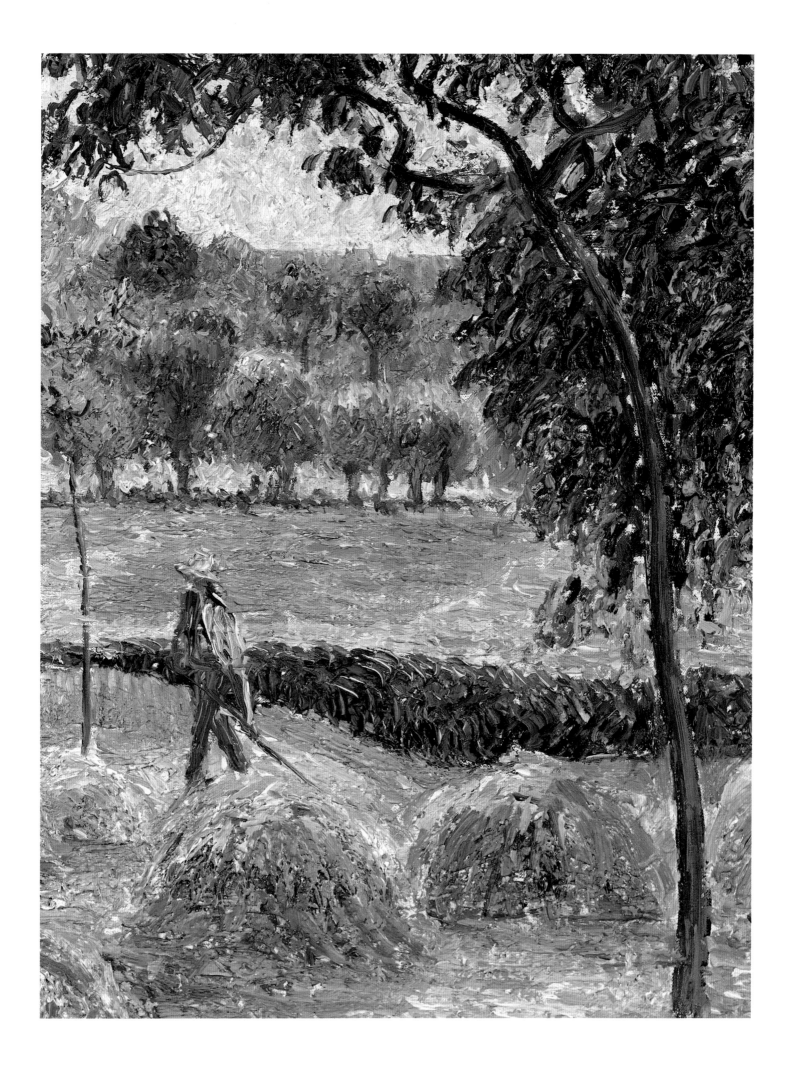

CAMILLE PISSARRO
VASE OF FLOWERS, 1878

Camille Pissarro is known chiefly as a landscape painter and, in fact, painted comparatively few still lifes during his long and productive career. Those few that do survive, however, are of superb quality, and *Vase of Flowers* is among the finest of the floral still lifes. It was probably painted in the winter of 1877–78, perhaps in Pissarro's Paris studio on the rue des Trois Frères, using flowers he purchased from a vendor rather than those picked from the flower garden of his house in Pontoise. Pissarro preferred to work out of doors in Pontoise, even if it meant painting from the window on a cold or rainy day. Yet, while in Paris, he rarely painted urban views during the 1870s, turning his attention instead to portraits and still lifes or to finishing works to be sold.

Vase of Flowers is a carefully wrought composition. It derives quite closely from the group of floral still lifes painted by Pissarro's pupil, Paul Cézanne, and shown in the Impressionist exhibition of 1877. Those four paintings were among the first still lifes Cézanne ever exhibited, and Pissarro, along with his friend and student Paul Gauguin, was extremely impressed by them. However, rather than applying his paint roughly with a large brush or palette knife as Cézanne had done, Pissarro defined his forms with thousands of tiny daubs and lines of paint, so that each flower and leaf quivers with life.

The painting is perhaps most interesting in the area behind the flowers. What appears at first glance to be nothing more than the beige wall of the background begins to vibrate gently in rhythms analogous to those of the flowers the longer one looks at the painting. On the wall, Pissarro used subtle hints of colors opposite to those used in the floral still life itself. This pictorial decision gives an optical vivacity to an otherwise simple, even humble, subject. It is obvious that Pissarro worked very hard on this painting, and in this it can be contrasted to the seemingly effortless floral still lifes of the other Impressionists, particularly Monet and Renoir. While they painted flowers *as* flowers, Pissarro was more concerned with the interaction of color and a complex, highly sophisticated facture. His *Vase of Flowers* looks less like an Impressionist painting than it does like one of the early still lifes of Gauguin or even Vincent van Gogh. The earliest painting in the Sara Lee Corporation Collection, *Vase of Flowers* bridges the gap between the Impressionism of the young Cézanne and Post-Impressionism.

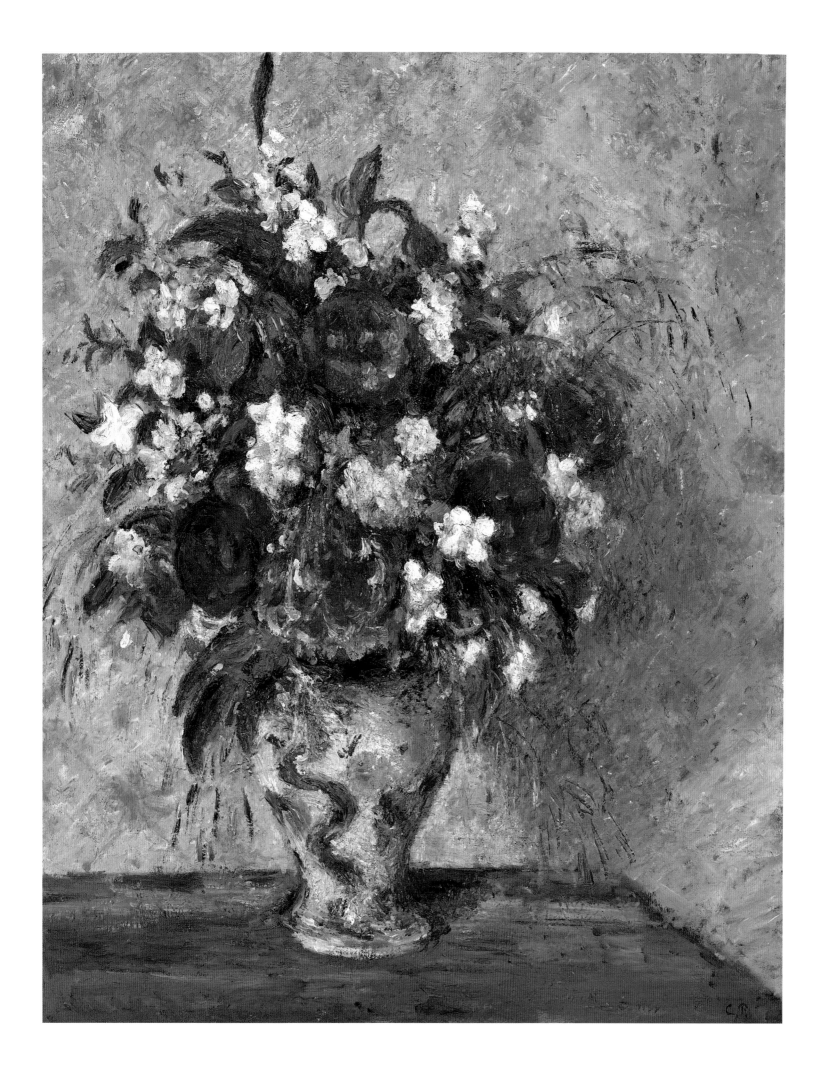

BERTHE MORISOT
YOUNG WOMAN IN A GARDEN, 1883

Young Woman in a Garden is among the masterpieces of a career that is without doubt the least known among the Impressionists. Mary Cassatt and Berthe Morisot both exhibited along with the more famous male painters, and in the exhibition of 1877 Morisot's work was hung prominently in the central gallery across from the paintings of Cézanne. However, because she devoted a great deal of her short life to her marriage and family and because many of the most important of her works have remained in family collections, too little is known of her actual contributions to the movement of which she was an important and faithful member.

If *In a Garden* is any indication, Berthe Morisot was a considerable painter. Made in 1883, just before the death of her brother-in-law and greatest friend, Édouard Manet, the painting represents a hired model named Milly seated in the garden of the artist's house on the rue de Villejust in Paris. The artist's daughter, Julie—whose famous diary is among the chief sources of our knowledge about late Impressionism and its literary associations—plays among the flowers, her face obscured by a straw hat. The ease and brilliance of Morisot's gestures and the assured control of the large surface are remarkable. Many passages, particularly in the foliage, recall the late landscapes of her mentor, Manet. Yet Milly's face, gloved hands, and clothing recall more clearly the revolutionary facture of the seventeenth-century Dutch painter Frans Hals, whose work was so intensely admired by both Manet and Morisot.

We see a well-dressed young woman seated in an enclosed, private garden. In spite of the presence of the rake at the left of the composition, she is surely no laborer, and like so many figures in French paintings of the 1870s and 80s, she merely sits, facing the painter-viewer with an easy acceptance of her role as model. Her gloves, her hat, and her dress are beautifully painted, each form evoked confidently with thick strokes of paint. Her face reveals nothing of her character, and as if in recognition of this, it was painted with considerably less attention than the painter lavished on her costume. For Morisot, as for so many great painters of modern life, the costume and setting were as important as the head and hands.

The scale and highly developed finish of *In a Garden* indicate that it was painted for public exhibition. Unfortunately, the Impressionists squabbled too much to organize an exhibition in 1883, and Morisot had long since abandoned the official Salon. Instead, she sent the painting to London for an Impressionist exhibition privately organized by the dealer Durand-Ruel, but it seems to have elicited no comment from the British press.

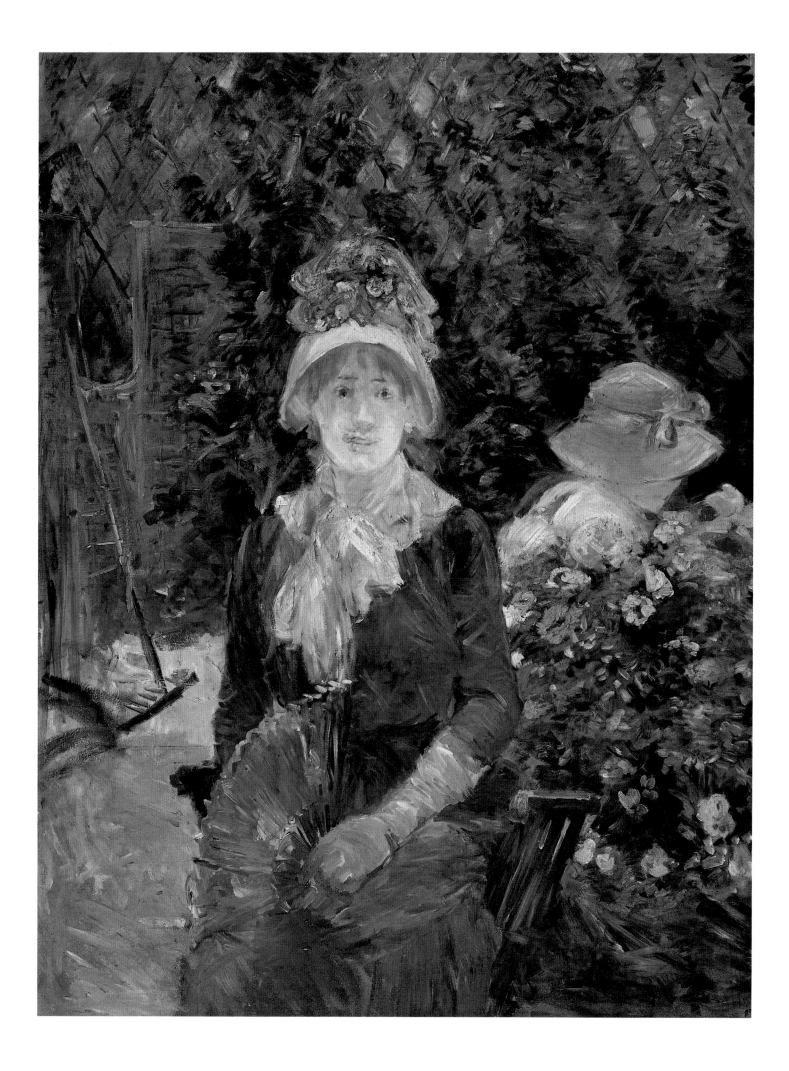

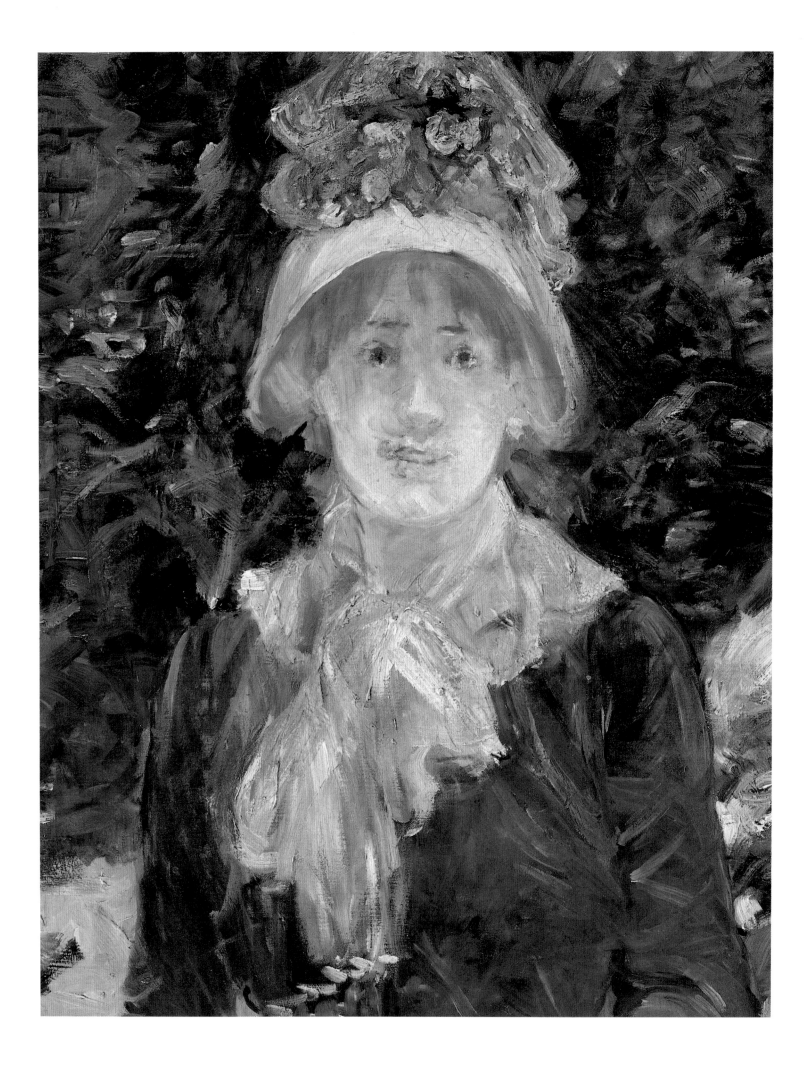

HENRI MATISSE
STANDING NUDE, 1911

There is little doubt that, with Picasso, Matisse was the greatest painter of the early twentieth century. Yet like his predecessors Daumier and Degas, as well as his illustrious Spanish contemporary, he occupies as important a position in the independent history of sculpture as he does in that of the pictorial arts.

Standing Nude is among a group of small figural sculptures from the first quarter of Matisse's career that owe their most profound debt to the sculpture of Degas. Matisse surely knew Degas's wax figures, which remained in the elderly Impressionist's studio until his death in 1917, just six years after *Standing Nude* was made. Matisse's sculpture, cast, as were the posthumous Degas bronzes, from a wax original, shares the flickering surfaces and generalized anatomical exaggerations that are at the core of Degas's sculptural aesthetic. Both artists made sculpture as an integral part of their aesthetic projects. Each drew from them, learning in the process lessons of weight, balance, and silhouette that they both eagerly applied to their pictorial art.

It is the stark contrast between the rectilinear rigidity of the right leg of this statue and the rubbery, flaccid contours of her left leg and arms that fascinated Matisse and that makes this small figural sculpture both so unclassical and so painterly. Here, in *Standing Nude*, Matisse the painter-sculptor was able to release the human body from gravity.

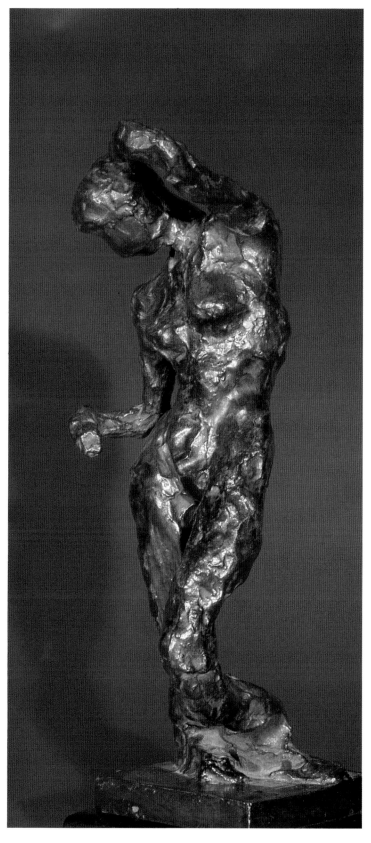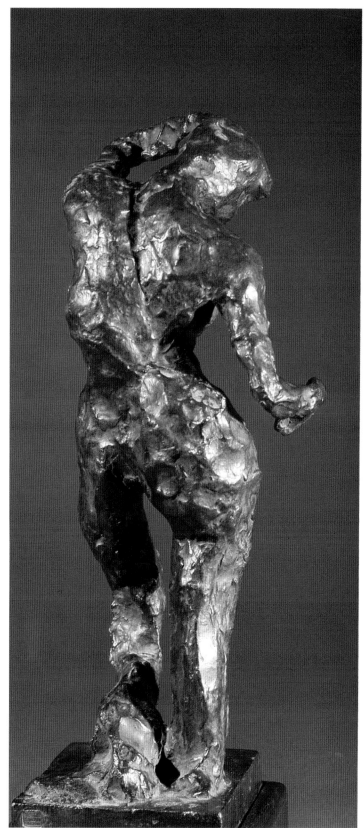

ROGER DE LA FRESNAYE
THE BATHERS, 1912

The Bathers is a self-conscious masterpiece. With three monumental nudes in a stable, triangular composition and its strongly defined signature, it was evidently painted for public exhibition. Indeed, *The Bathers* was Roger de La Fresnaye's major contribution to the 1912 Salon d'Automne, the first major public exhibition to show evidence of the Cubist revolution privately inaugurated by Braque and Picasso in the previous two years. De La Fresnaye was twenty-seven years old in 1912, younger than Picasso, Braque, or Matisse. Yet he was an essentially traditional painter, whose *Bathers* was made as a contribution to the French classical tradition. From Poussin to Léger, French artists measured themselves against each other by painting the monumental nude for public exhibition, and the battle for painterly preeminence in this genre was being waged fiercely in 1912. Matisse, Braque, Picasso, and Léger had already passed the test with major paintings, all of which are now considered to be pivotal works in the sequential history of modern painting.

On viewing *The Bathers*, one thinks not only of Poussin, Le Brun, and Boucher, but also of Courbet, Manet, Renoir, Degas, and above all, Cézanne, the immediate precursors of the young French painters on the eve of World War I. De La Fresnaye attempted to join the newest pictorial discoveries of Braque and Picasso with the tradition of the nude, and this quality of compromise still haunts *The Bathers*. Yet, how authoritative it is! The nudes are not the hulking, druidic giants of Braque or the flattened African prostitutes of Picasso. In spite of their muscularity and their mannish angles, they indeed possess an undeniable sensual presence as they stretch and pose out of doors. They seem almost to have been painted in response to the plea of the novelist Émile Zola, whose book *The Masterpiece*, of 1888, challenged modern artists to abandon their landscapes and to take up the greatest pictorial subject, the monumental nude.

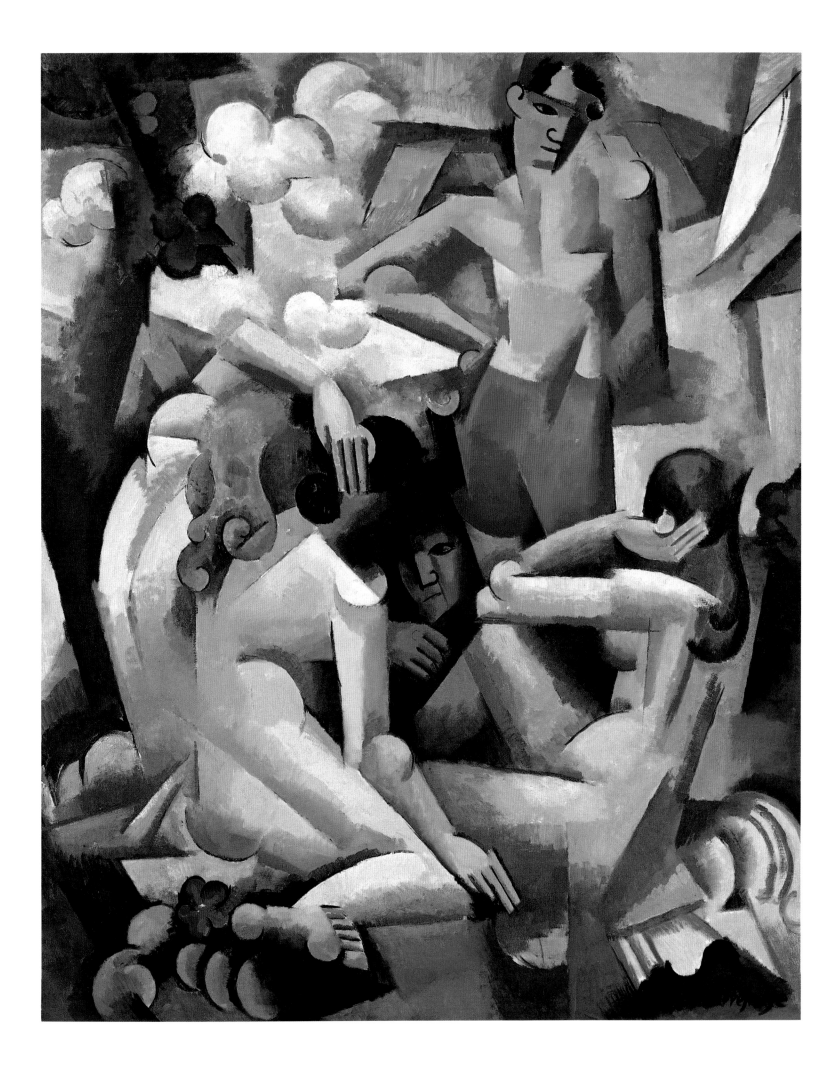

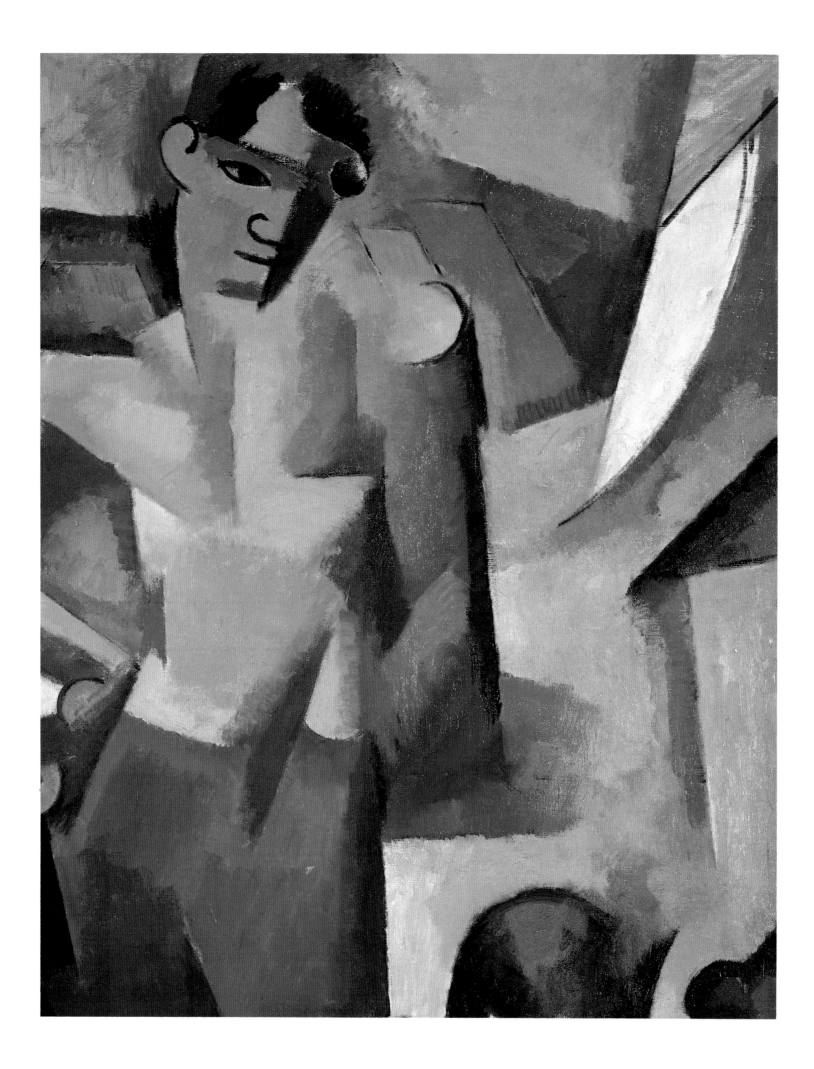

PAUL GAUGUIN
CLAY JUG AND IRON JUG, 1880

This superb still life is among Gauguin's earliest important investigations of that classic genre. Painted in 1880—three years before he quit his job as a prosperous stockbroker to become a full-time artist—it entered the collection of his friend Émile Schuffenecker and was never exhibited during his lifetime. On a tabletop three elements are arranged simply: a clay jug made by Gauguin himself, a plain iron jug, and a piece of dark green fabric that acts to obscure the edge of the table. On the wall hangs a Peruvian textile, partly visible at the top of the picture.

When one compares it with contemporary still lifes by his friends Pissarro, Monet, Renoir, or Cézanne, this painting is startlingly simple both in composition and in its selection of still-life elements, all of which he used on other occasions. The clay jug was evidently a favorite because he included it in at least two other still lifes painted in 1883 and 1885, and the smaller iron jug appears in a rather conventional still life from 1883. The textile from Peru was also loved by the painter, who included it in his most important early painting, *Study of a Nude*, shown in the Impressionist exhibition of 1880, as well as in a portrait of his wife and in a still life dating from 1886.

Yet *Clay Jug and Iron Jug* has a simplicity of composition shared by none of these other paintings. Why, then, did Gauguin juxtapose a large clay jug with a smaller iron one? The answer, curiously, lies in a text. Gauguin was making a pictorial reference to "The Clay Pot & The Iron Pot," one of the most famous fables of both Aesop and La Fontaine, the great Greek and French fabulists. There is little doubt that Gauguin read these fables to his children, several of which were used as sources for later paintings and prints.

The meanings he sought to embody in this "visualization" of a fable are not easy to discover, particularly because Aesop's and La Fontaine's versions differ in important ways from each other. Although it is likelier that Gauguin relied on the French fabulist, there is no positive evidence. In any event, the fable begins with a conversation between a clay jug and an iron jug held in the safe confines of a home. The iron jug proposes a journey to the clay jug, but the latter is afraid to be broken and wishes to remain at home. However, after repeated entreaties, the iron jug prevails and, after journeying a while, the clay jug is indeed broken.

Gauguin had already traveled extensively throughout the world before marrying a Danish woman, fathering five children, making a fortune as a stockbroker, and finally, turning almost full time to painting. In 1880, he still maintained his business ties, mostly at the insistence of his wife. It is tempting, given even a nodding acquaintance with this biography, to interpret this still life in autobiographical ways. Yet, Gauguin is ever elusive, and we are forced to recognize that his painting, like the fable it "illustrates," can be variously interpreted. Is the clay pot a manifestation of Gauguin's wife, Mette, and thus, a premonition that she—or their marriage—will be broken when they make the voyage? Is the already worn and dented iron jug Gauguin? Will there be a "voyage" to some specific place or did Gauguin mean to suggest that this voyage, fatal to the clay jug, will be an artistic one? And, finally, when will the clay jug break?

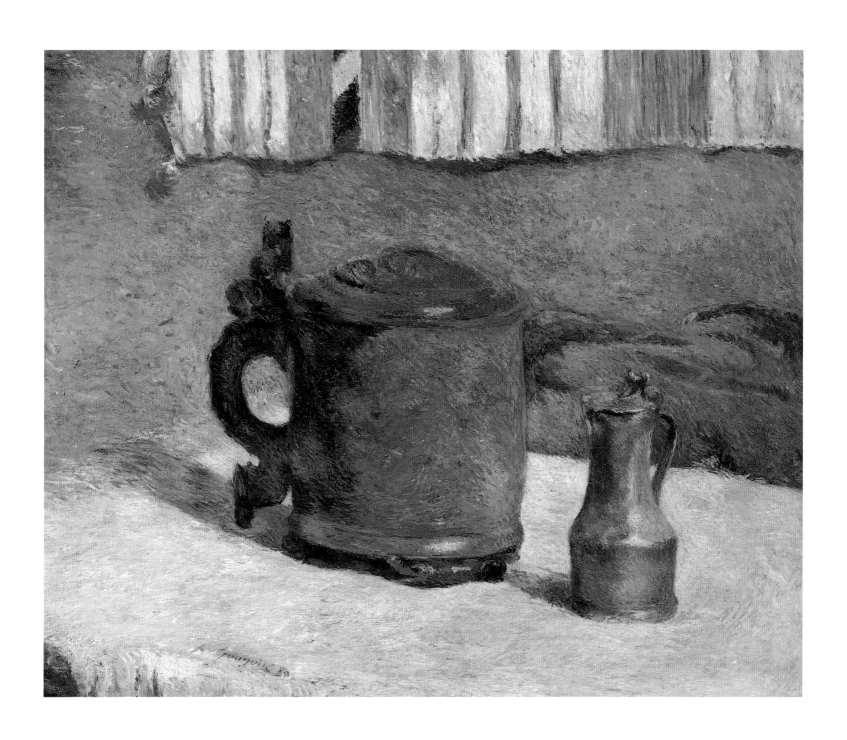

HENRY MOORE
MOON HEAD, 1964

The artistic legacy behind *Moon Head* is less classical than Surrealist. We are, of course, encouraged to think of this "pair" of sculptures as a single head, but how different from the Greek or Roman portrait bust it is! For Moore, the head becomes two irregular disks, each on its own neck and each cut through with a powerfully negative shape. Hence, the subject of the work is "doubly double"— the interaction of two forms as well as the interaction between volume and void.

There is no "inside" of Moore's *Moon Head*, only a "face." And with this odd visual-verbal pun, he takes us on a journey through the space of the mind, a journey that takes us via Miró, Tanguy, and even early Gorky. The resulting bronze is playful without being toylike or trivial, preserving for the ages in bronze an attitude toward form that is a fundamental part of twentieth-century art.

In this cast, the forms are smooth and neat, and the patina uniformly colored and textured. How one wants to caress these two forms with one's eyes, as the disks curve seductively in a dance of rounded forms. Is the moon made of gilded bronze, we may ask? Is it flat or spherical? Does it have a face?

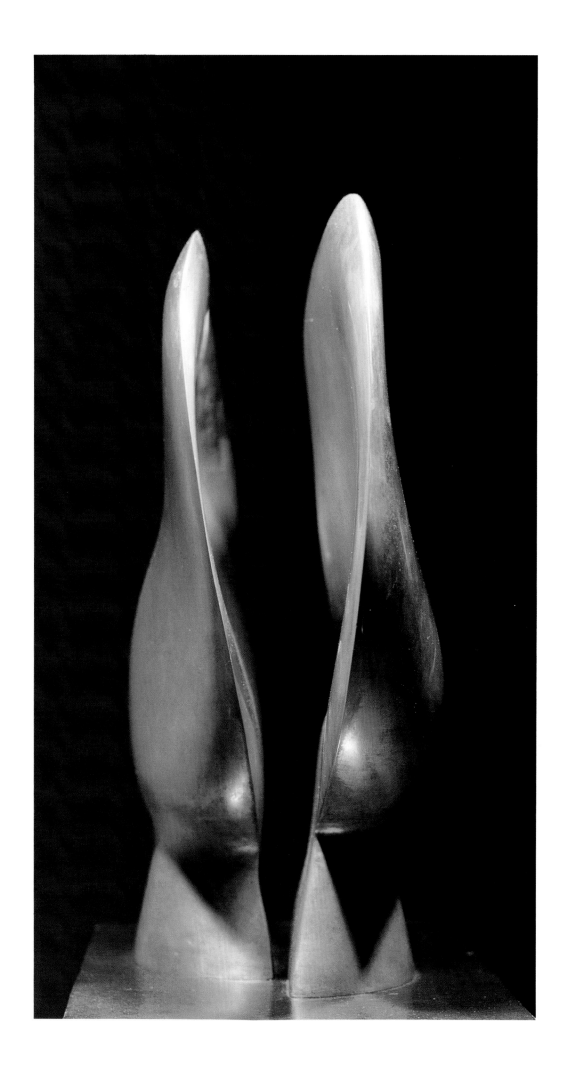

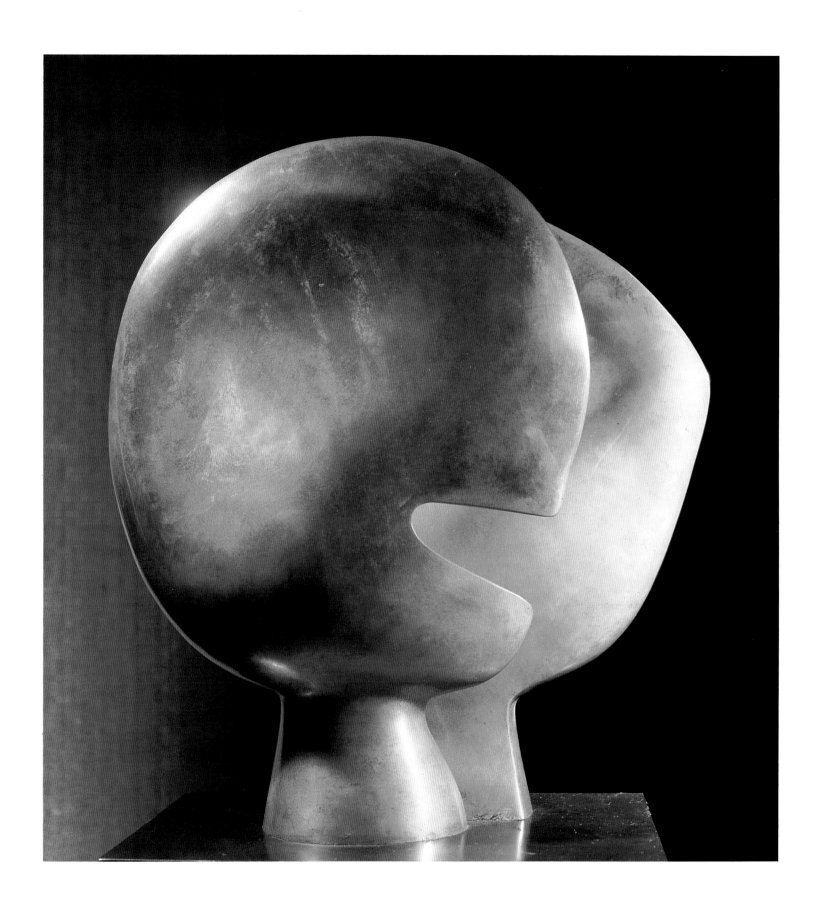

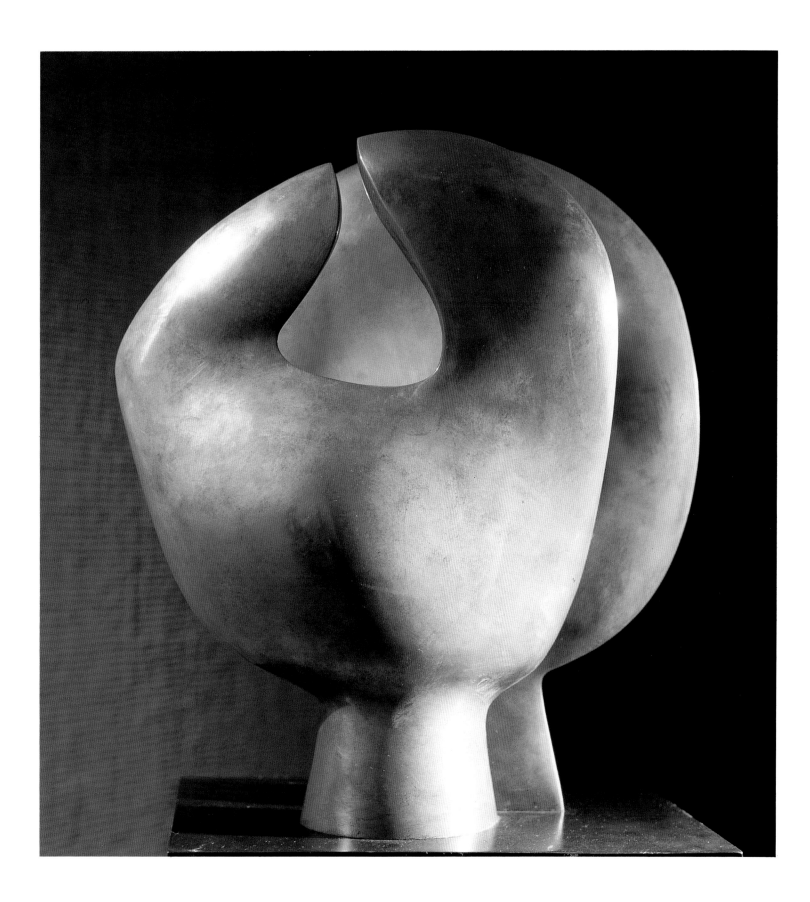

ÉDOUARD VUILLARD
THE BAY WINDOW AT POULIGUEN NEAR LA BAULE, 1908

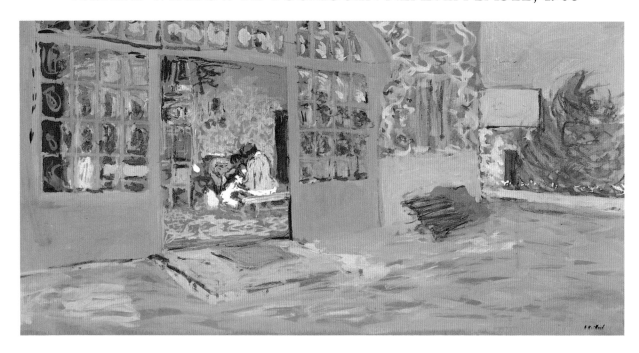

When Vuillard made this wonderfully subtle tempera painting at the age of forty, he had already moved closer to the world of visual appearance. Like the Impressionists before him, Vuillard represented the people and places around him with an unfettered directness. The majority of this picture's surface is devoted to the facade of a new country house in the sophisticated resort town of La Baule in Brittany. Each pane of glass in its window is faithfully described, and the flickering of light over its rough stone facade is evoked with a few straggling lines of light gray tempera. Only the pale orange tile roof of a nearby house is flattened to become a rectangle of pure color apparently parallel to the picture plane.

All of the landscape and architecture becomes a kind of frame for the true subject of the picture, the interior of a room seen through an open door. Inside, a woman who has been identified as Vuillard's great friend Lucy Hessel amuses the small children of their mutual friend, Alfred Natanson. Yet the identity of the figures does not interest Vuillard as much as do their scale, placement, and color. It is the perfect balance between the particularity of the place and the anonymity of its inhabitants that is so characteristic of Vuillard at his greatest. In this masterful gouache, we, the viewer, are outside on the terrace, apparently alone. The weather is gray and rather dreary; the sun casts no reassuring shadows. Although it is a summer day warm enough for the door to be kept open, the wind rustles the leaves of a nearby tree, thereby creating a sense of movement or change. Interestingly, we have turned from the spectacular view of the sea for which La Baule was famous towards the interior, but this very room is remote from us, its figures unaware of or uninterested in our existence.

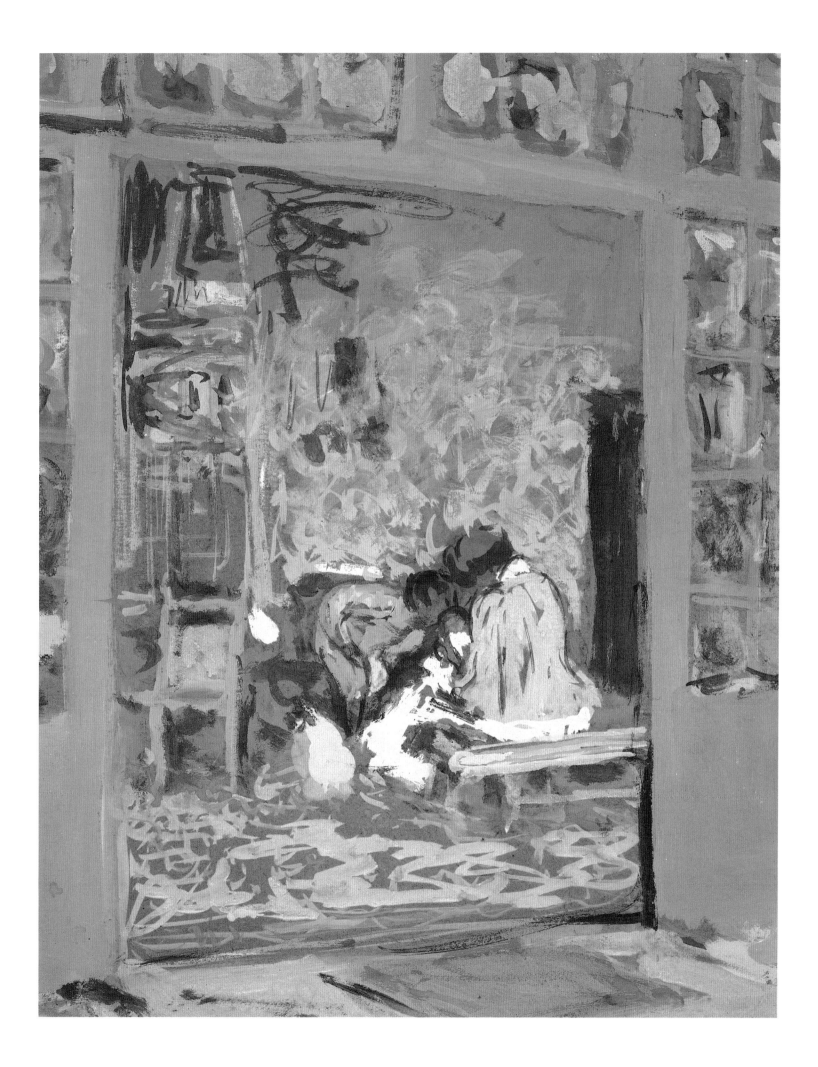

ALFRED SISLEY
SAINTES-MAMMÈS—MORNING, ca. 1884

Alfred Sisley was, in some respects, the purest Impressionist. His career, like that of Pissarro, developed late in the 1860s, and he painted his most important landscapes in the 1870s. Yet unlike his colleagues Renoir, Monet, and Pissarro, each of whom eventually abandoned their styles of the Impressionist decade—the 1870s—Sisley developed within that visual language, refining rather than altering his art. In 1880, he left the suburban landscape west of Paris where Impressionism was invented and turned to the more traditionally picturesque villages along the Loisne and Seine rivers near the forests of Fontainebleau. There, he painted landscapes without factories, trains, or any of the other trappings of industry, regressing more than a little from the overt modernism of the Impressionist movement in its early days. Unlike his fellow landscape painters Monet and Pissarro, Sisley aged both as a man and as a painter and died before any of his Impressionist peers and in relative poverty.

This landscape is one of the largest and most important canvases painted by Sisley in the village of Saintes-Mammès in the mid-1880s. His paintings of this site are difficult to date with precision not only because so few were dated by the artist himself but also because, though Sisley never lived in Saintes-Mammès, the village is within easy walking distance of all the small towns in which he did live during the last two decades of his life. Sisley painted four other closely related paintings of this woodworking yard on the banks of the Seine. Here, the great logs from the forests around Fontainebleau were sawed and prepared for shipping to Paris as they had been for centuries. The only change in this scene from one that could have been recorded in the seventeenth century is the motor-driven saw that spews out smoke just to the left of the tree. All else—the river, the rows of lumber, even the houses along the unpaved road—are essentially unchanged. In this way, Sisley's landscape abounds in continuities between past and present. Like his friend Pissarro, Sisley was interested in landscapes alive with human activity. However, where Pissarro's landscapes depict the work of the fields, Sisley preferred the life of the river, with its boats, its ferries, its washerwomen, and its traditional occupations.

For all the apparent conservatism of the subject, *Saintes-Mammès—Morning* is painted with great energy and vigor. Sisley pushed and jabbed at the canvas with a loaded brush. Sometimes drawing with small brushes, he worked furiously to evoke the complex forms of the landscape with hundreds of linear strokes. For the sky, he painted loosely with a large brush in thinned, pale blue oil paint, letting the prepared white ground of the canvas shine through to become the light that so preoccupied the Impressionists.

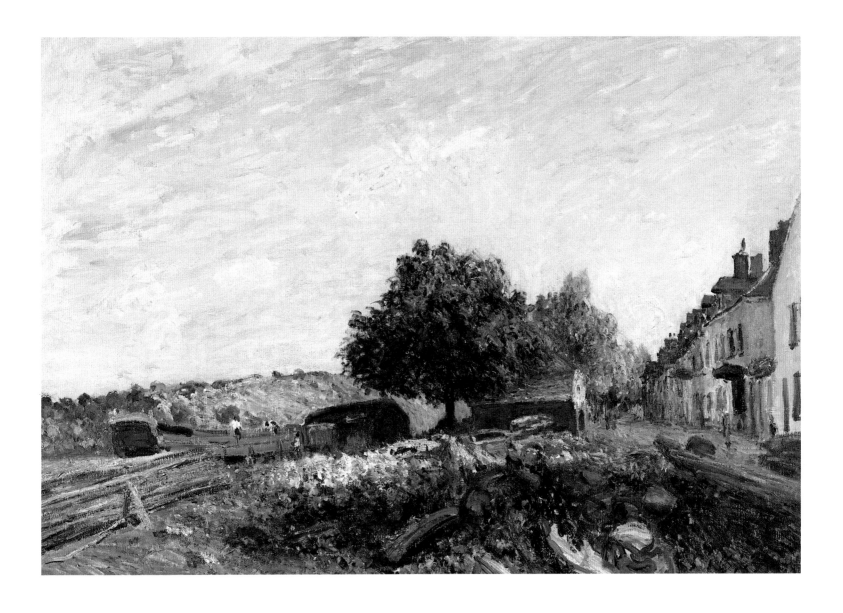

PIERRE BONNARD
THE APPLE PICKERS, 1898–99

Pierre Bonnard was, with his friend Édouard Vuillard, the greatest painter of decorations in France in the late nineteenth and early twentieth centuries. From 1890, each artist contributed to the distinguished tradition of private, decorative painting that extends from Boucher through Robert to Corot and Monet. This kind of painting, often commissioned for a private home or apartment, enjoyed a considerable revival in the 1890s, and both Bonnard and Vuillard painted decorations for private clients and even for public exhibition. Often compared to frescoes or tapestries, decorations were usually large-scale paintings conceived to fit as panels between doors and windows. Their subjects tended to be informal and easy, and women and children dominated them. Their palettes were most often monochromatic or "grayed" so as to be part of the ensemble of the room in which they were placed, and their compositions were carefully contrived so that no element overpowered another. Gentle and lyrical, decorations were intended almost as theater flats for the performance of domestic drama. They were to complement—*never* compete with—the players.

The Apple Pickers was painted at the very end of the 1890s, and there is a suggestion in the literature that it was owned by Thadée Natanson, the founder of the *Revue Blanche* and a leading patron of both Bonnard and Vuillard. It is possible that the painting was intended as part of a large ensemble of decorations, the largest panel of which, *The Large Garden (Le Grand Jardin)*, has recently entered the collection of the Musée d'Orsay in Paris. Two other panels, one also called *The Apple Pickers (La Cuillette des Pommes)* and *Child Playing with a Goat (Enfant Jouant avec une Chèvre)*, share the same imagery and vertical dimension and might well have been designed for a single large room.

A visitor to this room would have been surrounded by women and children in a large, overgrown garden. The women picking apples have an undeniable biblical resonance, and the children playing with dogs and goats lend a pastoral ease to this Garden of Eden. Green predominates, and Bonnard drew his forms on this verdant ground in easy, fluid lines. Although the dimensions and style of these paintings suggest that they were intended to be seen together, this seems never to have happened, and each of the four paintings has had a separate history. Like so many decorations by great artists, they became more valuable apart than together.

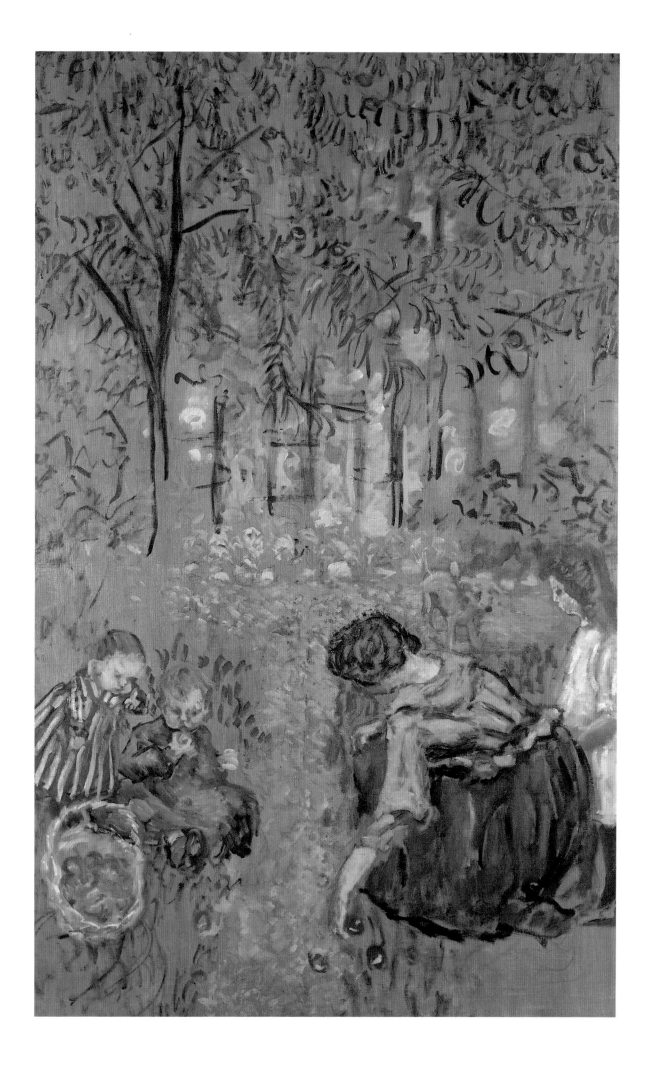

FERNAND LÉGER
STILL LIFE WITH A COMPASS, 1926

If ever there was a painting that demonstrates absolutely the tenets of the Precisionist movement and which almost in itself proves that its artist began his career as an architect, it is *Still Life with a Compass* by Fernand Léger. Painted in 1926, when the Precisionist movement was at its height, this still life is the record of the intimate ties between painting and architecture in Paris during the middle and later part of that decade. How easy it would be for us to imagine this painting hanging in the living space of Le Corbusier's Villa Savoye, designed only two years later. Indeed, it embodies that taut, sheerly mechanical exactness that was such a crucial part of the optimistic technological romanticism so important in France after World War I.

This is no traditional still life. There are no apples, no plates, no flowers, not even a tabletop on which to set the objects. Instead, the artist chose to enlarge and describe, as if in diagram, two portions of a compass and two mechanical objects in front of orange and yellow planes that function more as architectural elements than as spatial indicators. Each form is exactly bounded in black and neatly unified with a single color, and the resulting painting functions more as a sign than a representation. Like many other works by Léger from the mid-1920s, *Still Life with a Compass* both recalls the traditional still-life genre and reflects modern technological society.

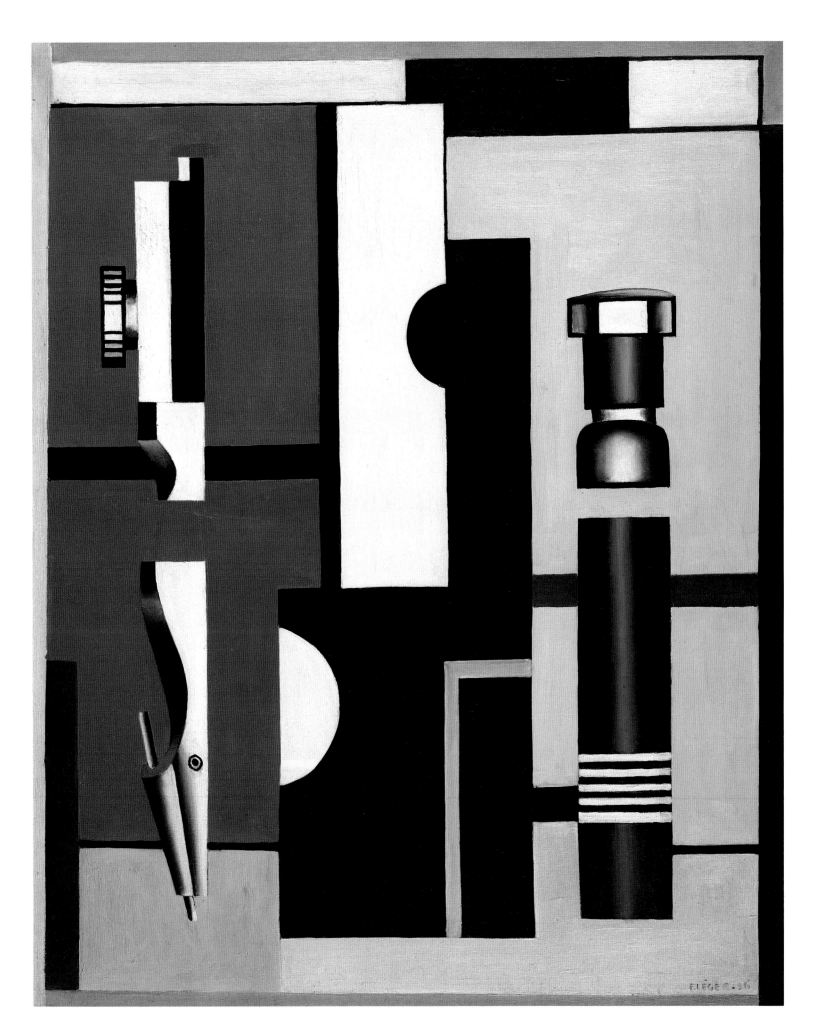

HENRY MOORE
UPRIGHT MOTIVE, 1955–56

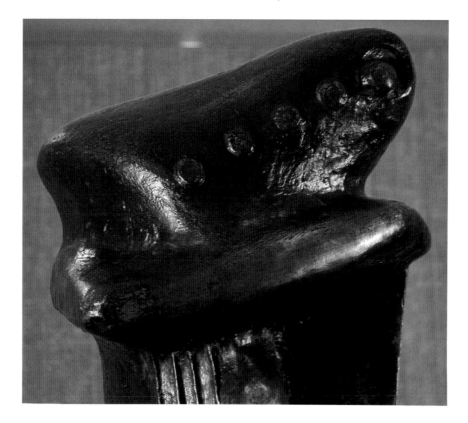

Upright Motive is among the finest of a group of totemic vertical sculptures made by the great English sculptor Henry Moore in the mid-1950s. Moore himself worked initially in small-scale wax and clay figurines, several of which he selected to be enlarged to human proportions in plaster. These plasters were then worked extensively by the artist before they were cast in bronze so as to achieve surface textures and subtleties of massing appropriate to their newly enlarged scale.

Despite its apparently abstract title, *Upright Motive* has many allusions—to *kouroi,* to bones, to columns, to Benin bronzes, and to tribal ancestral figures in wood. Indeed, it is the very resonance of the forms and their associations with the scale and bearing of the human body that gives them their mute poetry. Compressed within a column of form are the gestures of an artist who refused to allow his *Upright Motive* any gestures of its own.

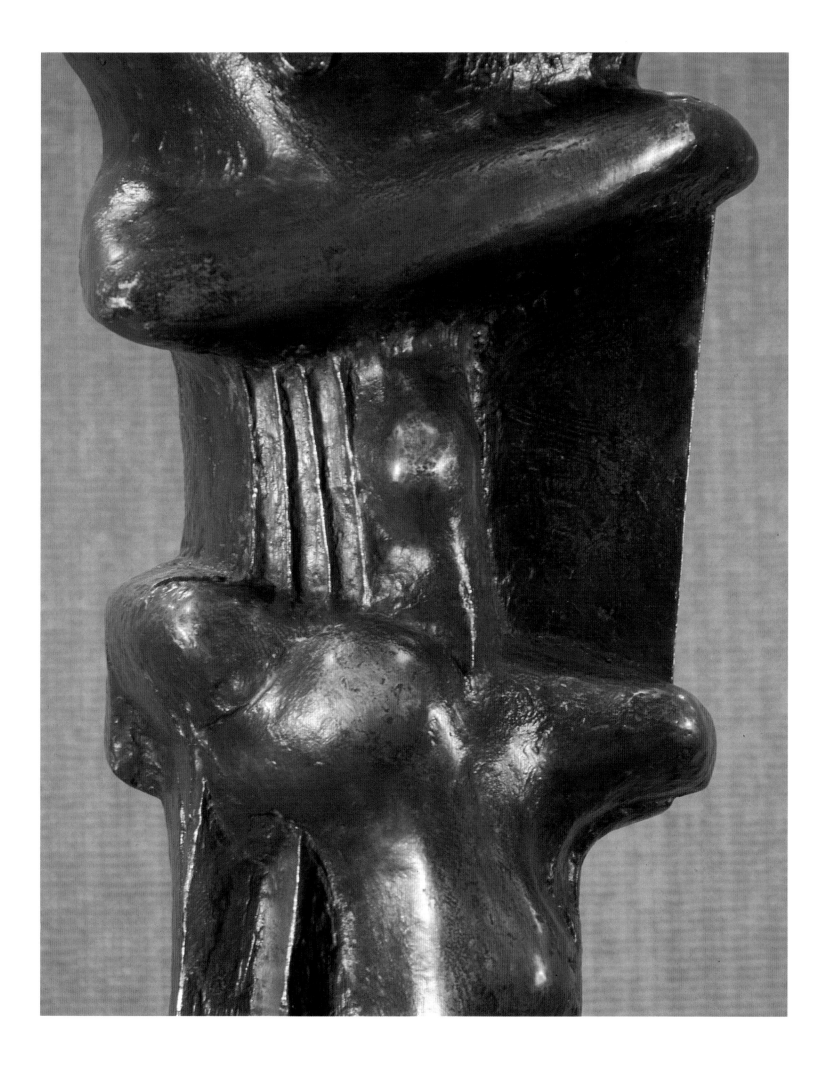

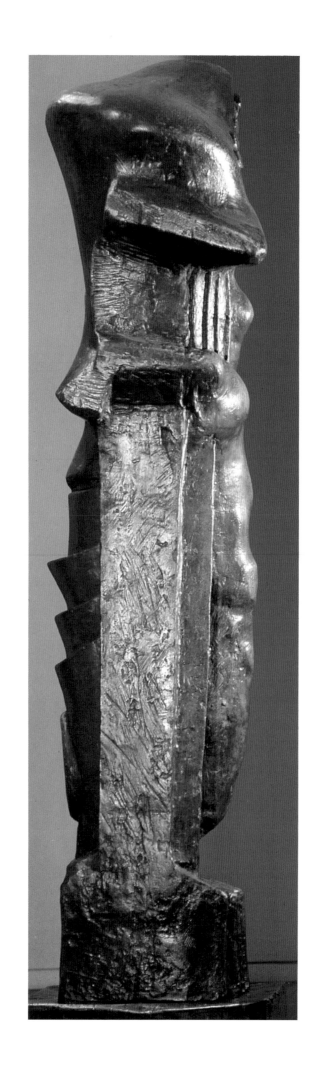

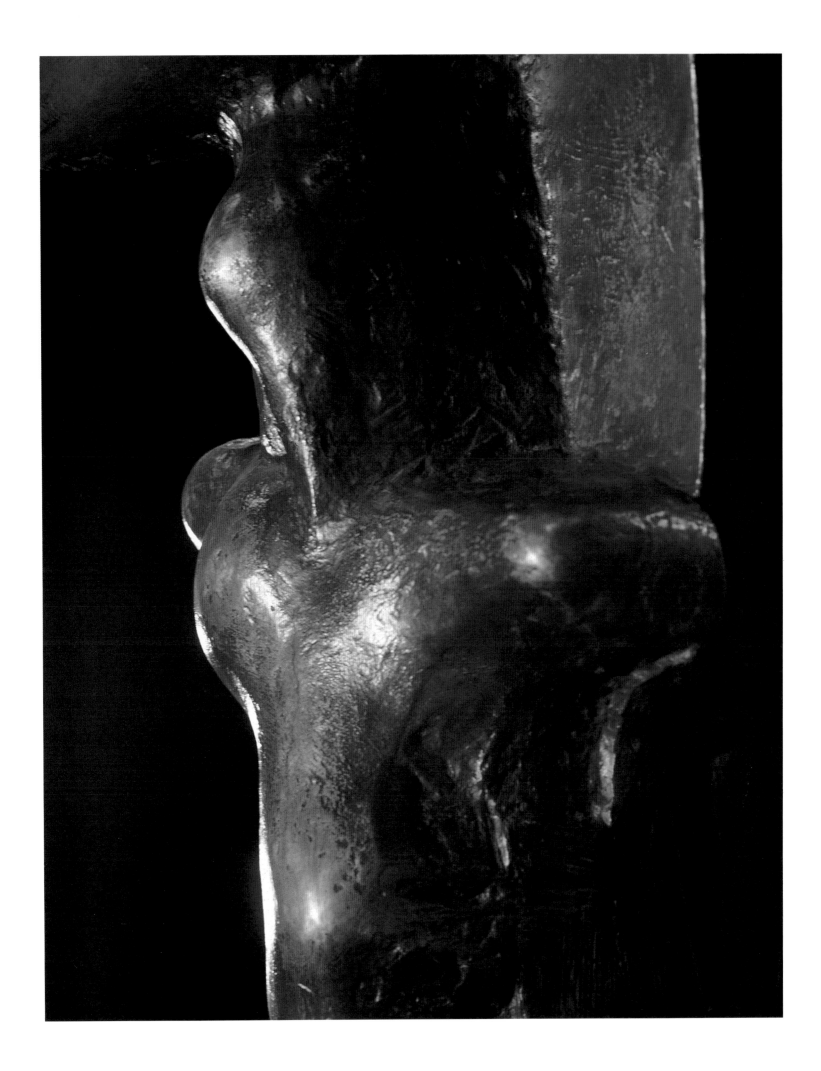

PABLO PICASSO
FEMALE TORSO, 1908

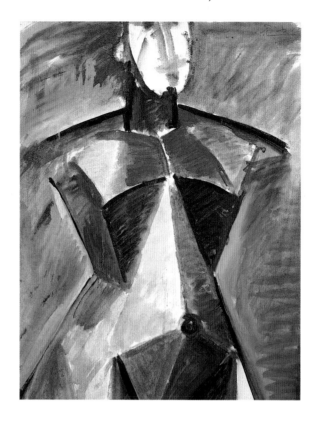

The invention and development of Cubism between 1906 and 1911 by an unknown Spaniard, Pablo Picasso, and a well-mannered Frenchman, Georges Braque, is one of the great collaborative adventures in the history of art. In a period of a few years, these two artists, so different in background and temperament, saw each other almost daily and challenged each other to greater and greater heights of artistic invention. At the very center of their enterprise was the human figure, most often the female nude. For Braque in 1907 and 1908, she could be a mythic dryad, stalking through the picture with a self-conscious primitivism. For Picasso, she could be a prostitute, posing with a leering directness for an unseen male viewer.

Here, in a small and powerful gouache by Picasso of 1908, she is an almost faceless torso, whose breasts and hips are rendered not as voluptuous curves, but as great polygonal masses. She appears to stride or lurch forward, pushing beyond the picture itself directly into our space. Her belly is shaped almost as if quarried from stone, her neck a thrusting cylinder. She is at once literal and elemental. Picasso made this gouache as part of a search for the female form in earthen geometries, a search that culminated later in 1908 when he finished the monumental *Three Women* now in the Hermitage Museum, Leningrad.

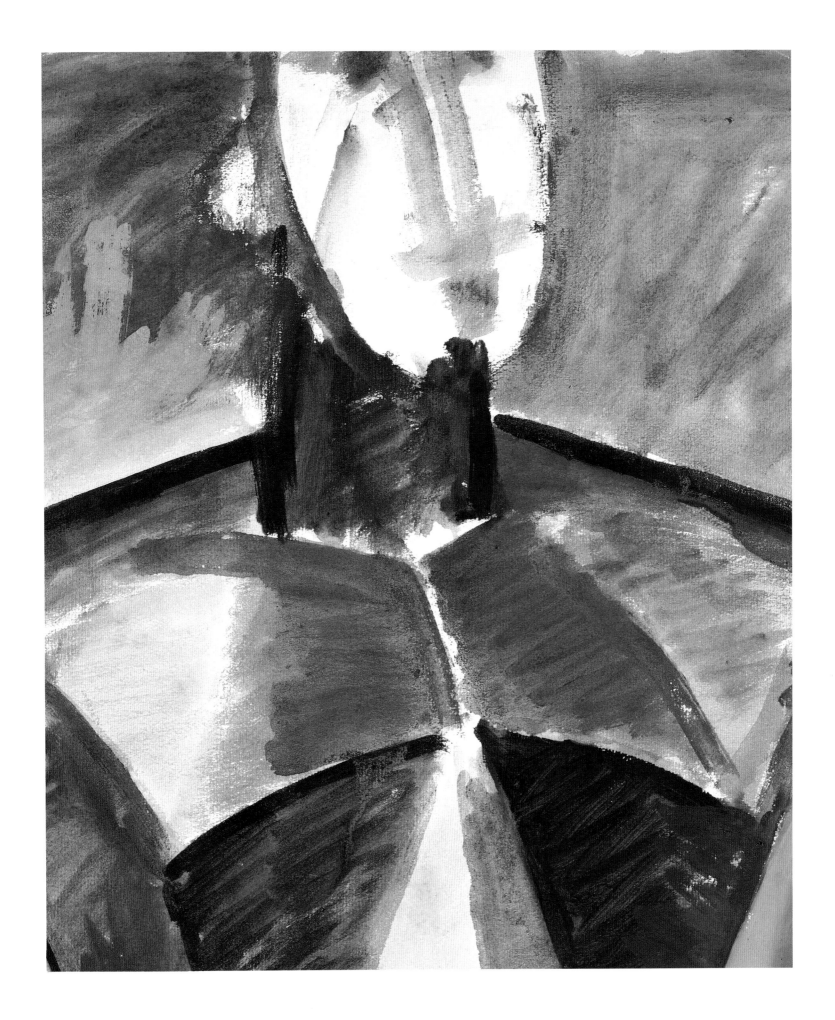

HENRI DE TOULOUSE-LAUTREC
DANCER SEATED ON A PINK DIVAN, 1886

Although small in size, *Dancer Seated on a Pink Divan* is among Toulouse-Lautrec's earliest master-pieces. The setting is the studio into which he moved in 1886, and several elements in the painting can be found in other works by him. The young dancer sits in a relaxed, candid position and looks without suspicion at the viewer. Interestingly, she is *not* at rehearsal or in performance, where she might usually be, but in the painter's studio. In this way, we are encouraged to interpret her less as a ballerina than as a hired model who wears the costume of a dancer. Yet even as a model, she is deficient because she is not represented in a pose. Rather, she simply sits and waits, perhaps to pose or perform.

The most obvious sources for the painting can be found in the oeuvre of Edgar Degas, whose work the twenty-two-year-old aristocrat already knew and admired. Yet the debt is not to Degas's radically simplified and brilliantly colored pastels that he made in 1885–86 (many of which were shown in the Impressionist exhibition of 1886), but rather to the works of his youth, the small oil paintings of the ballet produced in the late 1860s and early 1870s. Degas's example was a general one, and the young artist used no particular painting as his source. Indeed, in his play upon the idea of "model" and his frank acceptance of the studio setting for his dancer, Toulouse-Lautrec went beyond Degas and paid homage also to the works of Édouard Manet, whose death three years before this small painting was made rocked the fragile world of the avant-garde in Paris.

Painted in muted hues of gray, yellow-beige, sand, and ivory, Toulouse-Lautrec's canvas is given life by the accent of the pink divan and the dusky rose wall of the background. The painting was carefully executed and appealed to the artist's conservative uncle, Count Odon de Toulouse-Lautrec, who was its first owner.

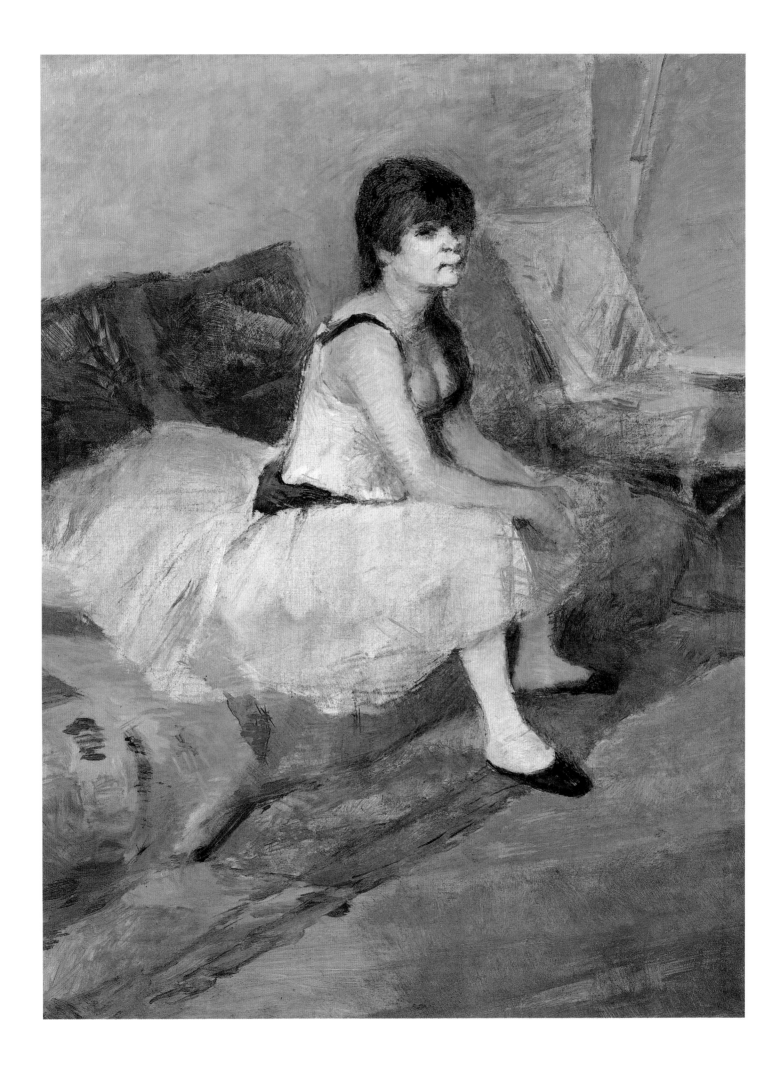

CAMILLE PISSARRO
YOUNG WOMAN BATHING HER FEET IN A BROOK, 1895

Camille Pissarro made very few figure paintings during the last decade of his life. Indeed, he seemed almost to have turned away from the human figure, preferring to paint both urban and rural landscapes in series. This painting of 1895 is a curious exception, and one must look into the history of art for its explanation. Surely, *Young Woman Bathing Her Feet* was conceived by Pissarro as the "pendant" to *A Bather in the Woods* now in The Metropolitan Museum of Art, New York. And it is likely, therefore, that they were Pissarro's attempt to rework—perhaps even to rival—Francesco Goya's famous paintings of nude and clothed *majas*.

We know that Pissarro had never seen Goya's paintings themselves, but he had surely seen photographs of them, for they were as famous in the nineteenth century as they are today. Pissarro greatly admired Goya's art and considered him a part of his own artistic heritage. Yet, while conscious of Goya's example, Pissarro subverted it. Goya's *maja* is in a protected interior realm; Pissarro's nude is out of doors. Goya's *Clothed Maja* is superbly dressed; Pissarro presents a simple peasant girl. Goya's *maja* confronts us with an almost terrifying directness; Pissarro's seems unaware of the viewer. Goya's painting is smoothly finished, Pissarro's is roughly textured—and the list of differences could go on almost endlessly. Pissarro thought of Goya's example *before* deciding to paint his pair of nude and clothed peasant women, but he showed little timidity or even respect for his prototype. Indeed, one can argue that Pissarro's paintings were intended quite simply to be the *opposite* of Goya's well-known masterpieces. However, since Pissarro's two paintings have been separated, this relationship has scarcely been noticed.

Although painted in an Impressionist style, this work was made in the studio from drawings and landscape studies and was *never* observed as such. Pissarro hired several local women to serve as models for the paintings as well as for various drawings and prints made between 1894 and 1896, and he posed one of these models clothed for a superb black-and-red-chalk drawing now in the Ashmolean Museum, Oxford, that was made in preparation for this painting. However—and in contrast to the drawing—the painting is full of self-consciously awkward passages and shows evidence that the painter worked over and over to correct and alter the relationships between the figure and the landscape as well as certain difficult aspects of the pose. The painting, like the contemporary *Bathers* by his friend Degas, is full of *pentimenti*, recording in relief the painter's struggle to resolve the internal problems in this ambitious pair of figures.

One must remember both the ambition and the complexity of this painting when interpreting it. At first an image of simple innocence, the painting is not without moral resonance. The painting certainly recalls other similar and famous subjects—particularly Susanna at the bath—and, reminded of those works, one begins to look for leering old men in the bushes.

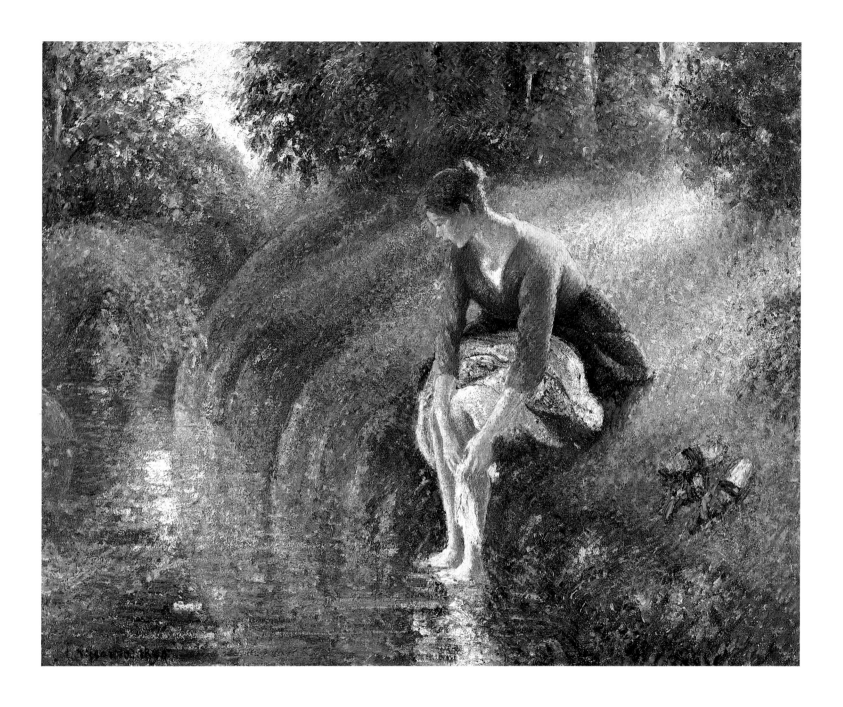

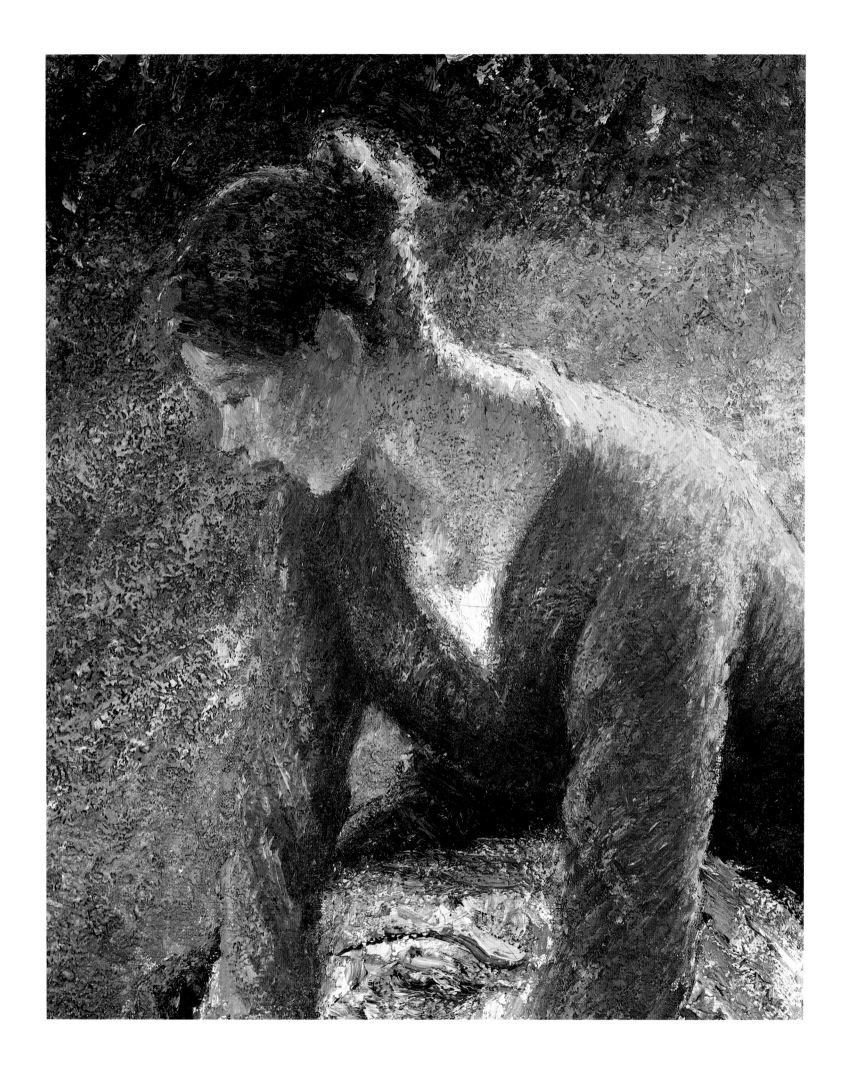

EUGÈNE BOUDIN
ENTRANCE TO THE PORT AT DUNKIRK, 1889

Eugène Boudin occupies a prominent niche in the history of modern art because he was the first important teacher of the young Claude Monet and was, with Johann Barthold Jongkind, a father of Impressionism. This view, while correct in fact, substantially limits our understanding of his oeuvre because Boudin not only took part in the first Impressionist exhibition of 1874, but also continued to paint important Impressionist landscapes until his death in 1898. In many ways, Boudin can more correctly be considered a *true* Impressionist, and his career is most closely related to that of Alfred Sisley, who died only one year after him. Both artists were preeminently landscape painters. Each played a crucial role in the revolutionary history of landscape painting in the 1860s and 70s, and each continued in the Impressionist mode they had established in those years during the last two decades of the century.

Entrance to the Port at Dunkirk was finished in 1889 along with thirteen other views of that now-famous northern French city. Other works from the group were included in an important one-man show at the Durand-Ruel Gallery in Paris during July of that year. But this canvas was perhaps finished somewhat later in the year because it was not seen in public until 1890 at the first exhibition of the National Society of Fine Arts, of which Boudin became a charter member in 1889. Among the Dunkirk canvases, it is one of two probably painted indoors, using a slightly smaller plein-air canvas as its model. This latter painting, identically titled and composed, was not exhibited during the artist's lifetime and remains in a private collection.

The canvas reproduced here was probably made specifically for the first exhibition of the National Society of Fine Arts. This organization, whose first president was the academic painter Ernest Meissonier, was set up in opposition to the government-sponsored Salon and the related Academy of Fine Arts and was, therefore, one of hundreds of antiacademic artistic organizations founded in the late nineteenth century. Boudin painted two views of Dunkirk for the exhibition. The other, *The End of the Port at Dunkirk*, was also painted in the studio from a smaller plein-air canvas and was conceived as a highly finished—and ambitious—exhibition picture.

Like all the finest paintings from Boudin's maturity, this canvas is at once complex and subtle. Its surface is covered with hundreds of deft interlocking and juxtaposed touches of paint—some daubs, some lines, and some patches—all applied with a complete ease and confidence of execution. For this reason, the painting bears careful analysis. Its balanced composition, with a low horizon line and shimmering water, derives from the tradition of seaport paintings inaugurated in seventeenth-century Holland. Indeed, all that distinguishes it from its earlier prototypes are its looseness of touch, its little bursts of bright color, and its steamboats. And how different it is from Georges Braque's brilliantly colored and geometrically constructed *Antwerp*, a view of a comparable northern harbor painted less than a generation later and reproduced in this volume.

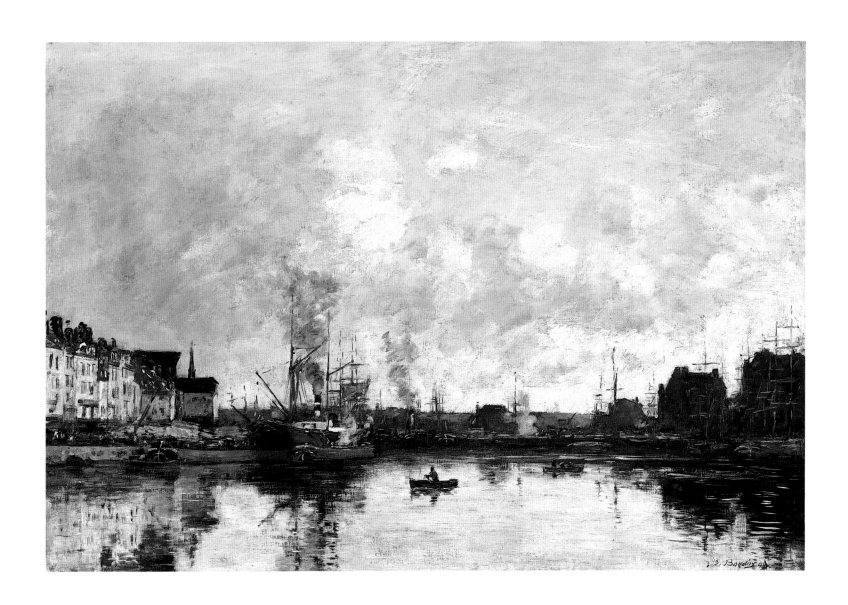

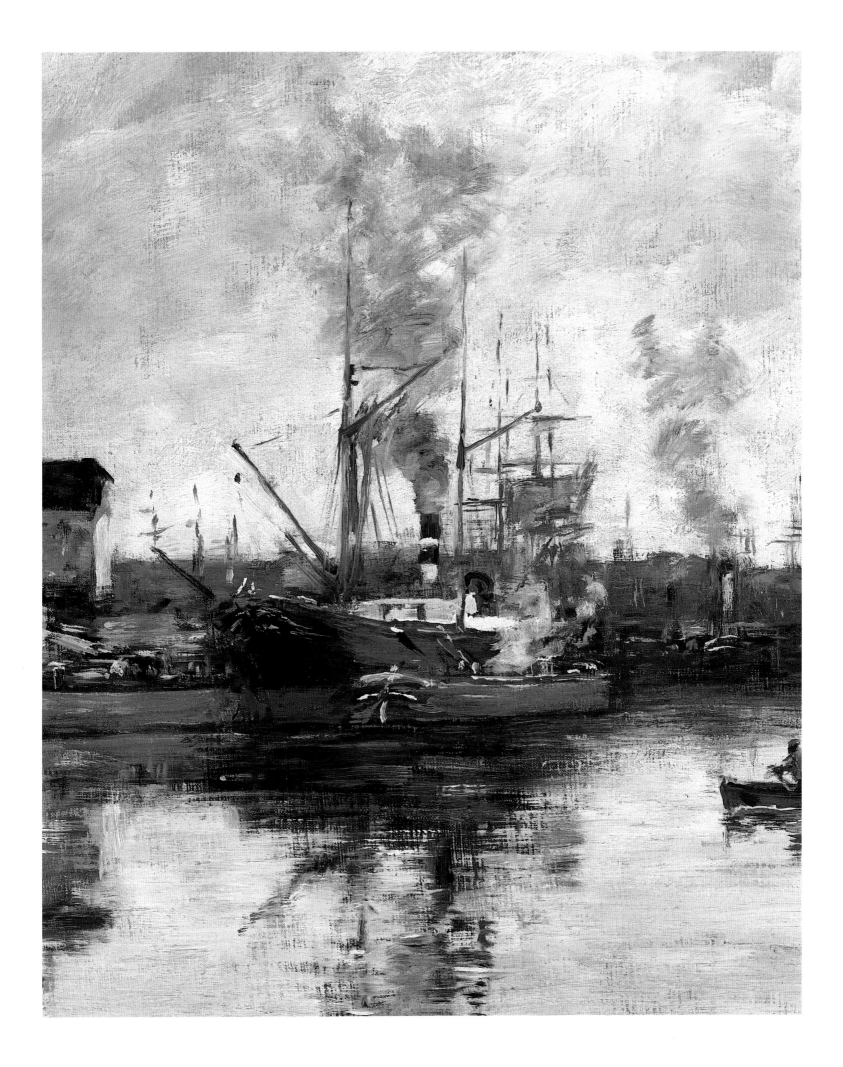

CHAIM SOUTINE
VIEW OF CÉRET, ca. 1919–20

The Russian-born painter Chaim Soutine moved from Paris to the tiny village of Céret in the Pyrenees in 1919 and lived there for three years. He is said to have made about two hundred paintings there, half of which were purchased by Albert Barnes, the great American collector. Soutine himself later repudiated these paintings, many of which he bought back from their owners and destroyed. However, the paintings sold to Barnes were largely out of the artist's reach, and many of the best works from these years therefore remain in American collections. All scholars place *View of Céret* toward the beginning of the painter's stay in that village. Indeed, it might have been among the first views painted after his arrival.

The tortured, almost visceral surface of *View of Céret*, which is characteristic of the artist, is perhaps the reason that Soutine's work appealed so strongly to the Abstract Expressionists in America. It is no accident that the first great Soutine exhibition in this country was at the Museum of Modern Art in 1950 and that the most penetrating criticism of his art was made by the Abstract Expressionist painters Jack Tworkov and, later, Andrew Forge. *View of Céret* was among the paintings "saved" from future destruction by Albert Barnes and has become one of the artist's most famous works. It was included in the 1950 exhibition and has been widely published and discussed.

In it, the landscape has no apparent stability, and gravity has lost its hold on form. The different rhythms of roofs, walls, paths, and windows quake along the surface, allowing no admission and little comfort to the viewer. If this is a view of a picturesque village, how little it invites us for even a vicarious visit!

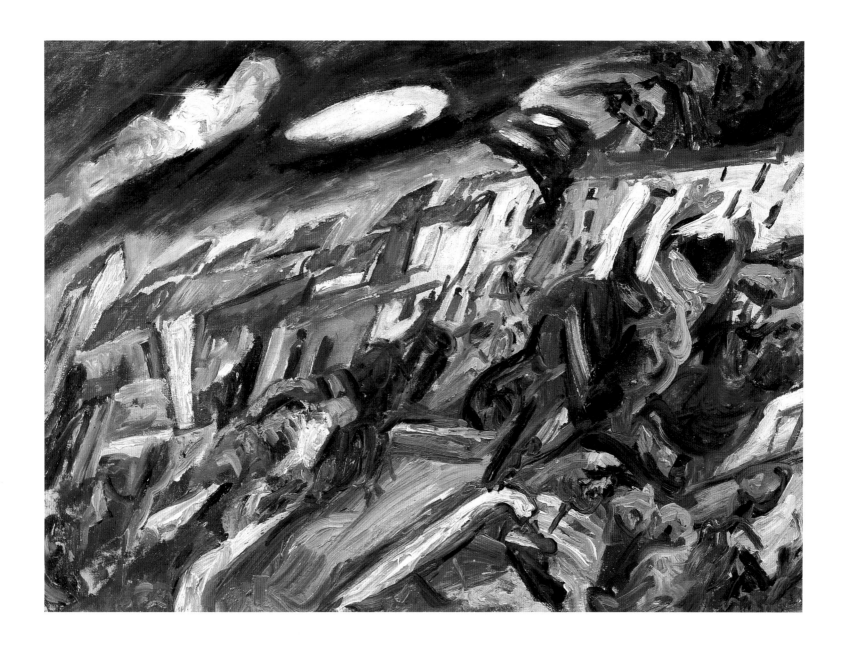

MARC CHAGALL
THE WHITE LILACS, ca. 1930–33

Like Joan Miró and Raoul Dufy, Marc Chagall was a beloved modern artist. Never difficult or cerebral, Chagall's works in every medium appeal—and were intended to appeal—directly and immediately to an ordinary viewer, demanding no special knowledge and little critical preparation. In this way, they relate more persuasively to the folk art, which was so important to the artist, than to the complex and theoretical movements of Cubism or Surrealism that were current when he first began to work in Paris. Yet, in fact, Chagall struggled: Like most great modern artists, he was poor and worked hard for recognition, first in Russia, where he was born and matured as an artist, and after 1911 in Paris. However, by the middle of the 1920s, his income was steady, and he was given many opportunities to spread his gentle, peaceful vision. Making full use of his profoundly Jewish background, Chagall built upon this tradition to create an iconography of love and world peace embodied in paintings, prints, murals, and stained glass.

The White Lilacs was painted after Chagall's acceptance as an artist, yet before his virtual canonization, which occurred only in the later years of his life. Traditionally dated 1924–25 because of its clearly Parisian setting and similarity to his paintings of the region around the Eiffel Tower, *The White Lilacs* was more likely painted in 1930–33, when the artist painted other versions of lovers and flowers, including *Lovers in the Lilacs*, 1930 (in the Zeisler Collection, New York). The white lilacs seem almost to glow from their simple bouquet, and we breathe the powerful scent of early spring. They occupy the center of the canvas, and beyond them stretch the Seine and the quays of Paris, Chagall's adopted city. The lovers—like many of the most important elements in Chagall's work—are compositionally peripheral, yet central to the signification of hope and love that is the message of this painting. Indeed, the towers of the basilica of Sacré Coeur on the buttes of Montmartre appear just above the two figures and seem to sanctify their love.

Even the artist's technique supports our reading of the painting. The surface is at once soft and irregular. No form is imprisoned with line, no color jumps forth in competition with another. Rather, Chagall applied his paint in small daubs and seemingly effortless strokes, allowing the canvas to breathe through the painted marks. In this way, a large painting has the informality and ease of a watercolor, and Chagall's liberation of the figures from the laws of gravity makes the painting itself seem weightless.

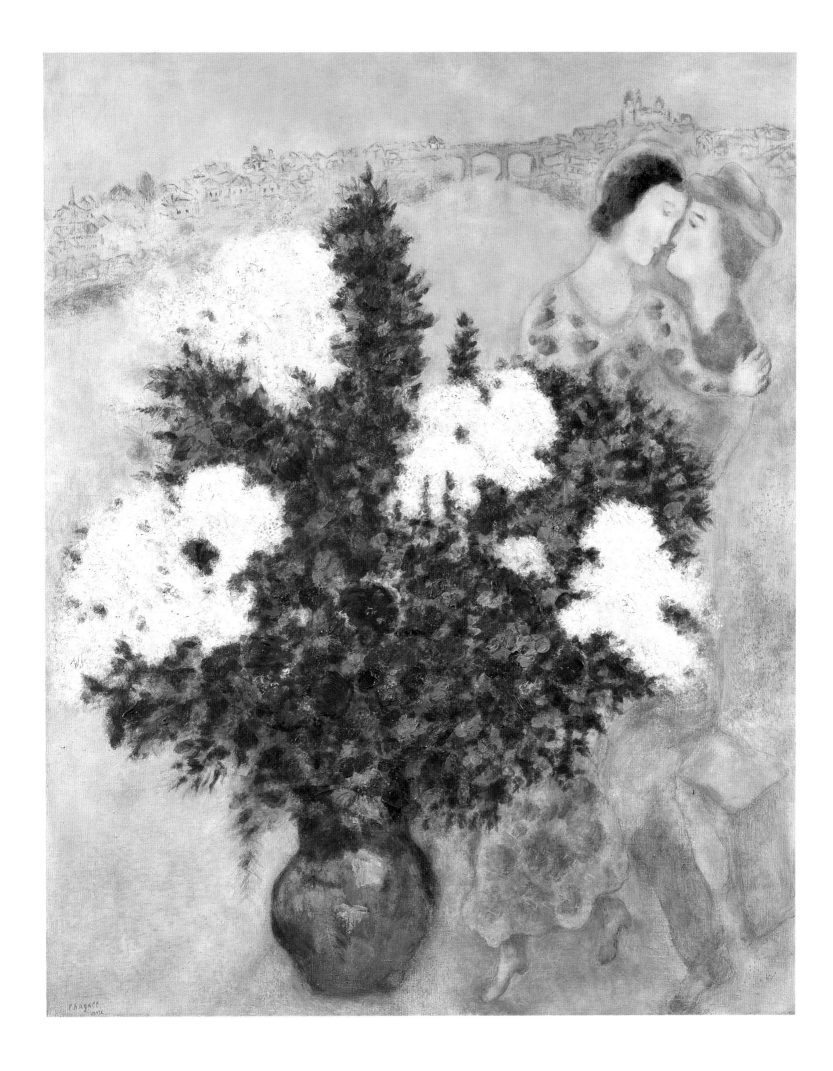

WASSILY KANDINSKY

LAYERS, 1932

If the quality of an artist's career is measured by his influence, Wassily Kandinsky was the greatest Russian painter of the twentieth century. While his early career developed securely in the Soviet Union, his subsequent stays in Munich, Paris, Dessau, and other European cities made his art and his writing accessible to an enormous and diverse audience. Kandinsky was probably the best-exhibited painter in the world before World War II.

As much theorist as artist, Kandinsky was a restless teacher and formulator of artistic doctrines. This small panel painting was made during his long and productive period as a teacher at the Bauhaus, first in Weimar, where he helped found the faculty, and then in Dessau, where it moved in 1925. From that date, each work of art for Kandinsky became as much a theoretical as an emotional exercise, and even the title of this work, *Layers*, tells us of the formal problem that Kandinsky tried to solve by making it: He wanted to use paint to achieve the illusion of overlapping, semitransparent planes in front of a constant pink background. This problem was explored by the students at the Bauhaus as well as their followers in American art schools after World War II. Indeed, *Layers* was made just months before the school was officially closed by the Nazi government and many of its students and faculty members fled Germany.

PIERRE AUGUSTE RENOIR
THE LAUNDRESS, 1916, AND THE BLACKSMITH, 1916

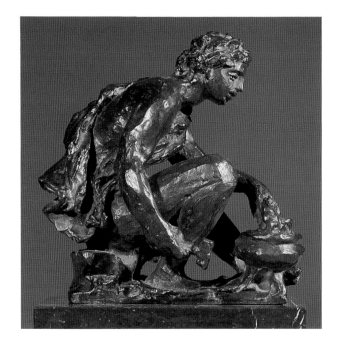 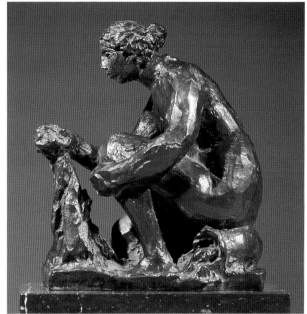

This pair of small-scale decorative sculptures is part of the late work of the greatest figure painter of the Impressionists, Auguste Renoir. As his eyesight failed in the twentieth century, Renoir turned increasingly to tactile mediums, molding human forms in wax and clay just as he had painted them in oil. Yet, unlike his colleague Degas, for whom sculpture was a lifelong preoccupation, it was the last resort for Renoir, and despite the beauty of his three-dimensional oeuvre, it occupies a peripheral place in his art.

Here, Renoir has created a balanced pair of opposites—man and woman, fire (blacksmith) and water (laundress). The obvious allusions to andirons and other purely decorative paired bronzes are surely not accidental, particularly given the imagery of the blacksmith, and many of Renoir's other late sculptures were in fact decorative. One can easily imagine these traditional bronzes atop an eightenth-century commode in a luxurious mansion in Paris, New York, or Chicago, perhaps flanking a vase of flowers beneath an Impressionist painting in an ornate gilded frame.

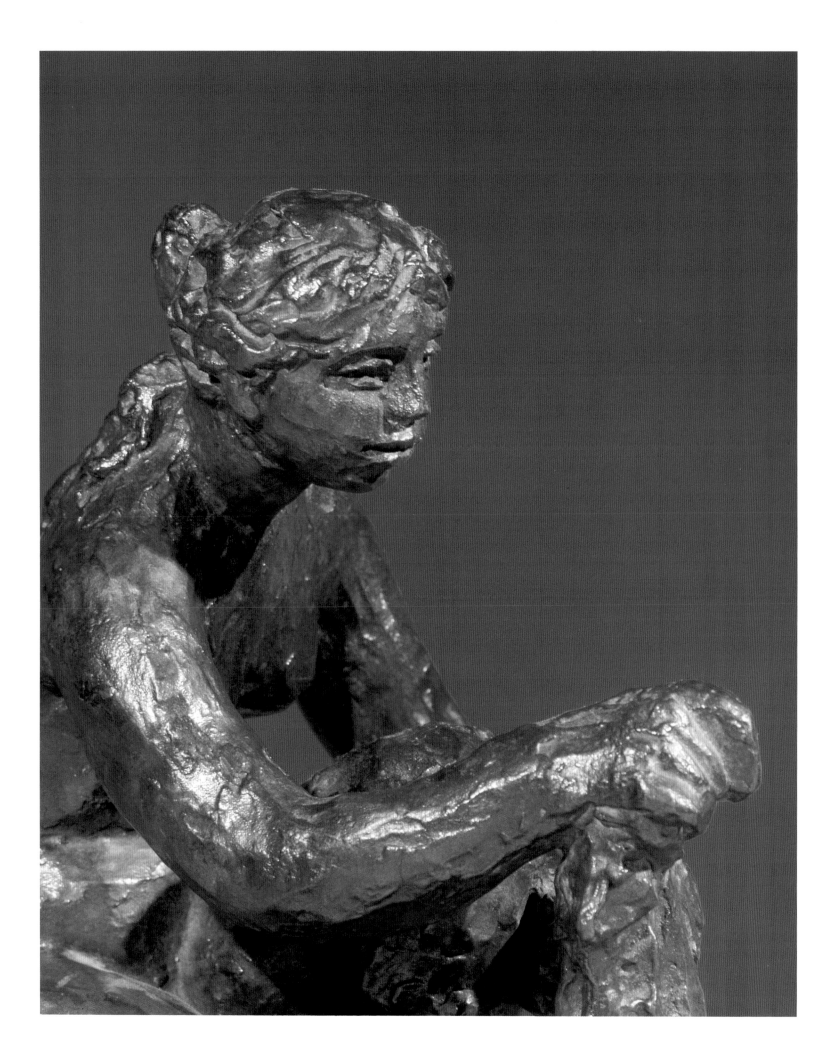

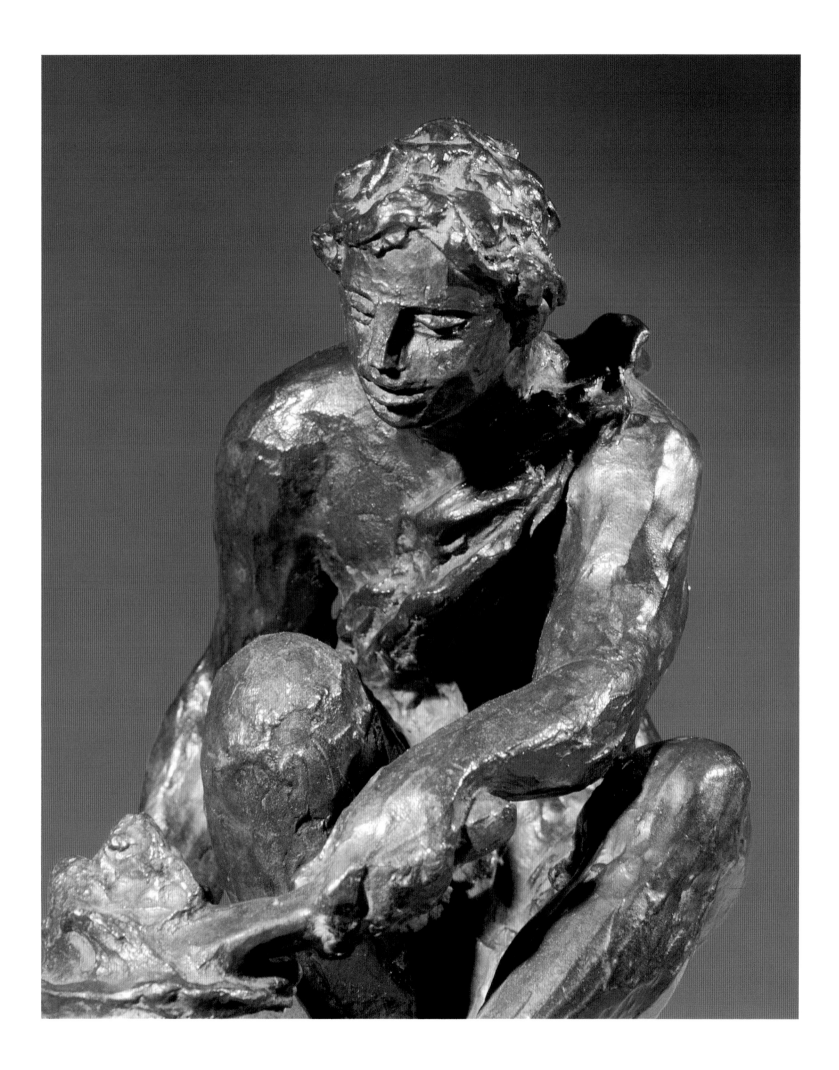

EDGAR DEGAS
RUSSIAN DANCERS, 1895

The late pastels of Edgar Degas are among the most magical in the history of that medium. Using conventional pastel crayons, powdered pastel, ether, fixative, and even atomizers, he created skeins of color that pulsate with life, and he used these energetic surfaces to represent forms in motion. Here, his subject is a group of folk dancers, apparently out of doors. Their legs kick, their waists bend, their arms fly, their hands clutch brightly colored scarves. Their faces are so generalized—one might even say so brutal—that they anticipate the druidic figures that Braque and Picasso would make nearly ten years later. These are not the happy peasants of convention!

Like virtually every work of art made by Degas in the last three decades of his life, this one is part of a sequence of closely related works with similar figures. By using tracing paper as an initial support for virtually all of these, Degas was able to take figures from one work of art to another, reversing them when he wanted, and altering his compositions without losing the underlying visual logic of his figural constructions. There are at least twenty surviving works that relate to the Sara Lee *Russian Dancers*, the most impressive of which is a pastel of the same title in the Blaffer Collection at the Museum of Fine Arts, Houston. Degas made this pastel differ from the others not only by altering the colors of the dancers' costumes, but also by adding another strip of paper to the lower part of the composition, thereby giving the work its own distinctive format and scale. The elderly artist often made these small additions to one or more sides of his late pastels, occasionally disguising them completely. Here, however, as in many other late pastels, he allowed the addition a complete visual integrity, forcing the viewer to think about the character of the work of art with—and without—the artist's deliberate addition.

Who were these Russian dancers? Historians have struggled to answer this question for years. Lillian Browse in her pioneering work on Degas's dancers relates them to a specific troupe seen by Degas in 1895, but other scholars have disputed her claims. Whatever the case, Degas seems to have conceived these peasant dancers very differently than he did his urban ballet dancers, and their rhythmic energy is clearly the opposite of the poise and balance of the ballet. Like many of his contemporaries, Degas was obsessed by the dialectical relationships of city and country, nature and art, and his portrayal of the Russian dancers surely shows us that the heart of this aging bachelor was not only in the city.

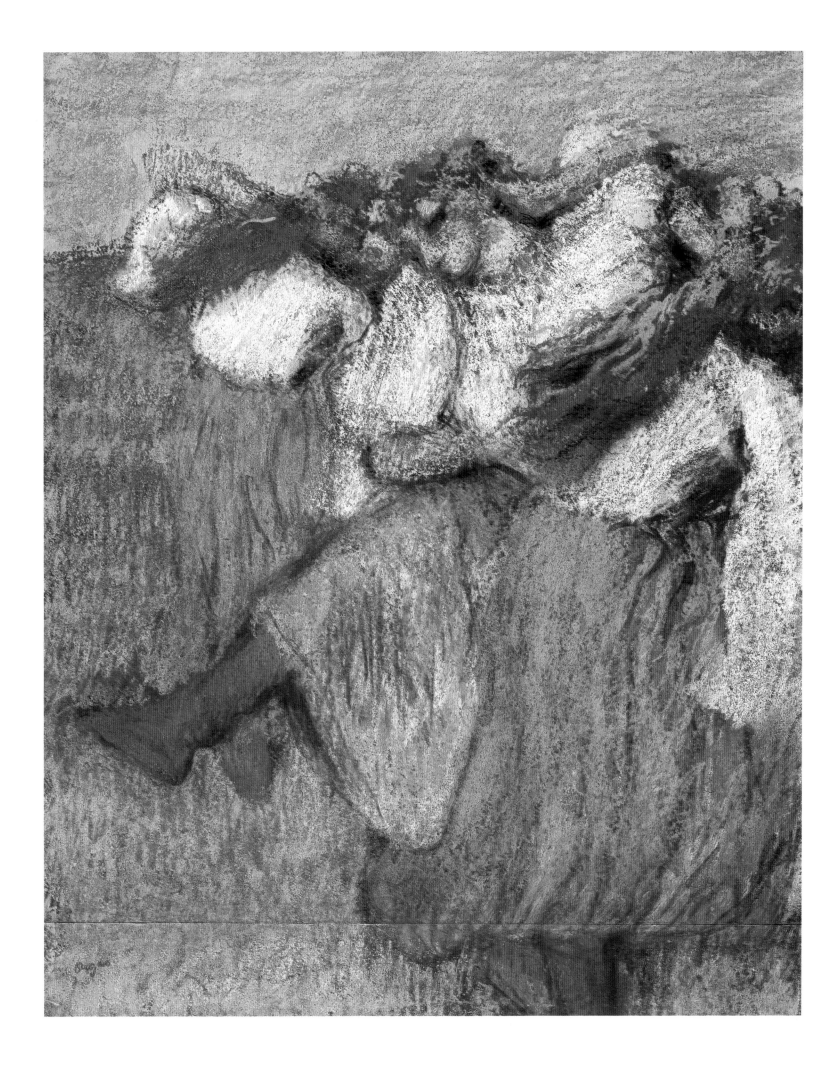

GEORGES BRAQUE
WOMAN PAINTING, 1936

Woman Painting is among the principal works produced by Georges Braque during the troubled years before World War II. It was recognized early and reproduced the year after it was painted in *Cahiers d'Art*, the most important avant-garde journal in Paris during the 1930s. Braque was fifty-three years old when he painted it and had retreated from the active position he had held in the French avant-garde before, during, and just after World War I. In the late 1930s, he consciously rejected the psychoanalytic and political art of the Surrealists, the major force in European aesthetics, turning to the French classical tradition for his imagery and style.

Woman Painting is at once rigidly geometric and gently curvilinear in its construction. The canvas is divided strictly into vertical thirds, each of which is treated as a separate pictorial sector. Yet, these three pictorial zones are linked by the flowing linear rhythms that move from the upper left around the head of the female painter and descend through her clothing to her palette in the lower right corner. Clearly, Braque has merged several species of design—the rectilinear and curvilinear, the geometric and the rhythmic, the artificial and the natural—to produce a synthesis. One is reminded of the great battles between the linearists and the colorists, the realists and the idealists, that played across the surface of French aesthetic theory in the nineteenth century. Braque, the modern artist, has internalized these dichotomies, producing a work of art that signals a new and inclusive aesthetic system.

For his subject, Braque looked no farther than his own studio. Yet, the resonances of the apparently effortless choice are many. Studio paintings abound in the history of French art, particularly in the nineteenth century, when virtually every great painter from Delacroix to Seurat explored the idea of art by representing its "laboratory," the artist's studio. Braque's version of this subject has its closest links with the late studio interiors by Camille Corot in which the female figure in the paintings is at once model and artist, muse and creator.

Her head becomes a "bust" to be observed—and idealized—by the painter. Her smock, with its billowing sleeves, also sports a geometric collar that acts at once as a base for the bust and an internal frame for Braque's painting of it. His painter-model is definitely at work, her brush poised in front of her palette as she selects a color. But Braque is uninterested in *her* painting, of which we have barely a glimpse, preferring instead to force us back into *his* painting of her. And a glorious, subtle painting it is! The shining white of the primed canvas glows through the blacks and dark browns, releasing us from what could have been the geometrical prison of a painting about painting.

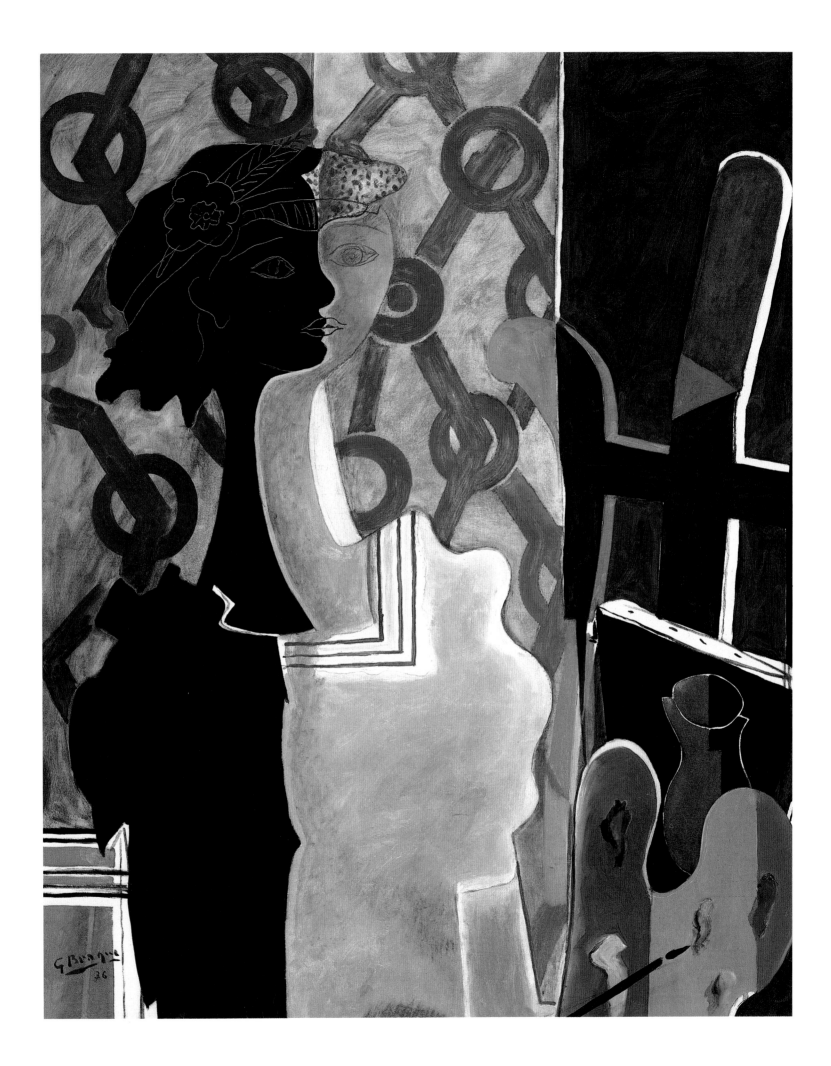

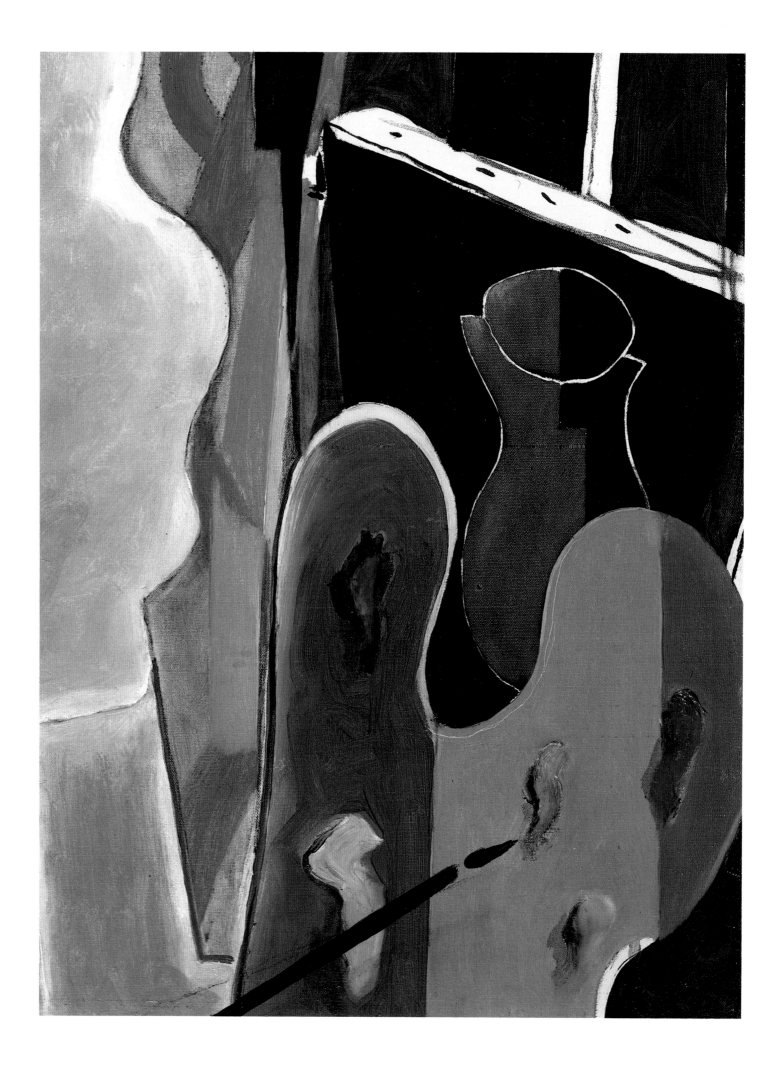

ALBERTO GIACOMETTI
DIEGO, 1954, AND ANNETTE IV, 1962

Alberto Giacometti was perhaps the purest, most uncompromising figural sculptor of the twentieth century. Unlike most of his contemporaries, who abandoned close analysis of the greatest of all sculptural subjects, the human body, Giacometti concentrated his attentions on the bodies, limbs, heads and torsos of men and women, using as models his family and closest friends. From the 1930s until his death in 1966, Giacometti worked to render the essential human form with a minimum of material. Indeed, his "thinned" men and women seem reduced to bones covered with gnarled flesh, and it is not surprising that Giacometti has often been called an "existentialist" sculptor.

The two busts in the Sara Lee Corporation Collection were not conceived as a pair. They represent the sculptor's brother, Diego, and Alberto's wife, Annette, each growing ambiguously from a bronze base. Like all of Giacometti's mature sculpture, they represent an equipoise of mass and nothingness. Indeed, Giacometti made figures that appear not to have been "formed" but to have been "reduced" to essential form by the sculptor. They seem *less* that they were in life, as if Giacometti started from the figure and removed piece after piece of clay or wax until the figure could no longer remain itself.

The surfaces of Giacometti's bronzes are living records of the artist's fitful, even expressionist gestures. As he gouged, jabbed, and molded his clay, he anxiously allowed the record of his struggle to remain, and today we see Annette and Diego as they emerge from the artistic battleground of Giacometti's studio.

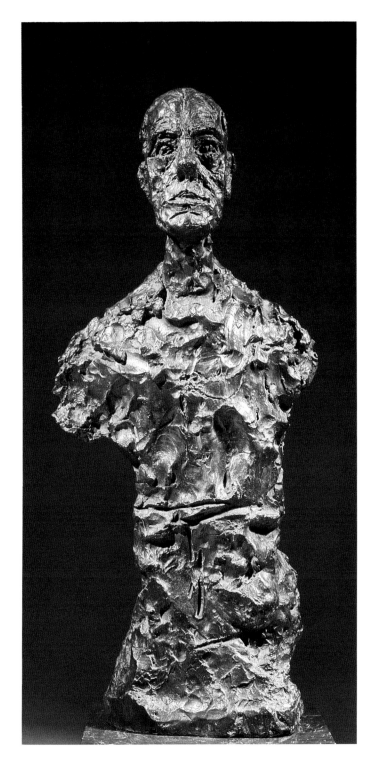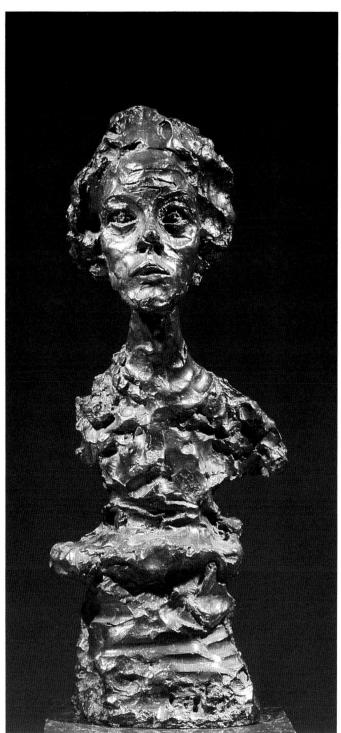

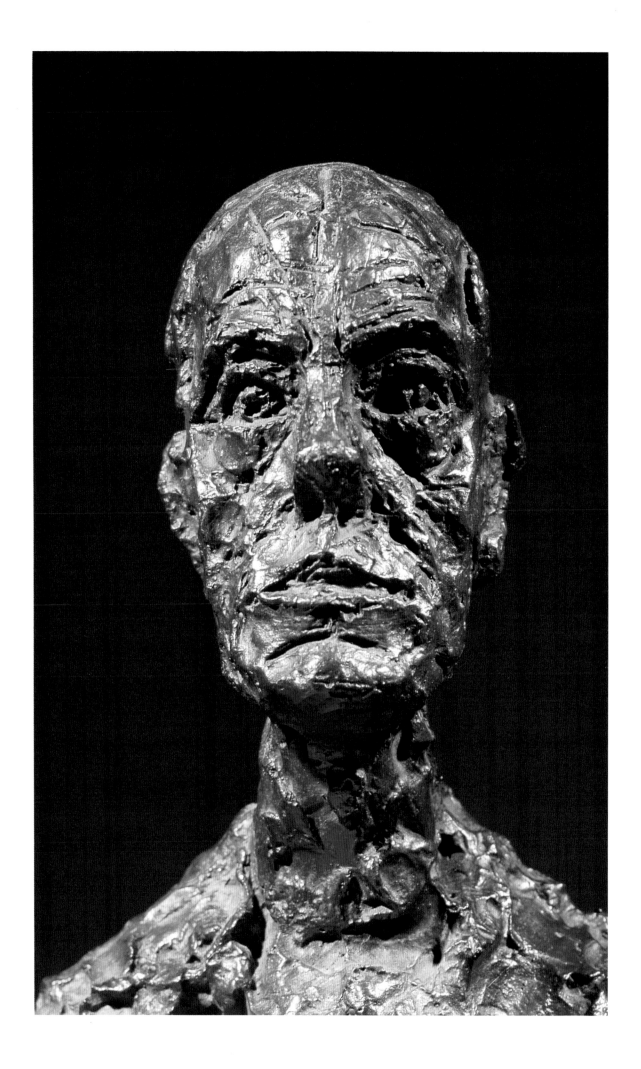

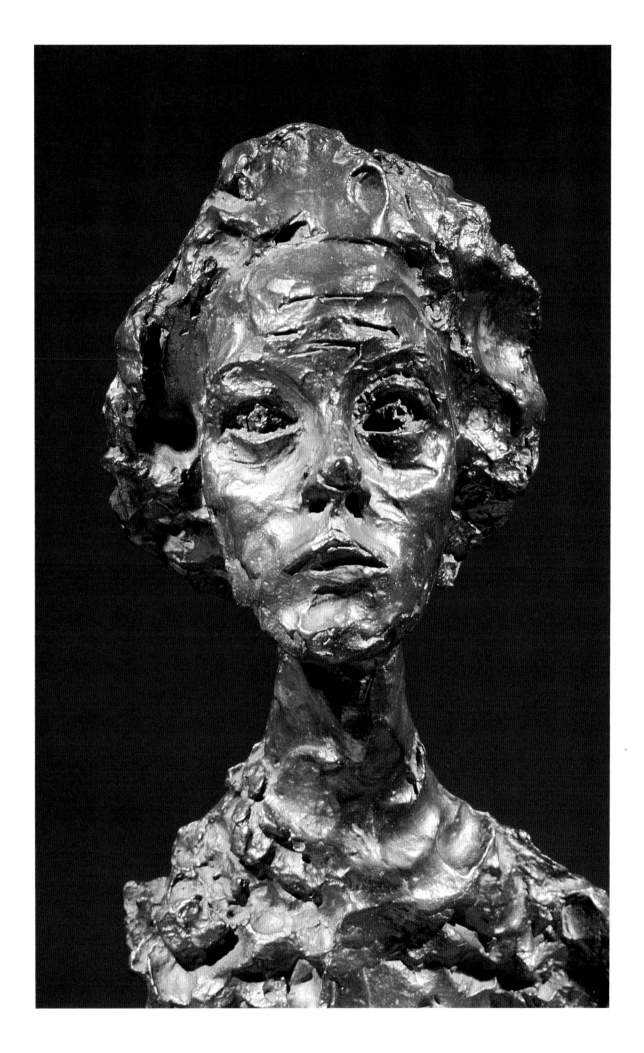

GEORGES ROUAULT
THE CIRCUS, 1936

The Circus is unique in Georges Rouault's long and productive career. Although he often painted circus clowns and other performers either alone or in small groups—particularly during the 1930s—he never again represented what one might call the "spectacle" of the circus. Here in the ring of a Parisian circus, Rouault has arranged a host of attractions: a performer on her horse; a pair of acrobats; and a muscleman, his hands on his hips, dominating the center of the show. The upper corners of the composition are curtained, as if to suggest a stage that has just been exposed for our viewing. The circus so revealed is different from any other in the history of modern art.

Much has been written about representations of the circus in nineteenth- and twentieth-century French painting, and virtually every artist of urban life tried his hand at the subject. From Renoir and Degas through Seurat and Toulouse-Lautrec to Picasso and Léger, the circus has performed in art. Yet, where each of these artists emphasized a different aspect of this form of popular entertainment, none made it as stylized, hieratic, and apparently symbolic as Rouault did in this painting. For Rouault, there is no audience and almost no movement. Each form is imprisoned by its thick, black lines, and the composition relates to Romanesque fresco painting and early Gothic stained-glass windows more than it does to the experience of the circus itself. For Rouault, the circus performance has become a ritual, as grave as a religious act.

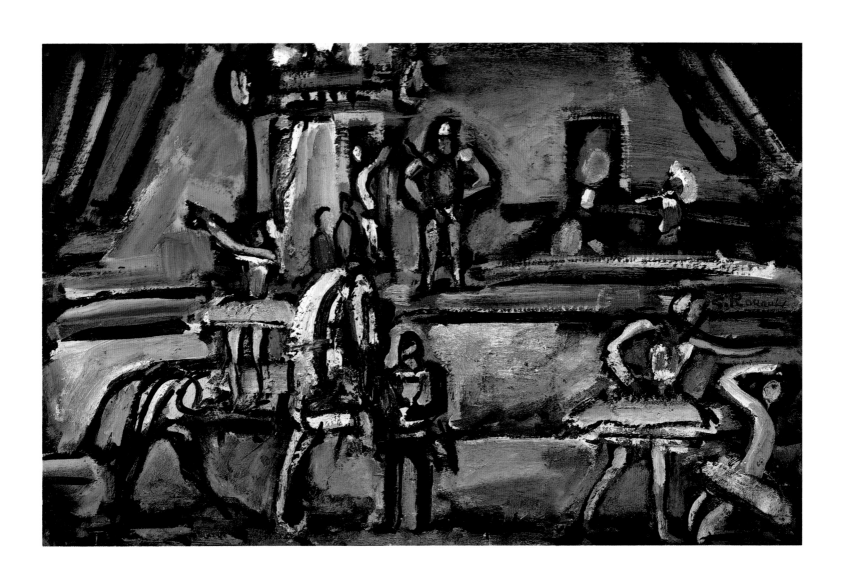

HENRI MATISSE
HENRIETTE I (GROSSE TÊTE), 1925

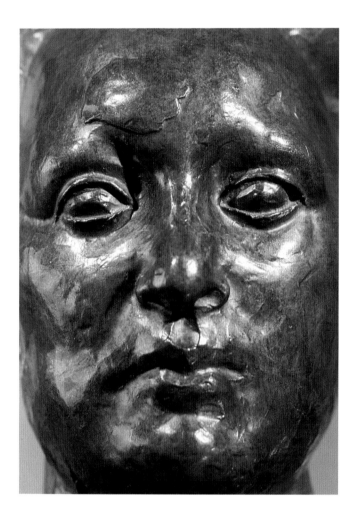

By the 1920s, Matisse's sculpture had veered decisively away from his paintings. While the latter showed his preoccupation with brilliant, flat color and patterned, silhouetted form, the sculpture gained in apparent mass and weight. Indeed, the very materiality of this head—the thickness of the lips, the bulging confidence of the eyes, the massively weighted hair, and the short, thick neck— amply justify Matisse's subtitle, *Grosse Tête*, or "Large Head."

This is most certainly not a portrait, in spite of the fact that we do know the name of the model. Rather, it was the translation of a head into pure volume that fascinated Matisse, a volume, that is, which in sculpture is more real than in life. Only the variable reflections of the bronze surface lend animation to this otherwise generalized and eternal head. And how different it is from the ravaged silhouettes by Giacometti, examples of which are reproduced in this book!

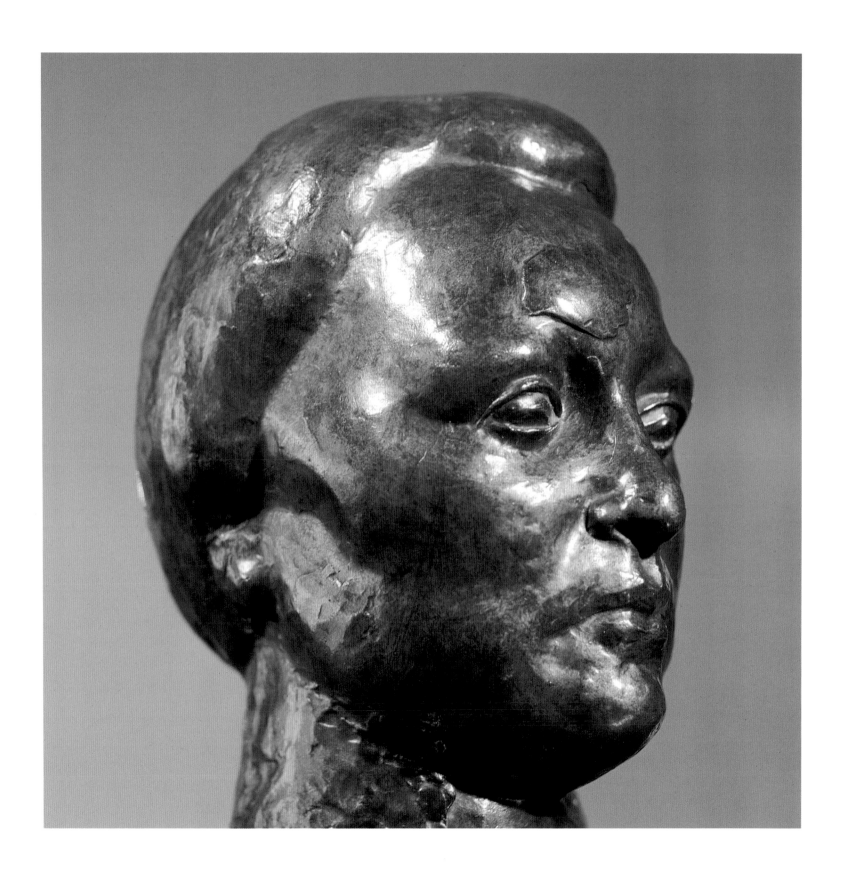

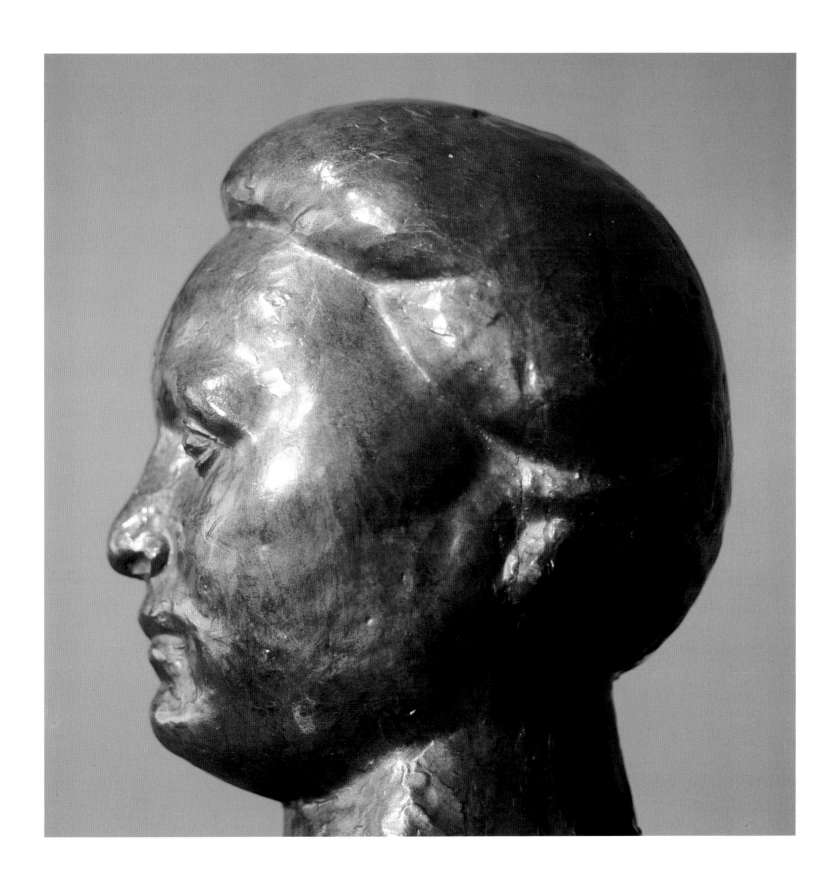

RAOUL DUFY
THE ALLEGORY OF ELECTRICITY, 1936–37

Raoul Dufy made these five paintings on paper as presentation sketches for his largest and most important painting, *The Allegory of Electricity*, painted in 1936–37 for the Pavilion of Light at the Paris International Exhibition of 1937. The final painting, nearly 200 feet in length, served as an energetic and informative background for four working electrical generators that powered the exhibition. At the center of the composition, the bolts of lightning that represent natural electricity seem to generate the energy that animates the immense composition and quickens the pulse of its viewers. Today, permanently installed in the Museum of Modern Art of the City of Paris, *The Allegory of Electricity* is among the principal attractions of that museum.

To explain every facet of these paintings—or even of their superb sketches—would require volumes. Dufy studied every aspect of electricity, from the history of its discovery and exploration to the modes of its production and its uses. He visited factories, hydroelectric power stations, and universities. He interviewed historians, scientists, politicians, and philosophers. He read texts from Lucretius through Franklin and Watts to Thomas Edison. And he drew and drew and drew. The resulting composition is more a compendium than an analysis of this massive body of material, and every aspect of the prehistory, history, theory, and practice of electricity is simultaneously present. Indeed, the viewer is more overwhelmed than informed, which is exactly what Dufy intended.

The Fay Electricity herself presides over the first panel, her allegorical draperies whipped about by some unseen wind, her hands desperately restraining her hair. Although wingless, she flies benignly over a world that brings together the forms of the European past with those of its future, while the Eiffel Tower is balanced by some futuristic fantasy of an atom smasher. Beneath her, an orchestra plays, frantically accompanying her journey. The following panels have casts of historical figures that anticipate the maddest of Hollywood extravaganzas, and the whole ends with a pantheon of classical gods reigning above the new generating machines of the future.

Dufy's Fay Electricity has clearly descended from Zeus to save the world. She is a messenger from the past and a harbinger of a unified, charmed world to come. There are no social ills, no difficulties, no disease, no dissension here. Dufy's great murals, even as they were conceived in sketch form, have all the ideological fervor of a political speech or a corporate pavilion at a trade show. Here, electricity is hope.

What saves *The Allegory of Electricity* from uncritical banality is the sheer confidence and beauty of Dufy's drawing. Rapidly made rhythmic lines build forms without either shading or closed contour. There is little doubt that Dufy was among the great draftsmen of the mid-twentieth century. What he lacked in a Matissian economy of means, he more than made up for in his apparently spontaneous linear exuberance. His brush seems to have flown across these sheets, each turn of the wrist and flick of a finger recording a form. There is a charmed energy that becomes a sort of controlled hysteria of line, and surely this—more than his preparatory reading or his interviews, and more than the names of the historical personages that crowd these sheets—is what is truly *electric* about them.

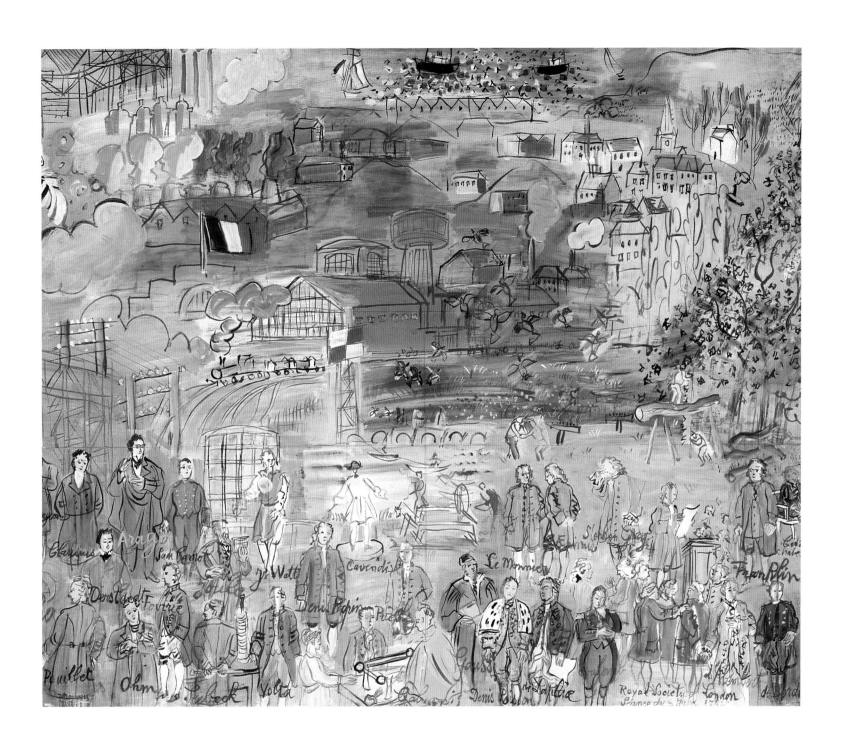

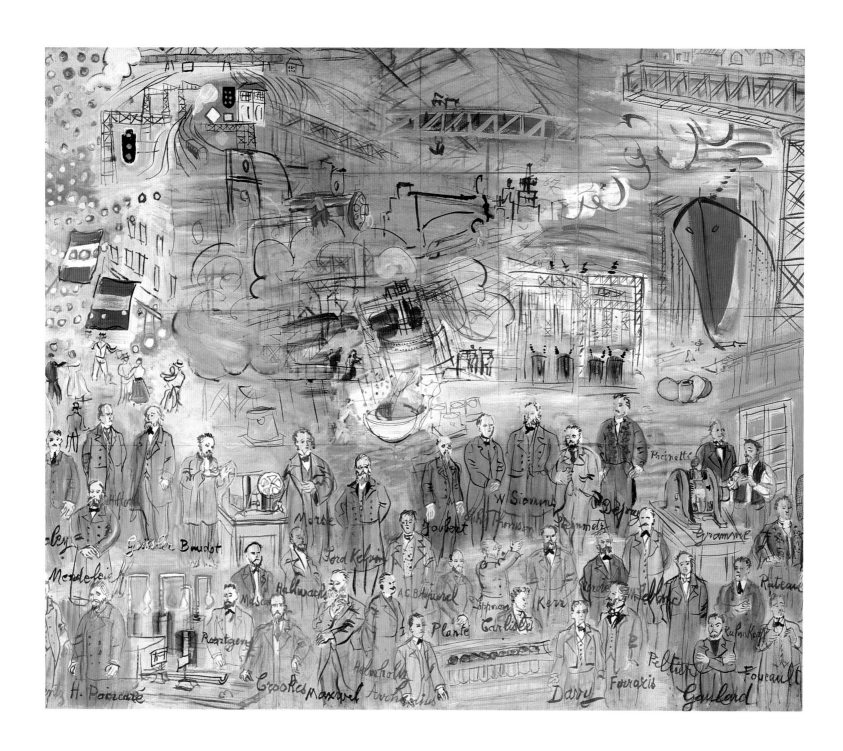

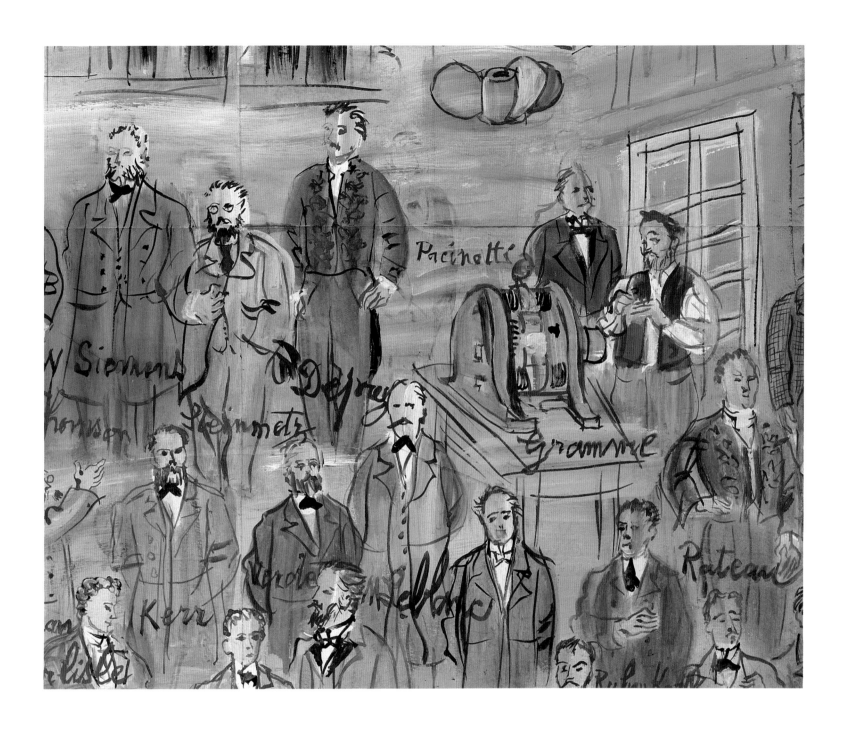

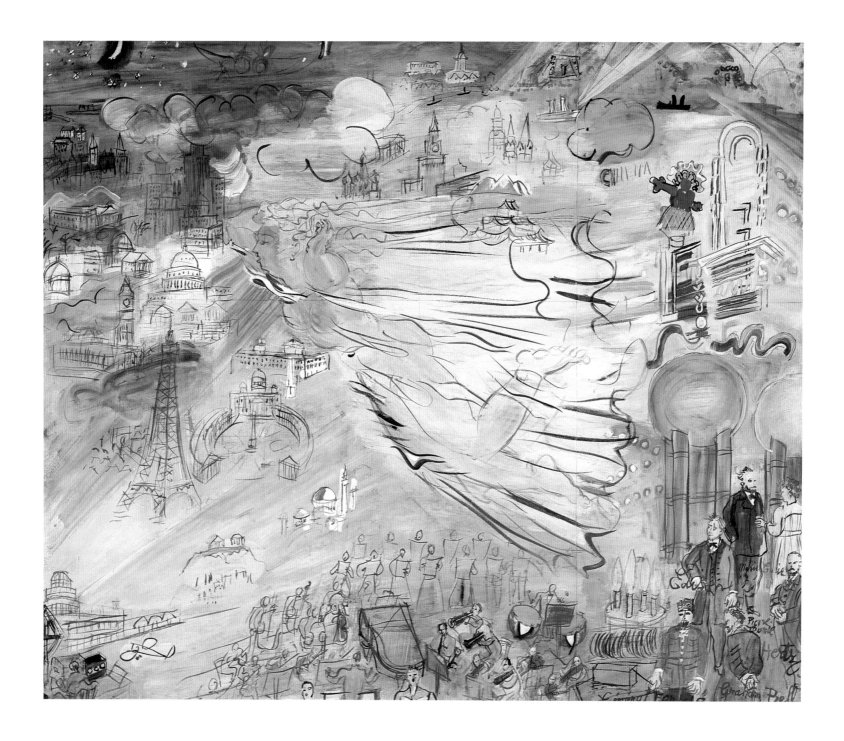

JEAN METZINGER
THE HARBOR, 1912

Jean Metzinger was at the peak of his powers as an artist when, in 1912, he painted this important composition, laconically entitled *The Harbor*. Its subject is aggressively urban, far indeed from the picturesque port views by Boudin (*Entrance to the Port at Dunkirk*) and Braque (*Antwerp*) in the Sara Lee Corporation Collection. Here, Metzinger breaks the subject into distinct geometrical segments, each representing a particular aspect of the larger "reality" of the port. The most conventional of these representational segments is in the center, where one sees a traditional port with its masted ship, sailboats, buildings, and mountains as if in diagram. Surrounding this "reality" are fragments of hoists, bridges, cranes, sails, smokestacks, ropes, and flags that, in their combination, evoke aspects of a seaport without "representing" it topographically.

In 1912, Metzinger joined with his friends Albert Gleizes, Juan Gris, and others to form an exhibition group called The Golden Section. Their works were designed according to rational, classically derived principles of design and proportion quite different from the theories of Braque and Picasso, whose own early Cubist paintings had not yet been publicly exhibited. With the exception of Juan Gris, these artists have been overlooked in the middle and later part of the twentieth century, and because they are largely unpublished it is therefore not easy to place individual works within their oeuvres.

It is tempting to assign *The Harbor* a date of 1915–16 because of its confident geometries and its resemblance to the paintings of 1913–15 by Picasso. However, there is ample visual evidence that the painting does date from 1912, the founding year of The Golden Section group. A close parallel can be found in a painting from that year representing the same subject by Albert Gleizes now in the Art Gallery of Ontario in Toronto. Also, a superb *Composition Cubiste* by Metzinger himself, now in the Fogg Art Museum, Cambridge, is particularly close in both palette and surface organization. If the date of these works is upheld by subsequent scholarship, Metzinger must be considered as a leader rather than a follower among the Cubists.

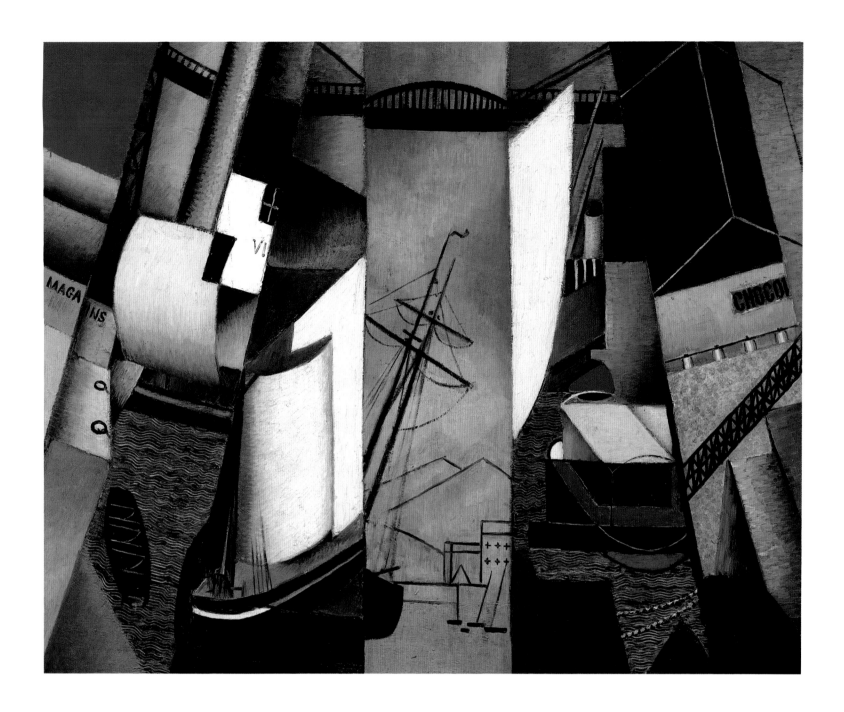

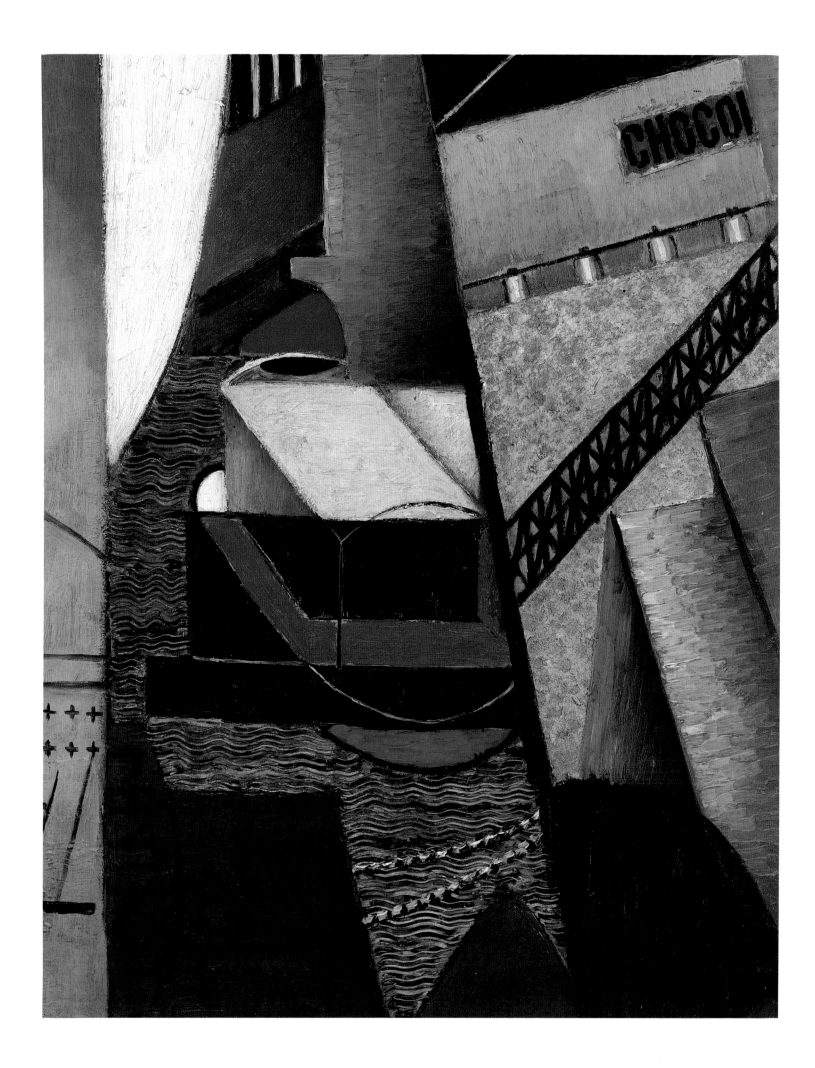

CAMILLE PISSARRO
YOUNG WOMAN TENDING COWS, ERAGNY, 1887

Young Woman Tending Cows, Eragny is among Camille Pissarro's most masterful works in gouache. Like his friend Degas, but unlike most of the other Impressionists, Pissarro worked equally well in all mediums, making prints, drawings, book illustrations, and even ceramics. His earliest works are drawings and watercolors, and he never ceased to draw. However, *Young Woman Tending Cows* cannot be considered *merely* a drawing since its scale and degree of finish give it a position equal to Pissarro's oil paintings. Indeed, as if in recognition of its quality, it was exhibited twice during the artist's lifetime.

Camille Pissarro himself considered 1880 to be a critical year as he turned increasingly away from the informal, Impressionist aesthetic that had preoccupied him for the previous decade and toward a newly structured, intellectual art. In 1885, he met the young Georges Seurat, whose Neo-Impressionism was based not only on the scientific principles of color-and-light interaction, but also on a highly studied process of preparation that rejected the plein-air aesthetics of the Impressionists. By 1887, when he painted this gouache, Pissarro was a confirmed Neo-Impressionist. He had already painted several of his most important compositions in that manner, one of which hung adjacent to Seurat's great masterpiece, *Sunday Afternoon on the Island of the Grande Jatte*, at the final Impressionist exhibition of 1886.

Young Woman Tending Cows is a tightly structured study of brilliant sunlight as it strikes a field. The figure is a young peasant woman whom Pissarro had hired as a model and who posed in the studio for preparatory drawings. She sits in the shade of a tree whose decoratively curving branches fill the elegant void of this assymetrical composition. Like Seurat and other Neo-Impressionist painters, Pissarro sought to achieve a "dry" or nonreflective surface in his paintings of the late 1880s, refusing to varnish his oils and turning increasingly to the "driest" of all mediums, gouache. Tiny, disciplined "commas" of gouache shimmer across the surface, and one can almost sense the heat of a summer day. Here, Pissarro had borrowed a subject from the great Barbizon painter Jean-François Millet and had invested it with the modernity of Neo-Impressionism. There is not a single stroke of paint out of place in this work, which was created in a style that revolutionized the history of art. And one must remember that the artist who made this revolutionary work was then nearly sixty years old!

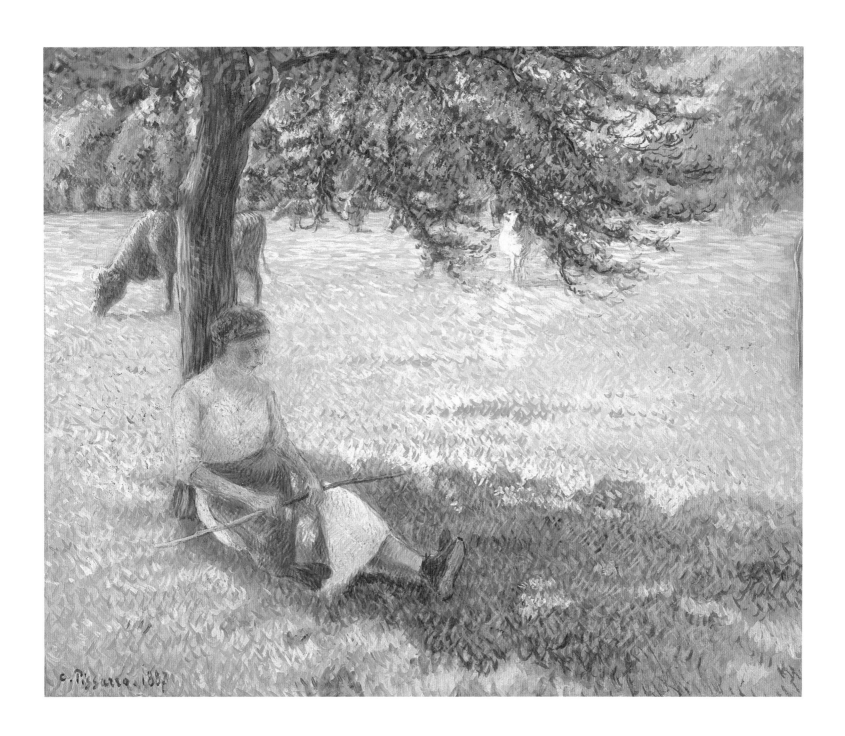

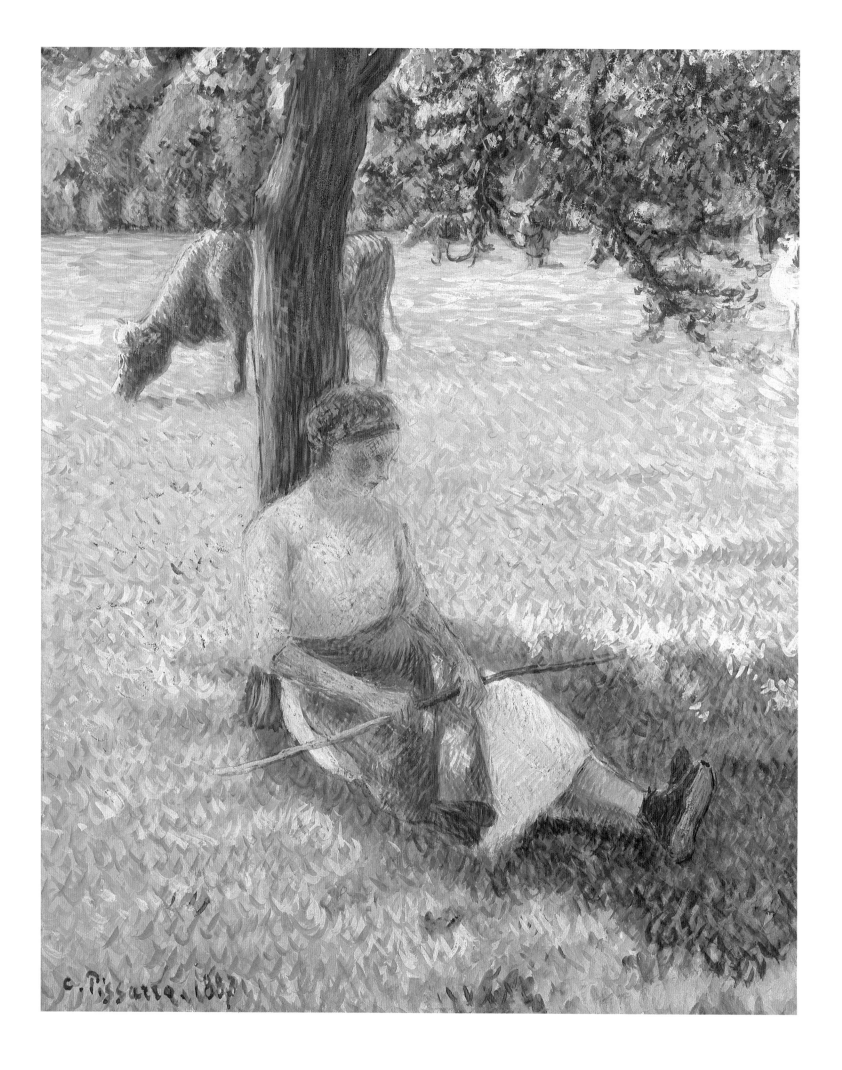

C. Pissarro. 1887

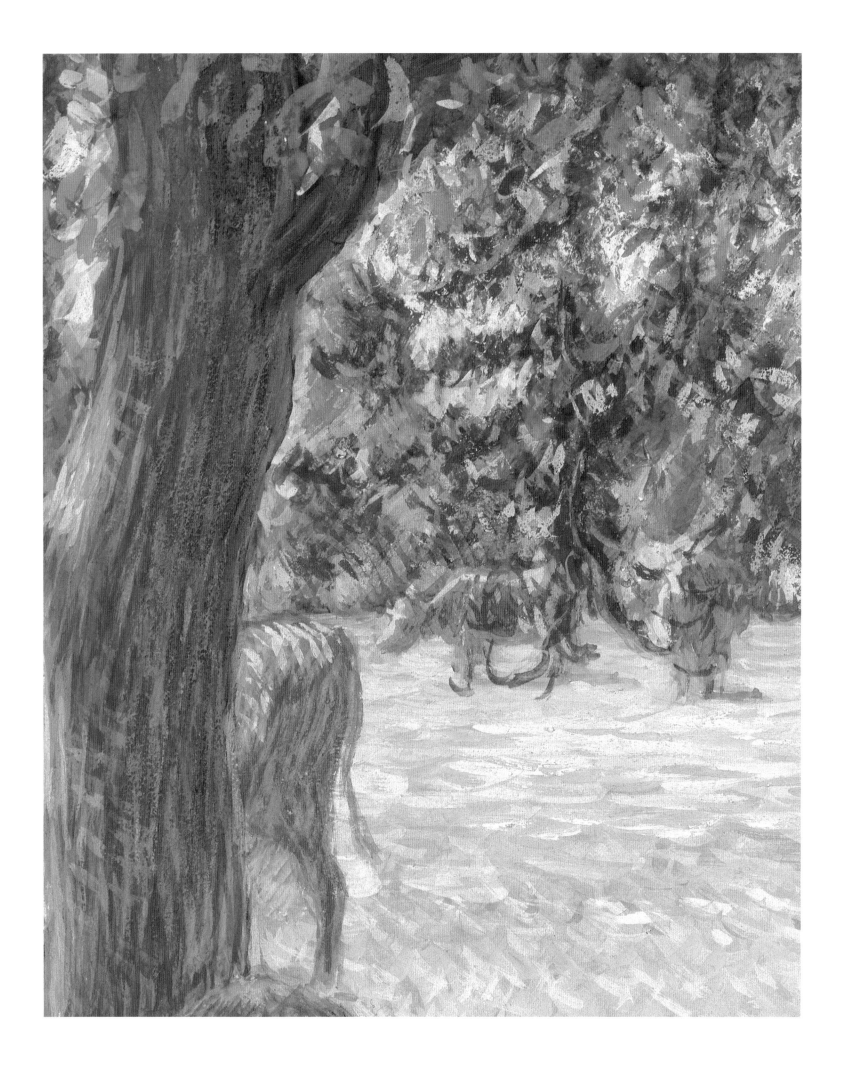

ARISTIDE MAILLOL
PHRYNE, 1903

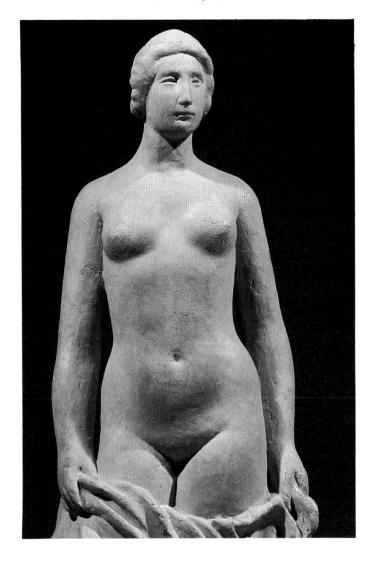

Aristide Maillol was the greatest classical sculptor of twentieth-century France. His massive female figures in bronze, lead, and stone have their roots in French sculpture of the seventeenth century and, ultimately, in archaic Greek sculpture. Unlike many of the major sculptors of his generation, Maillol was not an important painter, preferring to concentrate his energies on the production of a purely sculpted figurative art that lacks what one might call the "painterly daring" of Matisse's contemporary three-dimensional work. Yet, it is with the massive female nudes of Auguste Renoir's late painted oeuvre that Maillol's figures have their closest aesthetic parallels, and the sculptor's closest friends were all painters—Ker Xavier Roussel, Pierre Bonnard, and Édouard Vuillard.

Phryne is among Maillol's finest small-scale works in terra-cotta. The dry irregularities of its surface lighten and animate this otherwise massive bathing figure. In both scale and material, this terra-cotta evokes associations with the archaic Greek sculptures in the same medium found at Tanagra. These pre-classical works fascinated Rodin and Degas when they were first exhibited in Paris in 1878, and they were equally important to Matisse and Maillol in the twentieth century. Yet despite its archaic associations, *Phryne* ultimately is classical, and indeed its title alludes to a fourth-century B.C. Greek hetaera—a cultivated courtesan—used as the model for a sculpture by Praxiteles and for a famous painting by Apelles, now lost.

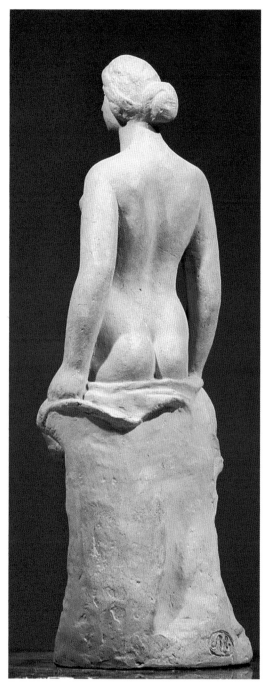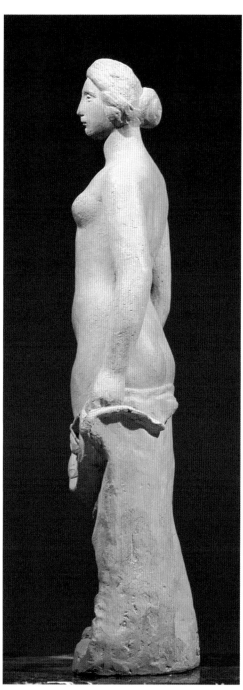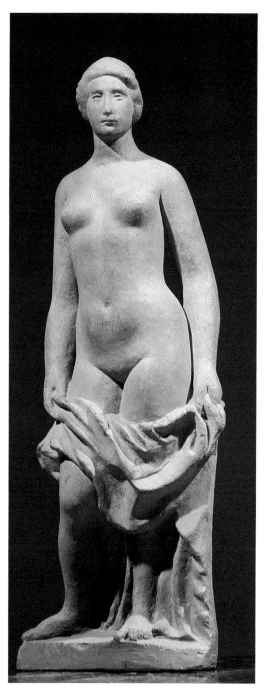

EDGAR DEGAS
BREAKFAST AFTER THE BATH, ca. 1895–98

When Edgar Degas died in Paris at the age of eighty-three in 1917, he left an enormous body of work to be sold at public auction. The resulting sales were among the greatest of the twentieth century, and the irascible old bachelor, who died in relative obscurity, came to life again through his art. Critics, collectors, and, above all, artists, marveled at the late pastels, many of which are among the very greatest large drawings in the history of art.

Breakfast after the Bath, drawn in several discreet sittings during the last five years of the nineteenth century, is surely among the masterpieces from Degas's sales. In it, a young woman seems almost to have leapt from her bath, her right arm and leg tensed to receive her full weight as she negotiates her way from the tub to a soft chair on which her dressing gown has been placed ready. Her maid is pushing the door open, while balancing the breakfast coffee so that nothing spills. Hence, everything is caught in motion, poised between two states.

The center of this dynamic composition is devoted to the back and buttocks of Degas's glorious nude, but, for all her lifelike vigor, she was most probably not drawn from life. Indeed, Degas had already captured her in an identical pose many times before, particularly gloriously in a pastel called *After the Bath* in the collection of The Art Institute of Chicago. By the time he made the Sara Lee pastel, his eyesight was erratic, and he seems often to have derived his source from other earlier works, sometimes by tracing and reversing figures from paintings or pastels and other times by using as his "model" a wax sculpture rather than a real woman. There is a wax sculpture now in the Mellon Collection that is directly analogous in pose to this wonderful nude.

We must not allow the indirectness of Degas's working methods to color our interpretation of the final works. The powerful directness of Degas's lines and the richly sensuous application of his color give this—and many other—late pastels a kind of kinesthetic energy that is lacking in his earlier work. Degas's paintings and pastels become, in the end, *more* rather than less realist, and one of his boldest devices in achieving this degree of realism is scale. More than three feet tall, this pastel is not a miniature evocation of an interior with two figures, but a powerful re-creation of that interior, in which the figures can be read as approaching life-size. When hung on the wall of a small room, like those in which Degas lived, the woman attains the scale of an actual figure perceived from a short distance. In this way, Degas seems himself to be present, reaching across the rose-colored fabric in the foreground to touch his own creation.

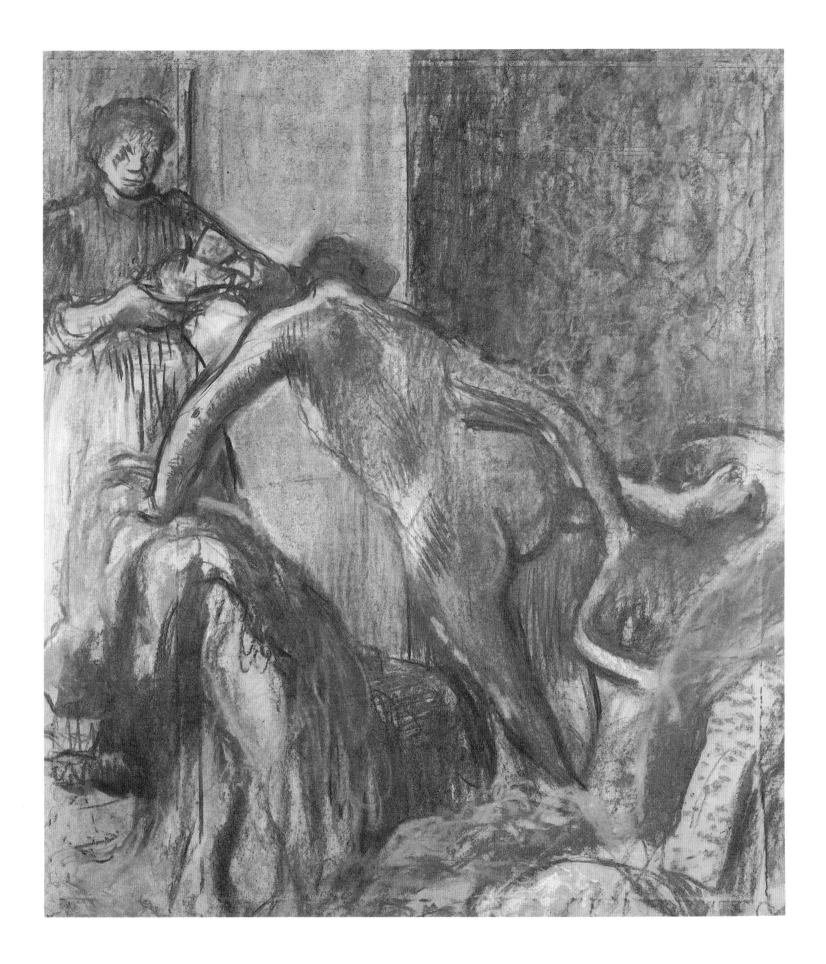

HENRY MOORE
FALLING WARRIOR, 1956–57

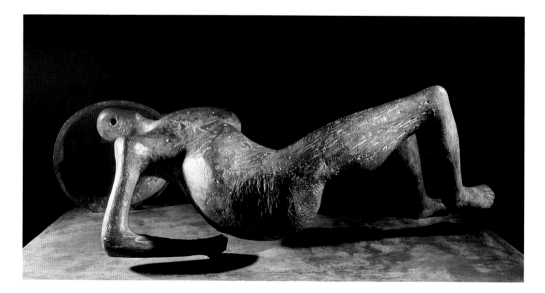

Henry Moore, the greatest figural sculptor of the twentieth century, was fifty-three years old when he made his first visit to Greece in 1951. There, in the shadow of the Parthenon, he visited the great museums of Athens with their treasury of archaic and classical Greek sculpture. In front of these monuments, Moore's earlier distrust of Greek sculpture disappeared, and he began to make a series of monumental figures inspired by Greece.

On his return to England, Moore went obsessively to visit the most important Greek sculpture outside of Greece, the fifth-century B.C. exterior sculpture created by Phidias for the Parthenon and housed since the nineteenth century in the British Museum. *Falling Warrior* derives quite clearly from this pedimental sculpture. Yet for Phidias the drama of the fallen warrior plays its part in a complex drama with other figures, in which the agony of the warrior is justified by the order of the world for which he fought. For Moore, in the decade after World War II, such optimism was not relevant, and the elemental struggle of a single warrior is itself the subject first of a maquette in 1956 and finally of the larger bronze. Moore must have felt that the warrior in the maquette looked dead, and, for that reason, altered the position of the figure in the final bronze so that we are clearly witnessing the final moments before death.

Falling Warrior has also been published with the title *Fallen Warrior*, but this latter title is surely wrong, not necessarily because Moore never sanctioned it, but because it fails to recognize the active struggle that is the real subject of the bronze. The warrior *is* falling, and, as he raises himself on his elbow, seemingly to right himself again, he attempts a last heroic act before falling finally to his death. The rough surface of the piece and its mottled patina suggest both the fretful workings of the artist's hand and the ancient metal of the falling warrior's shield.

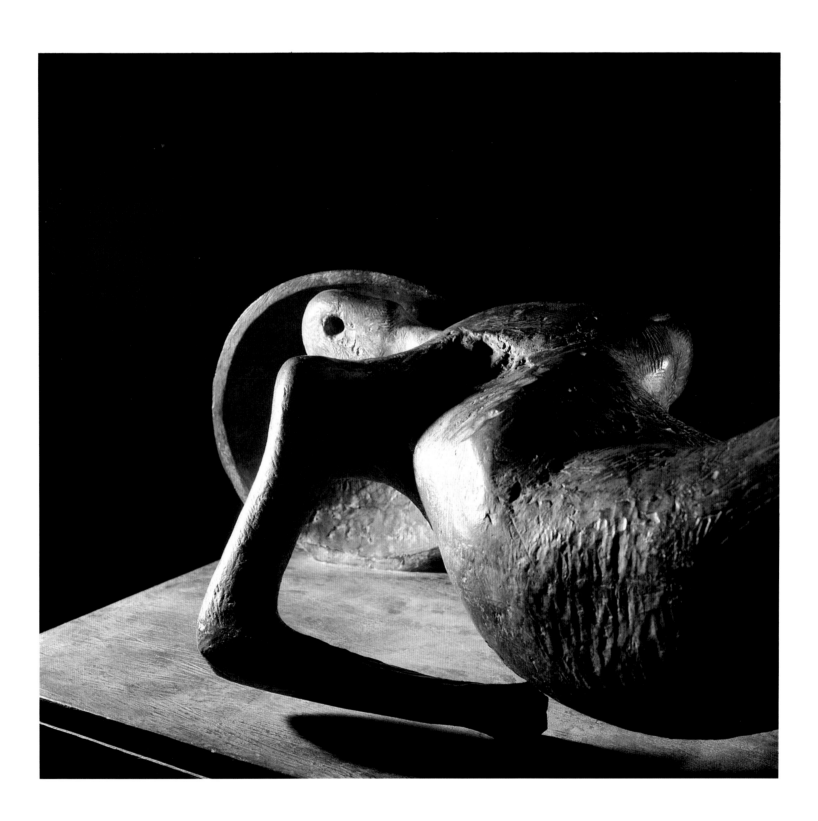

ALFRED SISLEY
A PATH AT LES SABLONS, 1883

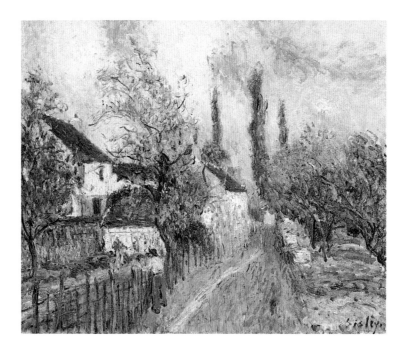

This bucolic landscape represents a rural path between a vegetable garden and an orchard in the small village of Les Sablons, southeast of Paris. Sisley combed the banks of the Seine and the outskirts of this village for motifs throughout the early 1880s, and a pencil drawing in Sisley's sketchbook at the Louvre enables us to date this painting to 1883.

The existence of the drawing challenges us to think about larger issues than the date. Why, if the Impressionists painted out-of-doors in front of the motif, does a drawing even exist? However, as today's scholars search the archives and private collections of the world for letters and drawings by the Impressionists, we are learning that they made drawings throughout their lives and that many Impressionist paintings have as much "paperwork" as do academic paintings of the previous generation.

When Sisley saw this modest landscape for the first time, he carried nothing more than a pencil and a notebook, and his drawing represents his first response to the motif. Afterwards, on examining his drawings and reflecting on his experiences, he re-entered the landscape and commenced work on the painting in earnest. It is therefore no accident that the painting quivers with the same kind of graphic energy as Sisley's drawings. Rather than applying paint in broad areas or with a large brush, Sisley literally drew with paint, creating a delicate web of lines that vibrate along the surface. What was, in reality, a rather dull path in a perfectly ordinary village near Paris is enlivened with the energy of the wind and the nervous gestures of the artist's hand.

ÉDOUARD VUILLARD
FOLIAGE—OAK TREE AND FRUIT SELLER, 1918

This large and important decoration by Édouard Vuillard was installed in the dining room of the great art dealer Georges Bernheim in 1918 as World War I raged across Europe. While Proust wrote about Parisian high society during the war and while the younger, avant-garde artists helped to develop camouflage techniques for the French army and while Léger fought, Vuillard painted, seemingly unaware of the most disastrous war in history. Begun as early as 1913, *Foliage* refuses to admit the existence of this war. Granted, there are no men present in this warren of suburban lanes and gardens. Yet, women tend their gardens, buy their fruit, and supervise their children, protected from the larger struggles of mankind. In its own gentle way, the painting represents a world in flux. A woman with a loaf of bread scurries along a lane, another opens a gate, children play on swings and rush about the lanes. There are dogs and carts. All of this movement is observed through a screen of leaves from the giant oak tree mentioned in the title of the decoration and placed by Vuillard to anchor this world of movement. In the midst of the human maneuvers of women and their children, the oak tree survives and stands for another, older age.

The sources for Vuillard's great decoration are numerous. One thinks of sixteenth- and seventeenth-century "verdure" tapestries with their interlocking layers of leaves. And Japanese screens, with their oblique perspectives and their "aperçus" to the everyday dramas of eating, sleeping, playing, and drinking tea were surely in his mind. Even the surface, with its dry stuccolike character, hints at another source, fresco painting. *Foliage* is an Impressionist world spread out along a vast surface for our delectation. How one would like to eat in a dining room dominated by this painting! Each day, each change of light or mood would reveal a different aspect of the decoration—another figure would appear, soon to be caught up in the web of leaves as one noticed yet another. This easy, harmonious world was painted both in preference for a world at peace and in rejection of a world at war.

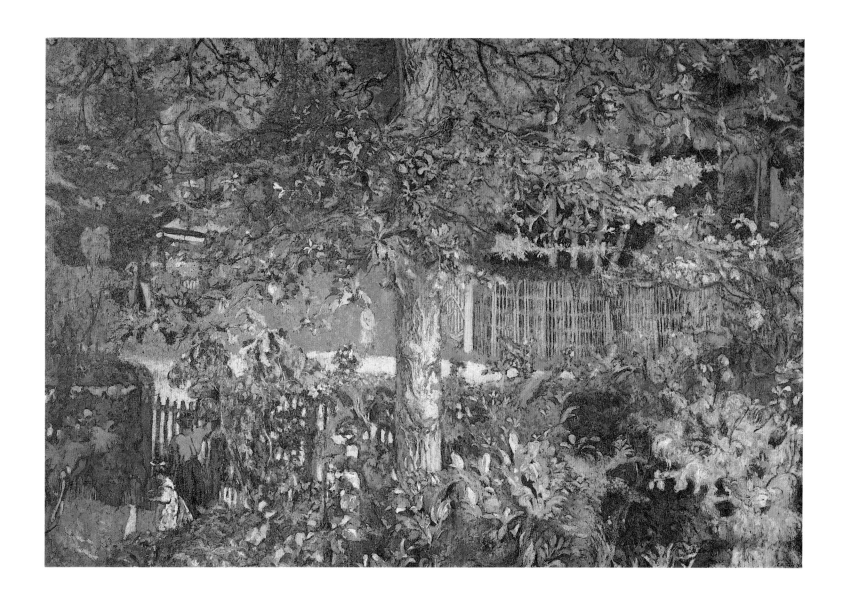

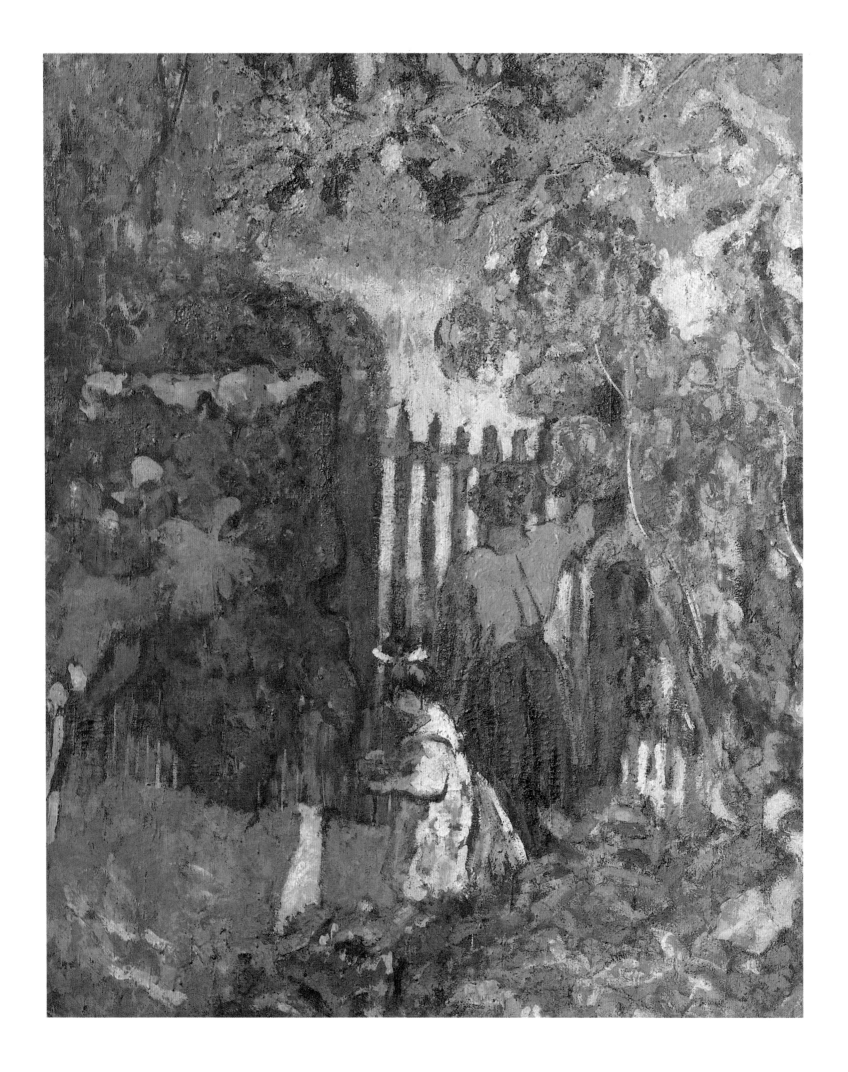

EDGAR DEGAS
THE RUSSIAN DANCER, 1899

The group of pastels by Edgar Degas representing dancers dressed in regional or peasant costumes, traditionally called *The Russian Dancers*, have become justly famous. The last major Degas retrospective exhibition of 1988 contained five of the fourteen variations on the subject, and the Sara Lee Corporation is fortunate to possess two. This sheet represents a single dancer who kicks her right leg, gestures rhythmically with her elbows, and twists her upper torso. Because she is dressed in a loose, long-sleeved blouse and long skirt, her clothing responds to her movements. For Degas, the powerful forms he found in rural clothing activated by arms and legs were as visually eloquent as the drapery in Hellenistic sculpture or the subtle mechanics of a ballerina's tutu.

Doubtless, the relationship between the two *Russian Dancer* pastels in the Sara Lee collection is a direct one. The major figure in the group composition is the single dancer in the simpler sheet. Both figures are of identical size, and both were drawn on tracing paper before being mounted later on lager sheets of paper. Yet, the exact relationship is unclear. Were both drawings traced from another sheet (indeed, the figure is a reversal of a figure in another group of pastels), or was one traced from the other? If the latter is true, which is the "original" or earlier of the sheets from which the other was traced? In fact, Degas loved to force his viewers into thinking anew about the preparatory process. He delighted in presenting preparatory drawings as finished works, and made whole sequences of works that appear to lead to a "finished" work, which was either never executed or never intended by the artist. In this case, it is tempting to consider the single-figure sheet as "preparatory" to the sheet with multiple dancers. Yet, there is no clear evidence to support this claim. Both sheets were drawn on tracing paper so as to appear to have been traced. Both were then mounted on larger sheets of paper, and the multifigural composition was "worked up" to a considerably greater extent than the single-figure sheet. Did Degas become bored with the simpler drawing? Or did he leave it in its current condition because he felt that it was successful enough to abandon in favor of another, unresolved work?

We shall never know the answers to those questions. Yet, the fact that we ask them was important enough to Degas. He himself compared the artist to a criminal and, by extension, the work of art to evidence of a crime. If this is true, then the viewer is cast as the detective, and Degas would have been delighted both to confuse us and to create a work of art that can never fully be "solved."

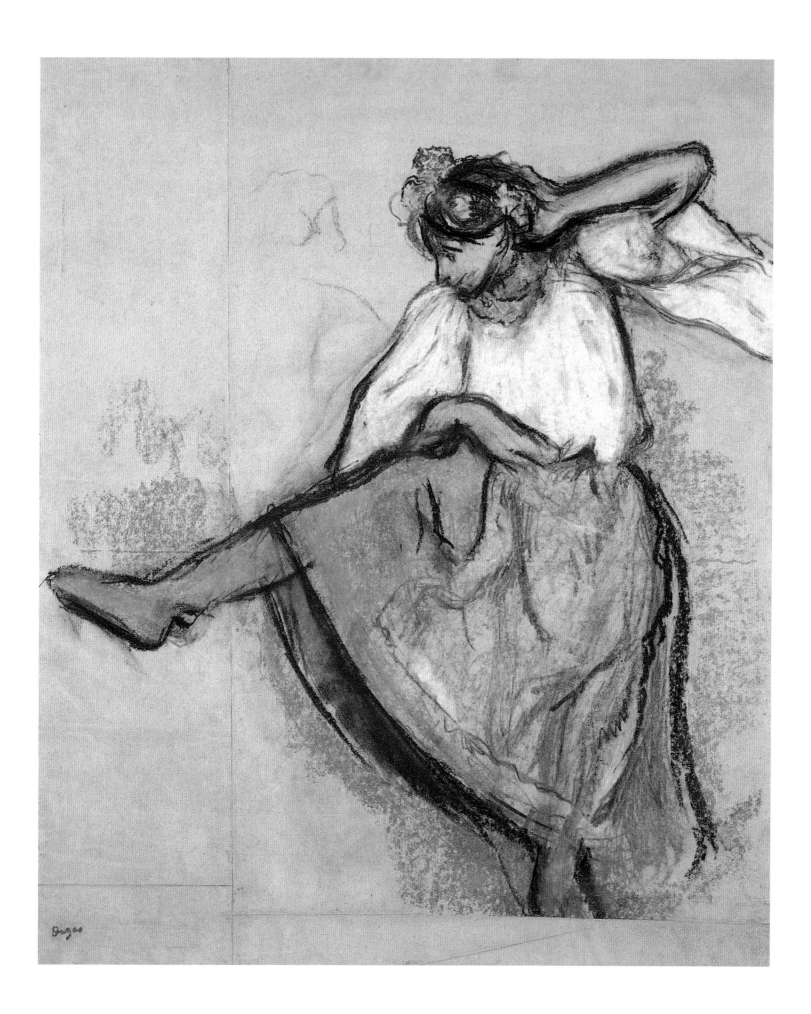

JEAN ARP
TORSO OF A KNIGHT, 1959

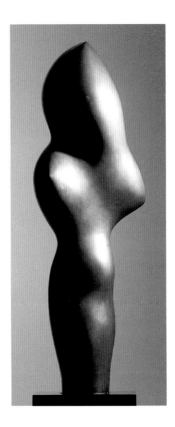

Jean Arp was born in Strasbourg, Alsace-Lorraine, and, like many modern artists, fought to transcend the narrow limitations of national identity. At once "German" (Hans Arp) and "French" (Jean Arp), he lived much of his life in Italy and was, therefore, utterly "European." The biomorphic forms Arp created early in his career are among the most eloquent sculptural inventions of the century. As the artist aged, he tried again and again to render these forms in the traditional materials of sculpture — stone and bronze.

Torse-Chevalier of 1959 is among a group of totemic, vertical sculptures that play with the classical tradition of figural sculpture. At first, this sculpture seems to be a kind of enlarged bud form relating to vegetal imagery. Yet, its verticality and its loosely anatomical character make us think of the human figure. Arp himself gave it various titles, but in English it usually has been called *Torso of a Knight*. And when we view the bronze again with this title in mind, its entire meaning shifts.

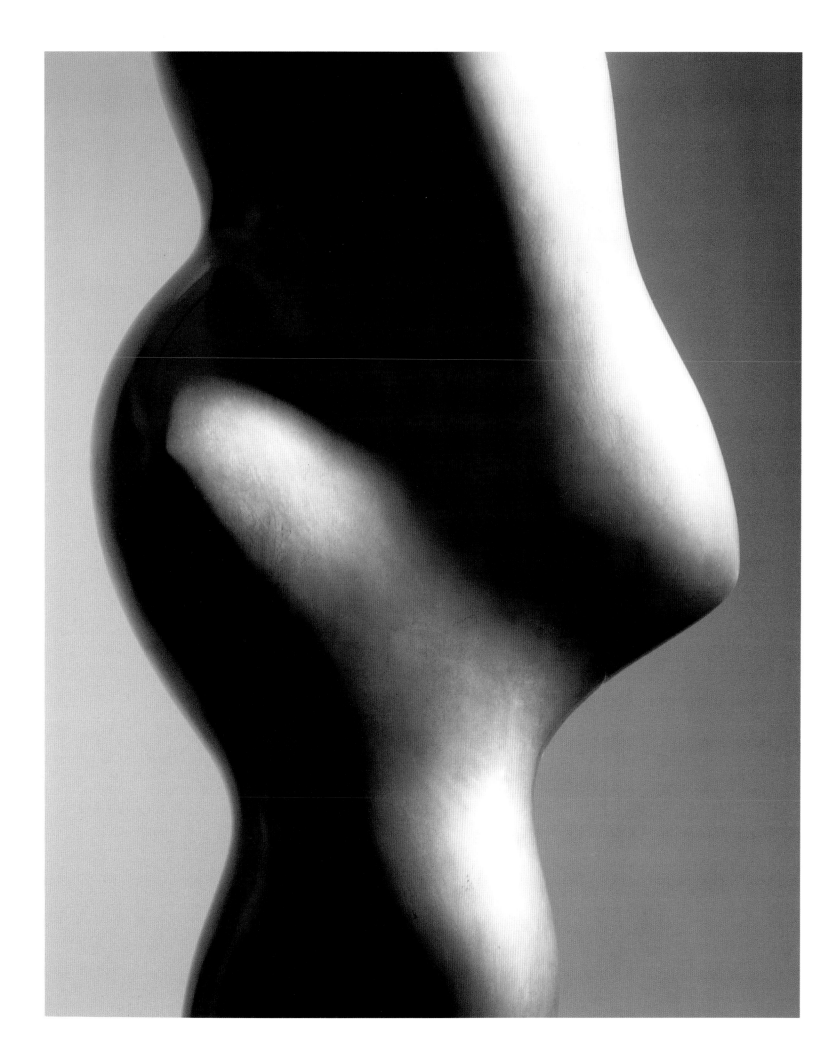

FERNAND LÉGER
CONSTRUCTORS WITH TREE, 1951

When Fernand Léger painted this exuberant, vital picture, he was seventy years old and as defiant of his own age as any great artist in history. Born in Normandy and educated as an architect, Léger joined the ranks of the greatest vanguard painters in the world by 1910. Always interested in the relationships between men, nature, and architecture, he not only painted, but also wrote about the new urban world of the twentieth century, a world dominated by machines, global economies, and immense cities. Although other artists of his generation felt compelled to reject this new world, Léger embraced it, creating an imagery of machines and men working together in the new "harmonies" of pure color, geometric forms, and precision parts.

During World War II, Léger lived and worked in New York, where he exulted in American skyscrapers and created painting after painting in which steel girders become a kind of jungle gym for the workers who build with them. The four "constructors" in this painting seem almost at play in front of a yellow sky filled with lumpy clouds. The irregularity of Léger's contours; the deliberately ill-fitting joints; the additions of orange and green into his "primary" scheme of red, yellow, blue, black, and white; and the informal "poses" of his constructors give this particularly successful large painting an air of almost childlike innocence. There is nothing menacing about the girders, and we have no fear that these men might fall from their great heights onto the unseen ground below. Indeed, the tree of the title surely grows from the earth, giving scale to the efforts of Léger's constructors, but keeping them close enough to the ground from which it grows.

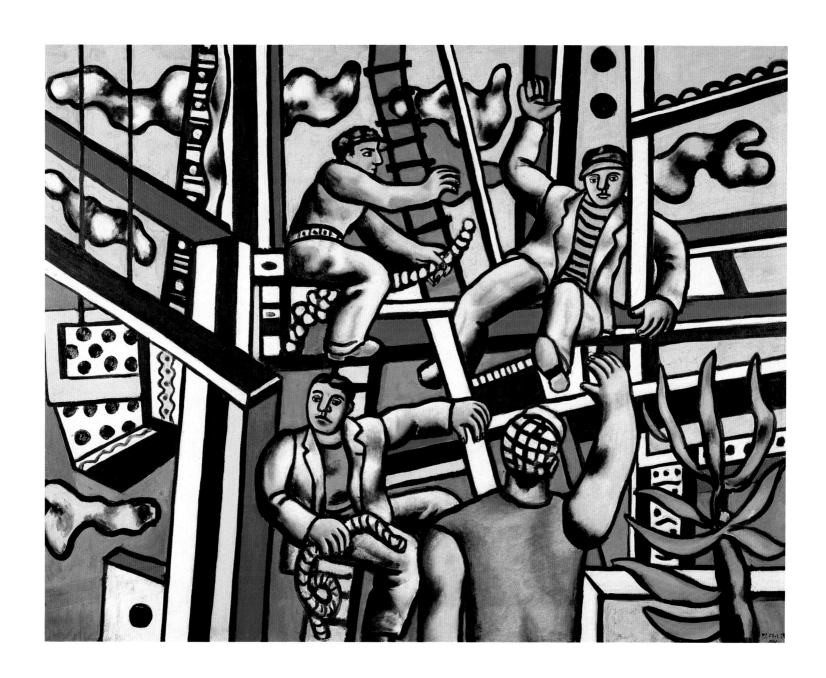

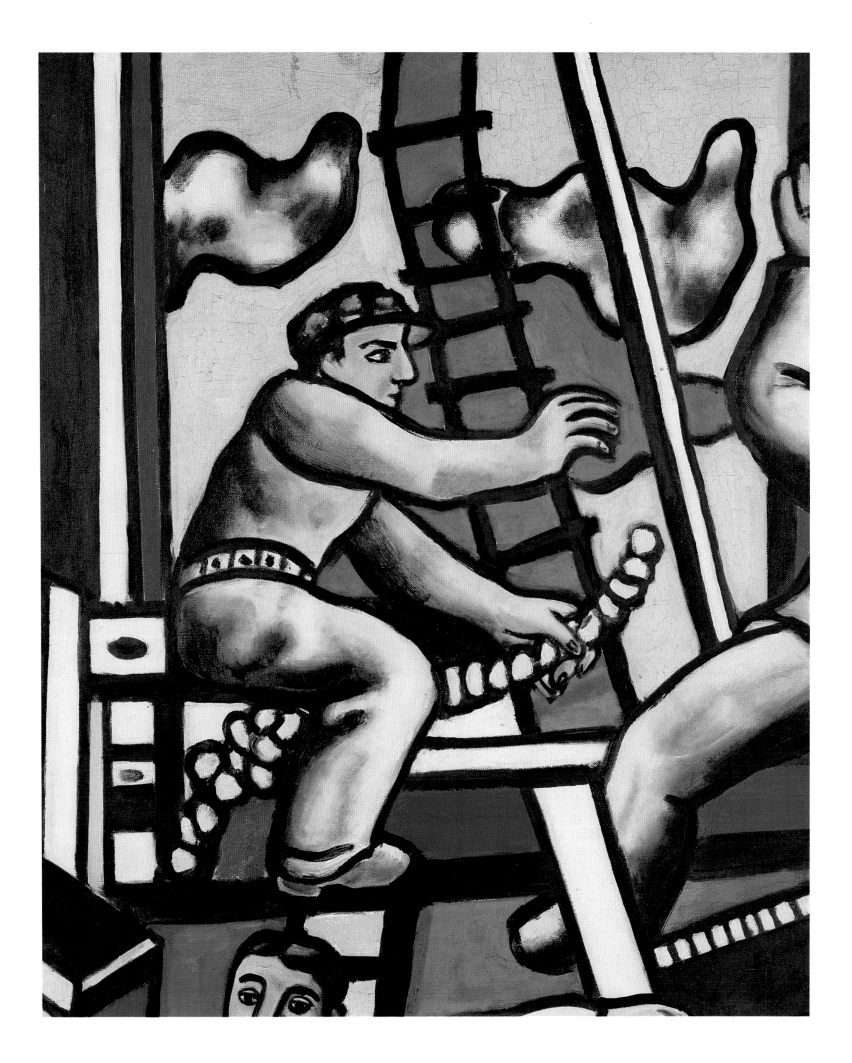

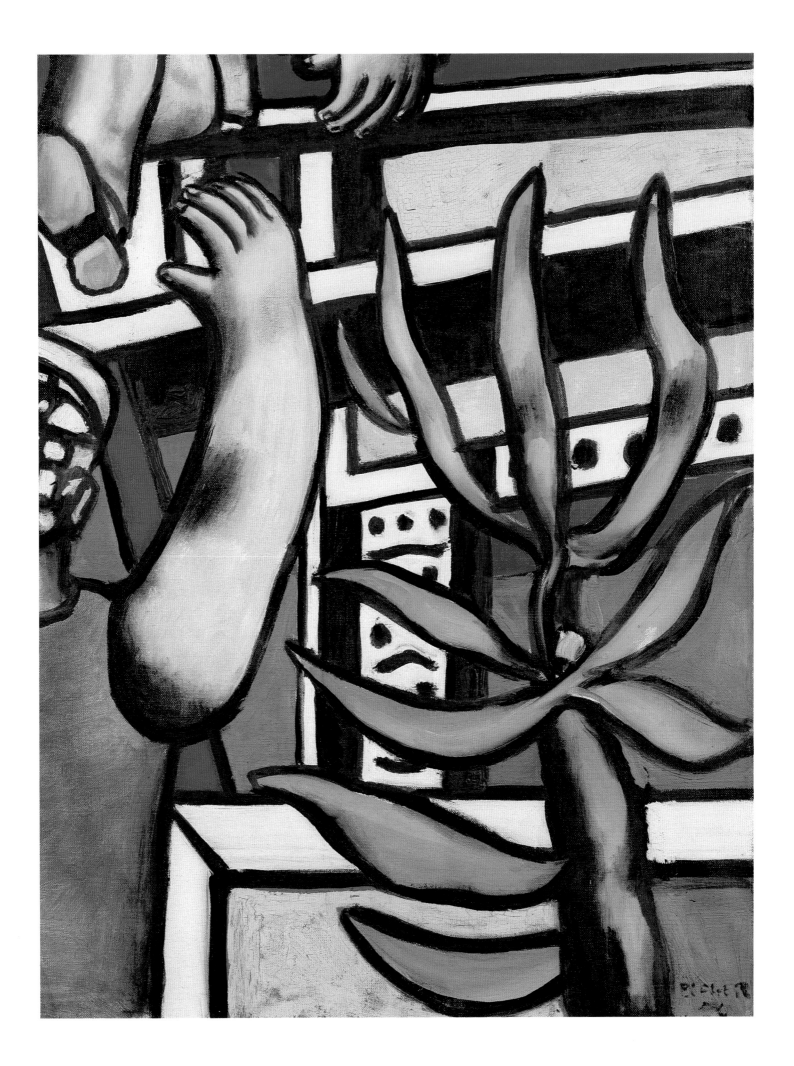

MAURICE DE VLAMINCK
LANDSCAPE—THE SEINE AT CHATOU, ca. 1912

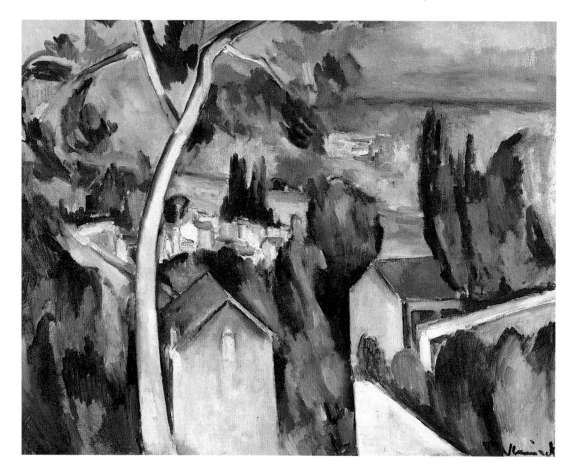

Maurice de Vlaminck was among the greatest of the Fauve landscape painters, working and exhibiting with Matisse, Marquet, and Derain in the Salon exhibitions of 1905–07. His first one-man exhibition was held at Vollard's famous gallery in 1907. However, shortly after 1910, he became dissatisfied with the freely composed landscapes of his Fauve period and began to rethink the structure and palette of his painting. Preferring to remain at home in the suburban landscape around the village of Chatou, just west of Paris, Vlaminck applied lessons from the paintings of Cézanne to a landscape that had been painted by Renoir, Pissarro, and Sisley.

Landscape—The Seine at Chatou borrows most of the structural principles of Cézanne's mature landscape paintings and exaggerates them for expressive purpose. Yet, unlike Braque and Picasso, who had turned to the work of Cézanne as early as 1906, Vlaminck insisted on painting from nature directly. The nature he chose was an ordinary suburban countryside, whose small stucco houses and trees he sought to structure and, hence, render eternal. Yet, if he borrowed heavily from Cézanne, his paintings are more active and tension-filled than those of his precursor. Each form and color vies for dominance over the others, and an ordinary landscape is given a heightened level of energy. None of the Impressionists who had painted these same houses and villages would have recognized them as they were transformed in the twentieth century by the young Vlaminck.

RAOUL DUFY
GUST OF WIND (FISHERMEN), 1907

Of the superb small group of fishermen paintings done by Raoul Dufy in Le Havre in the summer of 1907, *Gust of Wind* is the boldest and most imaginative. Indeed, were one to come across it in a German museum, its strident colors and self-consciously crude facture would make it seem completely at home with paintings by any of the German Expressionists. Paradoxically enough, this most expressionist of French paintings was made by an artist who, later in life, came to embody the easy, relaxed Gallicism of twentieth-century French art.

Raoul Dufy was thirty years old in 1907, when he painted this canvas. His earlier paintings derive from the tradition of French vanguard painting in the north of France, a tradition dating back to the 1850s with the work of Boudin and his most famous pupil, Monet. Yet there is little about that tradition that prepares us for this canvas. Its thick brushstrokes, heavy impasto, and forceful imagery make us think of northern painters like Van Gogh or Munch. Its thirteen figures react in various ways to this windy evening with its powerful sunset that shouts visually from a yellow-orange sky. Two male figures hold their hats in the gust of wind that gives the picture its earliest title. Two female figures turn away from the sun, while another faces its brilliance and is silhouetted against its reflection in the troubled waters of la Manche (the English Channel). The lone fisherman struggles with his catch as his pole begins to bend. And other figures are strategically positioned so that their shadows make jagged, emotionally charged patterns on the orange-tinted sand. Two fishing boats cavort in the wind, while a lone tug, with its requisite French flag, returns to the port of Le Havre at stage left.

This is not a seascape for the faint of heart. Every centimeter of its surface pulses with life and emotion. There is maximum wind and maximum light. The opposing colors — and substances — of the yellow-orange sky and the blue water struggle for dominance in powerful radiating triangles. How different this is from the dance of gently arching fishing poles in Dufy's other paintings of the same year.

One is tempted to look for the explanation in German art. Max Pechstein moved to France in 1906 and may well have met Dufy. Yet, the possibility of a foreign influence is not absolutely necessary as an explanation for this enigmatic canvas. There is little doubt that Dufy had seen Matisse's most violent and powerful painting, *Blue Nude, Souvenir de Biskra* when it was first exhibited in the spring of 1907. And the most powerfully expressionist works in Paris were being made in 1907 by an unknown Spaniard called Picasso, whose interest in African sculpture was awakened by Derain, a mutual friend of Dufy and Picasso, in the summer of 1907. If Dufy's superb *Gust of Wind* were to be gathered with a group of Picasso's paintings done at the time of Les Demoiselles D'Avignon and a select series of works by Matisse, Derain and Vlaminck, its participation in a crucial moment of French vanguard art would become apparent. Yet, this canvas is the single most critical evidence of Dufy's pictorial ambitions, at the age of thirty, to transcend his earlier Post-Impressionist aesthetic. Perhaps unfortunately for the history of modern art, he was so powerfully moved by the Cézanne retrospective held in the fall of 1907 that his expressionist impulse was nipped in the bud.

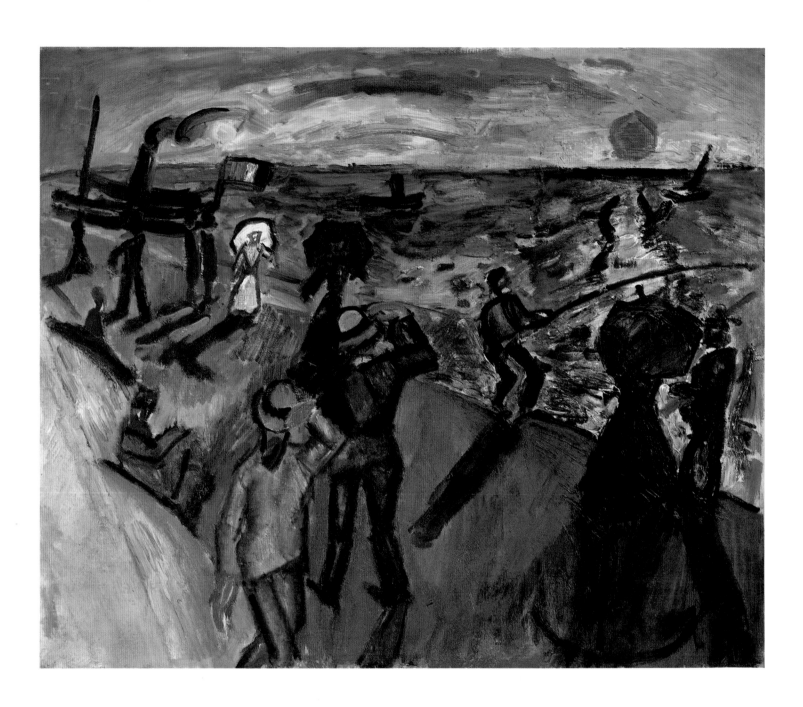

GEORGES BRAQUE
ANTWERP, 1906

Georges Braque is known today principally as the inventor—with Pablo Picasso—of Analytic Cubism. Yet, unlike his Spanish friend and colleague, he began his career as a landscape painter in the French Post-Impressionist tradition. Indeed, his paintings of 1906 and 1907 are among the finest Fauve paintings and were hung next to those by Matisse, Marquet, Puy, and Friesz at the Salon exhibitions of those years in which *Les Fauves*, the Wild Beasts, were given their name.

Braque painted *Antwerp* on a lengthy trip to that Belgian city made in the summer and early fall of 1906 in the company of the painter Othon Friesz. The group of urban, even industrial landscapes he painted there are among his earliest major paintings, placing him securely near the top of the Fauve group. *Antwerp* is among the finest of these, others of which are in the National Gallery of Canada, the Von der Heydt Museum in Wuppertal, and the Kunstmuseum in Basel. All of the paintings have a common source in the urban landscapes painted "from above" by Monet, Caillebotte, and Pissarro and are particularly close to Pissarro's late paintings of the port cities Rouen and Le Havre. Yet, Braque and his Fauve colleagues combined this naturalist, urban imagery with the symbolist theories of color exaggeration first propounded in the late 1880s by Paul Gauguin and his friends. Interestingly, Braque had seen the major Gauguin retrospective at the Salon d'Automne immediately before his departure for Antwerp. Thus, Braque's Antwerp paintings are hybrid works by a young artist struggling to compete with the strongest of his precursors and contemporaries.

Antwerp is both powerfully composed and intentionally awkward. The great swooping curve of the balcony from which he painted his views situates the viewer near the edge of—indeed almost outside—the arena of the landscape. Each building is isolated by a painted boundary in the "cloisonnist" manner of Gauguin and Émile Bernard. However, in the areas of the sky, water, and trees, as well as within the linear confines of the buildings, Braque applied his paint in a free, almost juicy manner, juxtaposing yellows, oranges, pinks, purples, blues, and greens throughout the canvas. With its powerful geometries, *Antwerp* is the most original painting of Braque's stay in that city. The other paintings represent the Schelde River and the ornamental garden in front of Braque's rooms in conscious parody of Impressionist urban views. *Antwerp* has few such prototypes, and its composition shows such an obsession with edges and corners as well as with geometric and proportional relationships that it becomes almost abstract.

Braque left Antwerp in the fall of 1906 as a major painter and went first to Paris and then to the south of France at l'Estaque and La Ciotat. In the south, he found in nature the brilliant palette he had already applied to the gray northern city of Antwerp.

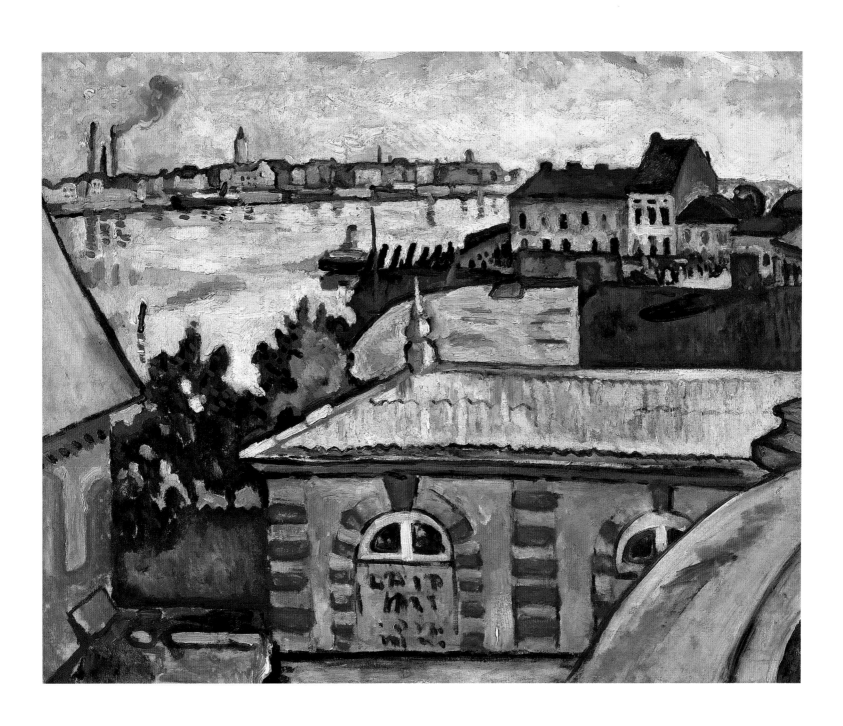

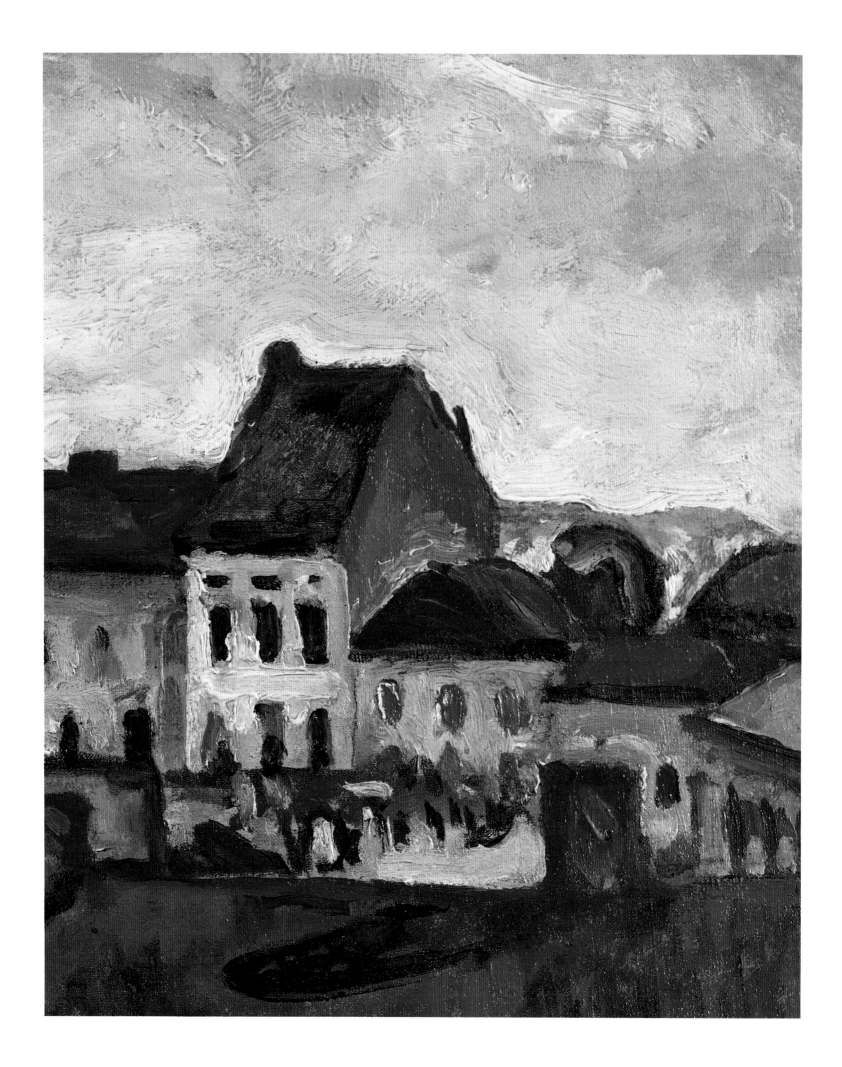

GIACOMO MANZÙ
SKATING GIRL, 1959

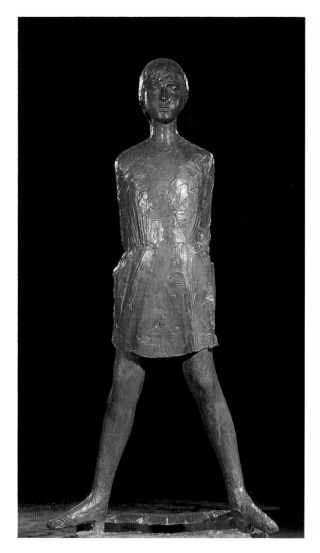
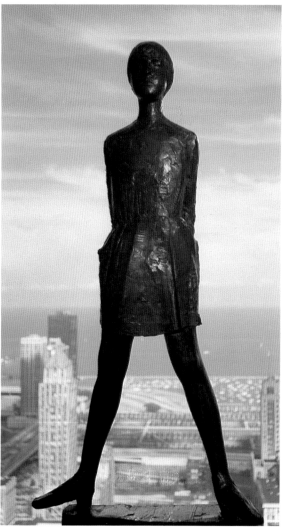

Giacomo Manzù was born and trained in Italy and considers himself less a "modern" artist than a sculptor in the Italian tradition stemming from the Renaissance. His often-professed love of Donatello's sculpture is important in considering the pure volumes and refined surfaces of *Skating Girl*, although the subject of Manzù's sculpture has no real precedent in the Renaissance. Here, Manzù attempts to convey an illusion of lightness and balance in a large-scale bronze, and his success is virtually total. He may leave out such bothersome details as the skates themselves and give the girl a short costume that would be absurd for actual skating, but his aim is not realism. Rather, the skating girl has just come to a stop, her heels digging into the invisible ice, and she stands at that moment of indecision. Will she go forward? Will she fall? Will she stand still forever?

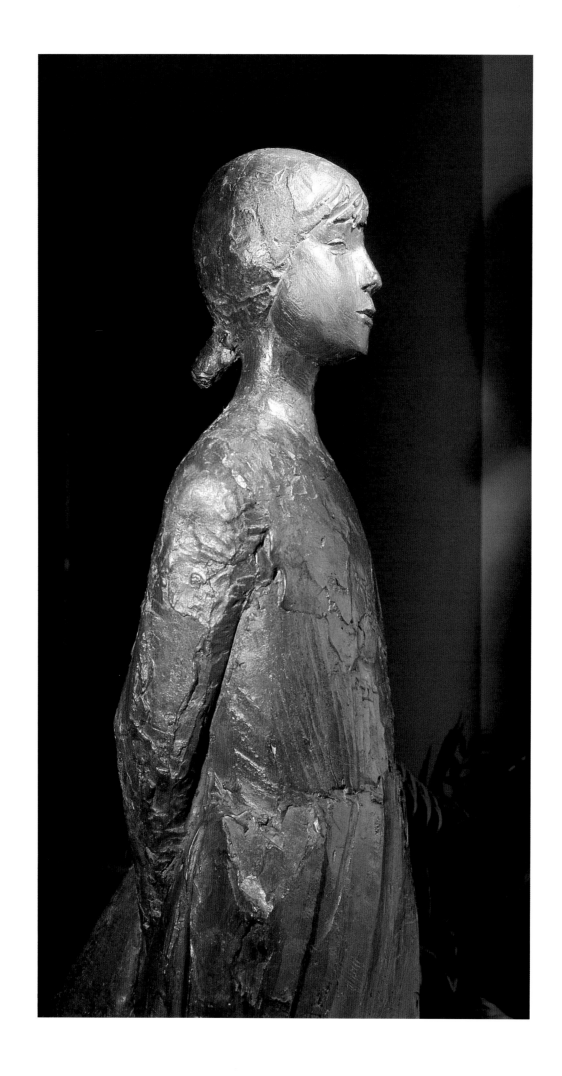

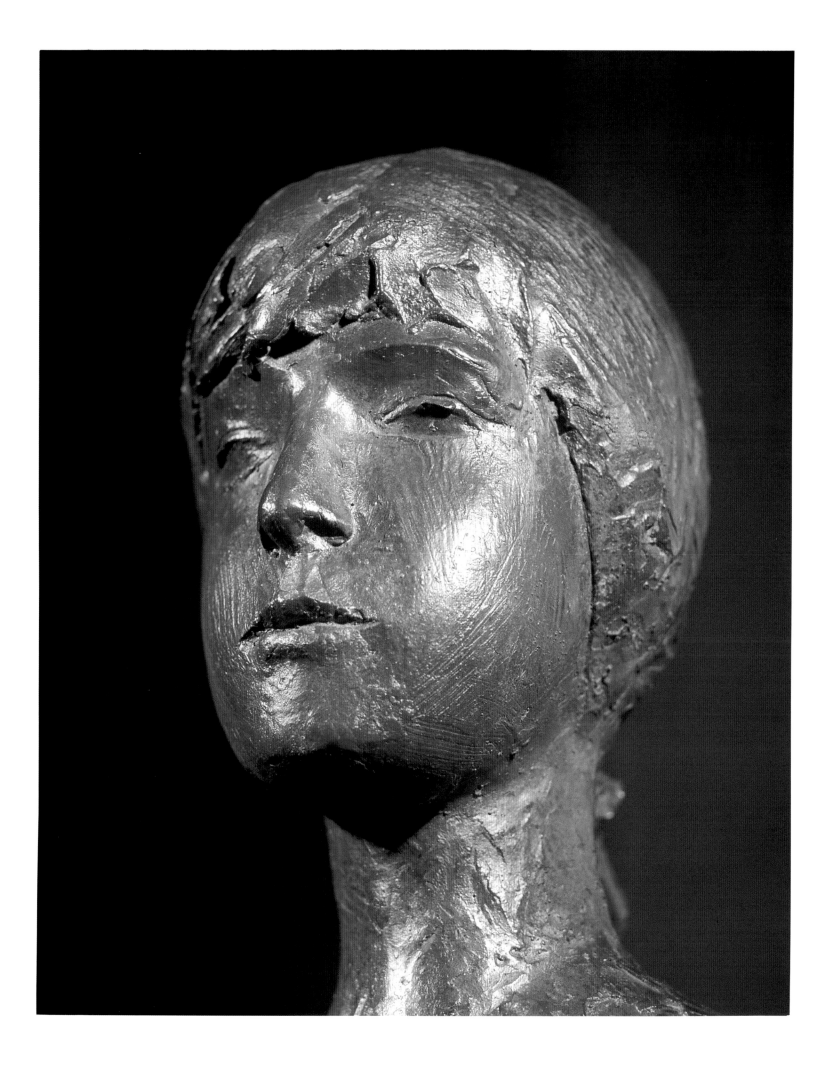

CHAIM SOUTINE
VALET, 1927–28

Like many great modern artists, Chaim Soutine was fascinated with the uniforms of modern life. Delivery boys, servants, shop girls, janitors, firemen, policemen, even businessmen — each wears a "uniform" to work. Sometimes, especially in the upper classes, it seems as if the uniform is worn by choice. In other cases — especially with workers — the uniform serves as a mode of both identification and social control.

Soutine was among the most troubled and fiercely independent artists in the history of modern art. His landscapes and portraits almost scream with intensity, and, perhaps as a result, his work appealed to a generation of modernist critics and collectors trained in the philosophy of the Existentialists.

Throughout the middle and later 1920s, Soutine created a series of "uniform portraits," portraits, that is, not of individuals, but of types of people. The Sara Lee portrait of a manservant, a *valet de chambre*, is among the most enigmatic. The artist shows us a very young man — probably a teenager — as he confronts us in his red-and-blue uniform. Its overscaled buttons, its immense sleeves, its constraining collar — all of these would have separated the boy from a man of fashion and signaled his lesser status as a servant. When shown frontally in this uniform, the boy is less a person than a type, and, in keeping with this anonymity, his name is intentionally withheld from the viewer.

When we look at this portrait, it is easy to think of Marcel Duchamp's uniformed "bachelors" doing the endless service not only of their imaginary "bride," but also of their masters. And it is scarcely a leap of the imagination to the behatted bourgeoisie who walk through the Surrealist worlds of De Chirico, Magritte, and Delvaux. Yet, for Soutine, there is a kind of Gorky-like resistance to the inevitability of the uniform. In Soutine's world, we, his viewers, yearn to understand this young boy; and, though we will never know the boy's name, Soutine does everything in his power as an artist to make us try to see through the uniform to his fragile personal identity.

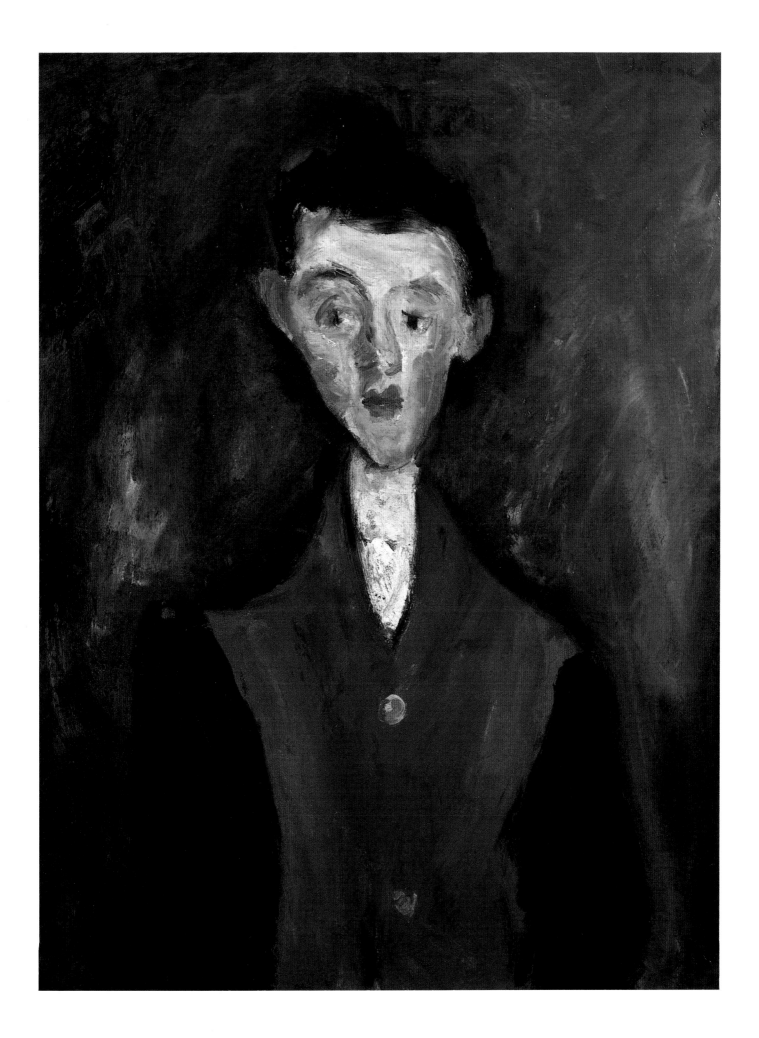

FERNAND LÉGER
RECLINING FIGURE, 1922

The closing of the Louvre in 1917 for the duration of World War I was a devastating blow to artists working in Paris. Although its stone facades are resolute and intimidating, and although its collections defined the greatness of the past without deigning to approach the present, many contemporary artists haunted the galleries of the Louvre for stimulation, inspiration, and even solace. After Armistice Day in 1919, it took two full years for the Louvre to reopen to the public, and when it did, art-starved artists were among its most regular and important visitors.

For that reason, the reopening of the Louvre had a profound effect on contemporary French art, and artists with sensibilities as various as Fernand Léger and Édouard Vuillard turned their attention to the past. In fact, there is little doubt that the post-modern "classicism" that one sees in paintings by Picasso, Léger, and many other Cubists can be related directly to the reopening of the greatest museum in Europe. The masterful *Reclining Figure* by Léger investigates one of the oldest subjects in Western easel painting, the reclining female figure. The Louvre itself was — and is — full of examples, from Giorgione onward, and one feels that Léger has taken this traditional subject, with all its allusions to the Western or classical tradition, and mechanized it. In place of supine curves of flesh are tubes with perfect contours; in place of velvets and luxurious pillows are bright geometric patterns with hard edges. Yet, for all this apparent modernity, the cool, perfect face of the figure and her calm control over her setting enable this painting to inhabit the realm of the classical.

Reclining Figure is the earliest of three major paintings by Léger in the Sara Lee collection. Its aesthetic maturity is evidence that this artist, who started as an architect, had gained complete mastery of the medium of painting. Indeed, by the end of World War I, Léger had become one of the very greatest and most consistent of French painters, and this superb meditation on traditional painting came at just the moment when he was strong enough as a modern artist to confront the past.

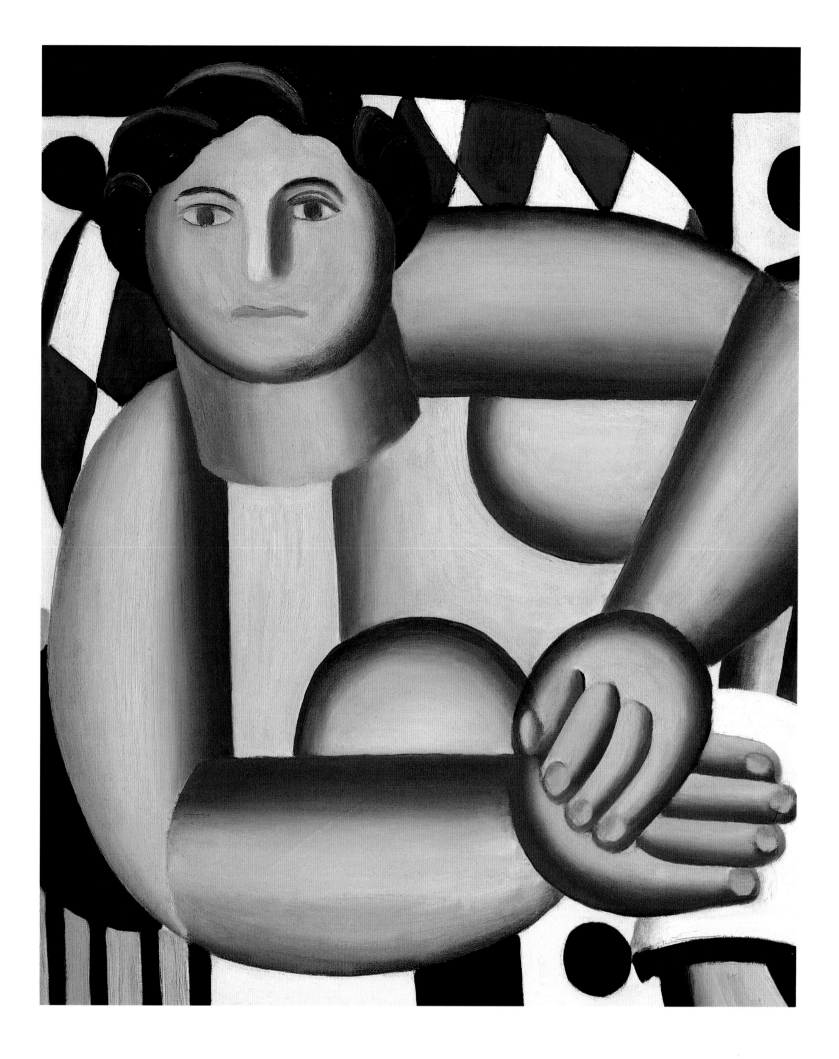

GEORGES ROUAULT
PIERROT, ca. 1937–38

Who was Pierrot? Historians of popular theater are unsure of his origins, but art historians have less trouble. The image of the "serious" clown from the Italian commedia dell'arte was immortalized by the French painter Antoine Watteau early in the eighteenth century, and this frontal image of Pierrot by Georges Rouault must be interpreted in juxtaposition to Watteau's famous painting in the Louvre. Where Watteau's Pierrot is a full-scale portrait of a standing clown, Rouault's is a generalized devotional image: One confronts Watteau's Pierrot, one worships Rouault's. Rouault constructed his clown with thick, deliberately applied impasto so that the painting has the physical weight and presence of architecture. At once a stained-glass window and a mural, Rouault's image of Pierrot has a solemnity and gravity lacking in Watteau's version.

Rouault was among a handful of modernist painters who represented both the sacred and secular realms of experience. His many paintings and prints of Christian subjects are balanced by his representations of popular performers. Of these, Pierrot and his companions in the commedia dell'arte are perhaps the least related to the actual experience of a Parisian. Instead, Rouault's Pierrot echoes the thousands of Pierrots enacted and painted throughout the years. He seems, in some ways, the *essential* Pierrot—older, that is, than Watteau's eighteenth-century prototype. Indeed, he seems to exist in the timeless realm inhabited by icons.

The almost mythic sadness of *Pierrot* is too easily read as Rouault's specific response to deteriorating world conditions in the late 1930s when it was painted. This would be wrong. Rouault's works of art were always based on his moral judgment, whether made in 1911 or in 1938, and his highly individual, medievalizing style had become set by the 1920s. This superb Pierrot stares forever out at us, leaving us to wonder if he stands in judgment not only of us, but also of our forebears and our heirs.

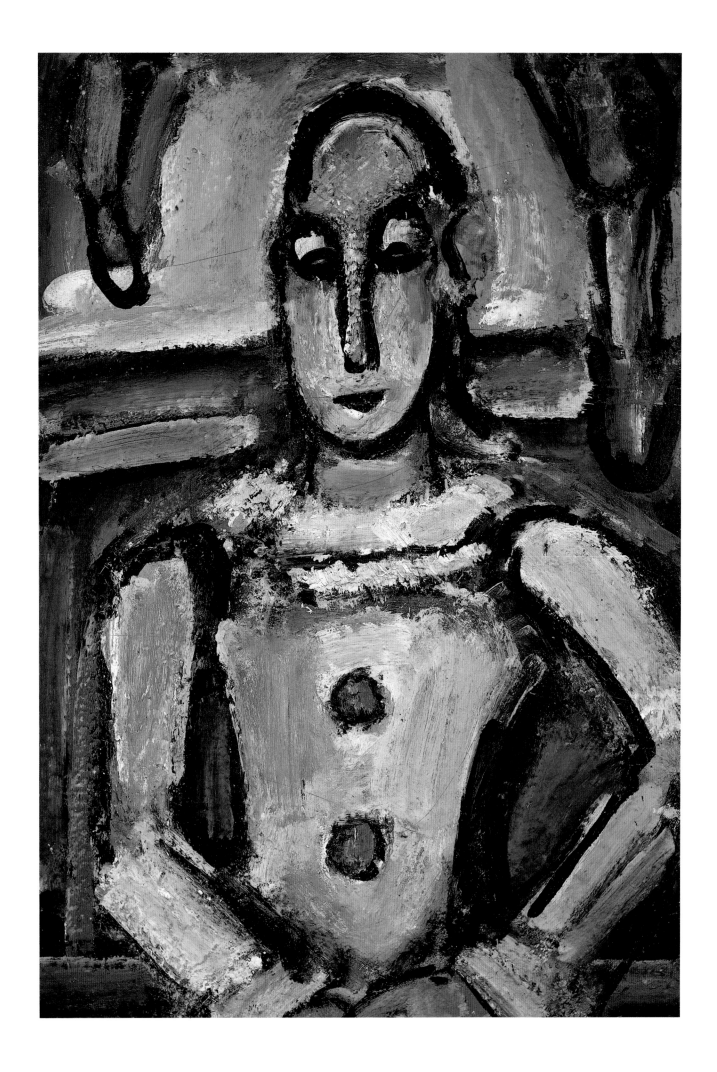

CATALOGUE

CATALOGUE

JEAN ARP (1886–1966)
Torso of a Knight (Torse-chevalier or *Torso eines Ritters), 1959*
Bronze, ed. 4/5
34⅜ x 11⅛ x 7⅞ in.
Arp-Hagenbach 191
1991.1

PROVENANCE
Jeffrey H. Loria and Company, Inc., New York
Nathan Cummings, Chicago
Herbert K. Cummings, Scottsdale, Arizona

EXHIBITIONS
Art Institute of Chicago, October 20–December 9, 1973,
Major Works from the Collection of Nathan Cummings,
no. 72

REPRODUCTIONS
Hans Arp: Skulpturen 1957–1966. Introduction by Eduard
Trier, bibliography by Marguerite Arp-Hagenbach,
catalogue by Francois Arp. Teufen, Switzerland: Verlag
Arthur Niggli, 1968, illus. p. 21.
Jean Arp: Skulpture 1957–1966. Introduction by Eduard
Trier, bibliography by Marguerite Arp-Hagenbach,
catalogue by Francois Arp. London: Thames and
Hudson, 1968, pl. 23.
Major Works from the Nathan Cummings Collection (exh. cat.).
Chicago: Art Institute of Chicago, 1973, p. 81.

SELECTED BIBLIOGRAPHY
Jean Arp. *Arp on Arp: Poems, Essays, Memories.* Translated by
Joachim Neugroschel. New York: Viking Press, 1972.
Carola Giedion-Welcker. *Jean Arp.* New York: Harry N.
Abrams, 1957.
Ionel Jianou. *Jean Arp.* Paris: Arted, Edition d'Art, 1973.
Museum of Modern Art. *Arp* (exh. cat.). Edited with an
introduction by James Thrall Soby. New York: Museum
of Modern Art, 1958.
Herbert Read. *The Art of Jean Arp.* New York: Harry N.
Abrams, 1968.

PIERRE BONNARD (1867–1947)
The Apple Pickers (La Cuillette des Pommes), ca.
1898–99*
Oil on canvas; 65 x 40½ in.
Dauberville 209
1984.1
* According to Charles Terrasse, nephew of the artist,
September 14, 1964, *La Cuillette des Pommes* was painted
around 1895-96 in "le grande jardin du Clos, au Grand-
Temps."

PROVENANCE
Thadée Natanson, Paris
Galerie Pierre Colle, Paris
Galerie H. Knoedler, Paris
M. Knoedler and Co., Inc., New York
Nathan Cummings, Chicago

EXHIBITIONS
Galerie Charpentier, Paris, 1943, *Jardins de France*
(exhibited as *Jardin de Provence*), no. 311
Royal Academy, London, January 6–March 6, 1966, *Pierre
Bonnard,* no. 22
Haus der Kunst, Munich, October 8, 1966–January 1,
1967, and Musée de l'Orangerie, Paris, January
13–April 15, 1967, *Pierre Bonnard,* no. 20
The Metropolitan Museum of Art, New York, July
1–September 7, 1971, *Selections from the Nathan
Cummings Collection* (not in catalogue)

REPRODUCTIONS
Jean and Henry Dauberville. *Bonnard: Catalogue raisonné de
l'oeuvre peint,* vol. 1. Paris: Editions J. et H. Bernheim-
Jeune, 1965, p. 221.
Pierre Bonnard: Centenaire de sa naissance (exh. cat.). Munich:
Haus der Kunst, n.d., no. 20.
Consolidated Foods Corporation's Nathan Cummings Collection.
Chicago: Consolidated Foods Corporation, 1983, p. 22,
fig. 17 (color).

SELECTED BIBLIOGRAPHY
Bonnard (exh. cat.). Paris: Musée National d'Art Moderne,
1984.
Bonnard and His Environment (exh. cat.). New York: The
Museum of Modern Art, 1964.
Jean and Henry Dauberville. *Bonnard: Catalogue raisonné de
l'oeuvre peint.* Paris: Editions J. et H. Bernheim-Jeune,
1965.
John Rewald. *Pierre Bonnard* (exh. cat.). New York: The
Museum of Modern Art, 1948.
Charles Terrasse. *Bonnard.* Paris: Henri Floury, 1927.

EUGÈNE BOUDIN (1824–1898)
*Entrance to the Port at Dunkirk (Dunkerque—
L'Entrèe du port), 1889*
Oil on canvas; 20 x 29¼ in.
Signed lower right: "E. Boudin" (followed by illegible date)
Schmit 2572
1980.1

PROVENANCE
Level, Paris
Beugniet et Bonjean, Paris
Galerie de Berri, Paris
Alan H. Cummings, Palm Beach
Nathan Cummings, New York

EXHIBITIONS
Salon de la Société Nationale des Beaux-Arts, Paris, 1890
New Brunswick Museum, St. John, Canada, April 24–May
 31, 1958
Maison Blanche and Company, New Orleans, September
 25–October 8, 1960
Minneapolis Institute of Arts, January 14–March 7, 1965,
 Paintings from the Cummings Collection
Reynolda House Museum of American Art, Winston-
 Salem, North Carolina, September 9–December 25,
 1990, and Dixon Gallery and Gardens, Memphis,
 Tennessee, January 20–March 17, 1991, *An Impressionist
 Legacy: The Collection of Sara Lee Corporation*

REPRODUCTIONS
Robert Schmit. *Eugène Boudin 1824–1898,* vol. 3. Paris:
 Robert Schmit, 1973, n.p., no. 2572.
Consolidated Foods Corporation's Nathan Cummings Collection.
 (Chicago): Consolidated Foods Corporation, 1983, p. 19,
 fig. 13 (color).

SELECTED BIBLIOGRAPHY
Georges Jean Aubry. *Eugène Boudin: La vie et l'oeuvre d'après
 les lettres et les documents inédits.* Neuchâtel: Ides et
 Calendes, 1968.
Georges Jean Aubry with Robert Schmit. *Eugène Boudin.*
 Translated by Caroline Tisdall. Greenwich, Connecticut:
 New York Graphic Society, Ltd., 1968.
Ruth L. Benjamin. *Eugène Boudin.* New York: Raymond and
 Raymond, 1937.
Claude Roger-Marx. *Eugène Boudin.* Paris: Cres, 1927.
Robert Schmit. *Eugène Boudin 1824–1898.* Paris: Robert
 Schmit, 1973.

GEORGES BRAQUE (1882–1963)
Antwerp (Anvers), 1906
Oil on canvas; 23½ x 28¾ in.
Signed verso: "G Braque"
1984.2

PROVENANCE
Mr. and Mrs. William Bedford, Copenhagen
Mrs. N. Bedford, New York
Kahnweiler Fine Arts Associates, New York
Nathan Cummings, Chicago

EXHIBITIONS
Royal Scottish Academy, Edinburgh, 1956, *G. Braque,* no. 5
Tate Gallery, London, 1956, *Braque 1956*
Art Institute of Chicago, September 20–October 22, 1963
Minneapolis Institute of Arts, January 14–March 7, 1965,
 Paintings from the Cummings Collection

Davenport Municipal Art Gallery, Davenport, Iowa, March
 21–April 11, 1965, *Collection of Masterpieces—Courtesy of
 Mr. and Mrs. Nathan Cummings*
Lyman Allyn Museum, New London, Connecticut, January
 19–February 18, 1968, *Paintings and Sculpture from the
 Collection of Mr. and Mrs. Nathan Cummings*
National Gallery of Art, Washington, D.C., June
 28–September 11, 1970, *Selections from the Nathan
 Cummings Collection,* no. 47
Art Institute of Chicago, October 20–December 9, 1973,
 Major Works from the Collection of Nathan Cummings,
 no. 42
Los Angeles County Museum of Art, October 7–December
 30, 1990; The Metropolitan Museum of Art, New York,
 February 14–May 5, 1991, and Royal Academy of Arts,
 London, June 13–August 18, 1991, *The Fauve Landscape*

REPRODUCTIONS
Cahiers d'Art 8, nos. 1–2 (1933), n.p.
G. Braque (exh. cat.). Edinburgh: Royal Scottish Academy,
 1956, pl. 12a.
*Collection of Masterpieces—Courtesy of Mr. and Mrs. Nathan
 Cummings* (exh. cat.). Davenport, Iowa: Davenport
 Municipal Art Gallery, 1965, cover.
Selections from the Nathan Cummings Collection (exh. cat.).
 Washington, D.C.: National Gallery of Art, 1970, p. 62
 (color).
Major Works from the Collection of Nathan Cummings (exh.
 cat.). Chicago: Art Institute of Chicago, 1973, p. 51.
The Fauve Landscape (exh. cat.). Los Angeles: Los Angeles
 County Museum of Art, 1990–91, pl. 103.

SELECTED BIBLIOGRAPHY
Raymond Cogniat. *Braque.* New York: Crown Publishers,
 1970.
John Elderfield. *The "Wild Beasts": Fauvism and Its Affinities.*
 New York: The Museum of Modern Art, 1976.
Henry R. Hope. *Georges Braque.* New York: The Museum of
 Modern Art, 1949.
Georges Isarlov. *Georges Braque.* Paris: José Corti, 1932.
Edwin Mullins. *Braque.* London: Thames and Hudson,
 1968.

GEORGES BRAQUE (1882–1963)
Woman Painting (Femme se peignant), 1936
Oil on canvas; 35½ x 28½ in.
Signed and dated lower left: "G Braque/36"
Mangin 1936–41/2
1981.2

PROVENANCE
Paul Rosenberg and Company, New York
Keith Warner, New York
E. and A. Silberman Galleries, New York
Nathan Cummings, Chicago
Herbert K. Cummings, Phoenix

EXHIBITIONS

Oslo, Stockholm, Copenhagen, 1937, *Exposition Braque, Laurens, Matisse, Picasso,* organized by M. Walther Halvorsen

Petit Palais, Paris, 1937, *Maîtres d'art indépendant*

Carnegie Institute, Pittsburgh, October 14–December 5, 1937, *The 1937 International Exhibition of Paintings*

Melbourne, 1939, *Melbourne Herald Exhibition 1939*

M. H. de Young Memorial Museum, San Francisco, 1953, *The Nathan Cummings Collection*

University of Oregon and Portland Museum of Art, 1953

Musée de Beaux Arts, Zurich, 1953, *Braque*

Arts Club of Chicago, September 1954

Musée des Arts Décoratifs, Paris, March–May 1956, *Collection Nathan Cummings d'art ancien du Perou et Peintures Françaises XIXe et XXe Siècle*

E. and A. Silberman Galleries, New York, December 1957, *Art—United Nations,* no. 26

New Brunswick Museum, St. John, Canada, April 24–May 31, 1968

Carnegie Institute, Pittsburgh, December 4, 1958–February 8, 1959, *International Retrospective Exhibition*

Contemporary Arts Center, Cincinnati, September 22–October 22, 1962, *Homage to Georges Braque*

Walker Art Center, Minneapolis, November 6, 1962–January 20, 1963

Paul Rosenberg Gallery, New York, April 7–May 2, 1964

Minneapolis Institute of Arts, January 14–March 7, 1965, *Paintings from the Cummings Collection*

National Gallery of Art, Washington, D.C., June 28–September 11, 1970, and The Metropolitan Museum of Art, New York, July 1–September 7, 1971, *Selections from the Nathan Cummings Collection,* no. 49

Art Institute of Chicago, October 20–December 9, 1973, *Major Works from the Collection of Nathan Cummings* (exhibited as *Woman at an Easel* [*Green Screen*]), no. 44

Reynolda House Museum of American Art, Winston-Salem, North Carolina, September 9–December 25, 1990, and Dixon Gallery and Gardens, Memphis, Tennessee, January 20–March 17, 1991, *An Impressionist Legacy: The Collection of Sara Lee Corporation*

REPRODUCTIONS

M. Walther Halvorsen. "Exposition Braque, Laurens, Matisse, Picasso, à Oslo, Stockholm, Copenhague," *Cahiers d'Art* 12, nos. 6–7 (1937), opp. p. 220.

Christian Zervos. *Histoire de l'art contemporaine.* Paris: 1938, p. 286.

Rosamund Frost. *Contemporary Art: The March of Art from Cézanne until Now.* New York: Crown Publishers, 1942, p. 54.

Maurice Gieure. *G. Braque.* Paris: Editions P. Tisné, 1956, p. 53, pl. 90.

John Russell. *Georges Braque.* New York: 1959, p. 52.

Catalogue de l'oeuvre de Georges Braque: Peintures 1936–1941. Edited by Nicole S. Mangin. Paris: Galerie Maeght, 1961, n.p., no. 2.

John Richardson. *Georges Braque.* Paris: 1962, n.p., no. 29.

Selections from the Nathan Cummings Collection (exh. cat.). Washington, D.C.: National Gallery of Art, 1970, p. 64.

Major Works from the Collection of Nathan Cummings (exh. cat.). Chicago: Art Institute of Chicago, 1973, p. 53 (color).

Raymond Cogniat. *Georges Braque.* Translated by I. Mark Paris. New York: Harry N. Abrams, Inc., 1980, p. 64, fig. 61.

Consolidated Foods Corporation's Nathan Cummings Collection. (Chicago): Consolidated Foods Corporation, 1983, p. 14, fig. 8 (color).

SELECTED BIBLIOGRAPHY
See entry for Braque's *Antwerp,* 1906 (except Elderfield)

MARC CHAGALL (1889–1985)
The White Lilacs (Les Lilas blancs), ca. 1930–33
Oil on canvas; 35½ x 28½ in.
Signed lower left: "Chagall/Marc"
Meyer 606
1981.20

PROVENANCE
Goldschmidt
Nathan Cummings, Chicago
Alan H. Cummings, Palm Beach

EXHIBITIONS

Art Gallery of Toronto, September 10–October 16, 1955, and Musée des Arts Décoratifs, Paris, March–May, 1956, *Collection Nathan Cummings d'Art Ancien du Perou et Peintures Françaises XIXe et XXe Siècle* (exhibited as *Vase de fleurs et amoureux),* no. 16

Palazzo Venezia, Rome, 1956, *Collezione Cummings*

Findlay Gallery, New York, October 13–25, 1961

National Museum of European Art, Tokyo, October 1–November 10, 1963

Municipal Museum, Kyoto, November 20–December 10, 1963

Beilin Gallery, New York, 1967

Lyman Allyn Museum, New London, Connecticut, January 19–February 18, 1968, *Paintings and Sculpture from the Collection of Mr. and Mrs. Nathan Cummings* (exhibited as *Les Amoureux de Vitebsk)*

National Gallery of Art, Washington, D.C., June 28–September 11, 1970, and The Metropolitan Museum of Art, New York, July 1–September 7, 1971, *Selections from the Nathan Cummings Collection* (exhibited as *Lovers of Vitebsk),* no. 52

Art Institute of Chicago, October 20–December 9, 1973, *Major Works from the Collection of Nathan Cummings* (exhibited as *Lovers of Vitebsk),* no. 65

Reynolda House Museum of American Art, Winston-Salem, North Carolina, September 9–December 25, 1990, and Dixon Gallery and Gardens, Memphis, Tennessee, January 20–March 17, 1991, *An Impressionist Legacy: The Collection of Sara Lee Corporation*

REPRODUCTIONS

Franz Meyer. *Marc Chagall: Life and Work.* New York: Harry N. Abrams, Inc., 1963, n.p.

Selections from the Nathan Cummings Collection (exh. cat.).

Washington, D.C.: National Gallery of Art, 1970, p. 67.
Major Works from the Collection of Nathan Cummings (exh. cat.). Chicago: Art Institute of Chicago, 1973, p. 74.
Consolidated Foods Corporation's Nathan Cummings Collection. (Chicago): Consolidated Foods Corporation, 1983, p. 16, fig. 10 (color).

SELECTED BIBLIOGRAPHY
Marc Chagall. *Ma Vie.* Translated by Bella Chagall. Paris: Stock, 1931.
Jacques Lassaigne. *Chagall.* Paris: Galerie Maeght, 1957.
Franz Meyer. *Marc Chagall: Life and Work.* New York: Harry N. Abrams, Inc., 1963.
James Johnson Sweeney. *Marc Chagall* (exh. cat.). New York: The Museum of Modern Art, 1946.

EDGAR DEGAS (1834–1917)
Breakfast after the Bath (Le Petit Déjeuner après le bain), ca. 1895–98
Pastel on paper, laid down on board; 36⅝ x 32¼ in.
Stamped with the signature
Lemoisne 1205
1987.2

PROVENANCE
Atelier Degas, Paris
Galerie Georges Petit, Paris
Charles Comiot, Paris
Nathan Cummings, Chicago
Alan H. Cummings, Palm Beach
Sotheby's, New York

EXHIBITIONS
Galerie Georges Petit, Paris, May 4–8, 1918, *Tableaux, Pastels et Dessins par Edgar Degas,* no. 176
Galerie André Weil, Paris, June 9–30, 1939, *Degas, peintre du mouvement,* no. 47
Minneapolis Institute of Arts, January 14–March 7, 1965, *Paintings from the Cummings Collection*

REPRODUCTIONS
Catalogue des Tableaux, Pastels et Dessins par Edgar Degas et provenant de son atelier (sale cat.), vol. 1. Paris: Galerie Georges Petit, 1918, p. 96.
Henry Hertz. "Degas, coloriste," *L'Amour de l'Art 5* (March 1924), p. 73.
P. A. Lemoisne. *Degas et son oeuvre,* vol. 3. Paris: Paul Braume et C. M. De Hauke, 1946, p. 701.
Fiorella Minervino. *L'Opera completa di Degas.* Milan: Rizzoli Editore, 1970, p. 133, no. 1048 (related study).

SELECTED BIBLIOGRAPHY
Dunsten Barnes. "The Pastel Techniques of Edgar Degas." In *American Artist,* vol. 36, September 1972, pp. 41–47.
Norma Broude. "Degas's 'Misogyny.'" In *Art Bulletin,* vol. 59, March 1977, pp. 95–107.
Degas (exh. cat.). New York: Metropolitan Museum of Art, 1988.
Eunice Lipton. "Degas' Bathers: The Case for Realism." In

Arts Magazine, vol. 54, May 1980, pp. 94–97.
_____. *Looking into Degas: Uneasy Images of Women and Modern Life.* Berkeley, California: University of California Press, 1986.
Julius Meier-Graefe. *Degas.* Translated by J. Holroyd-Reece. London: Ernest Benn, Ltd., 1923.
Ambroise Vollard. Degas: *An Intimate Portrait.* Translated by Randolph T. Weaver. London: George Allen and Unwin, Ltd., 1928.

EDGAR DEGAS (1834–1917)
The Russian Dancer (La danseuse russe), 1895
Pastel and charcoal on joined paper laid down on board; 25½ x 21½ in.
Stamped with signature lower left: "Degas" (Lugt 658)
Lemoisne 1193, Minervino 1085
1992.1

PROVENANCE
Atelier Edgar Degas
Galerie Georges Petit, Paris, December 11–13, 1918 (2eme vente), lot 122
Collection Veron, Paris, 1940s
Nathan Cummings, Chicago
Alan H. Cummings, Palm Beach

EXHIBITIONS
Musée des Arts Décoratifs, Paris, March–May 1956, and Palazzo Venezia, Rome (dates unknown) 1956, *La collection Cummings: Peintures françaises, XIXe–XXe siècle,* no. 8
Minneapolis Institute of Arts, January 14–March 7, 1965, *Paintings from the Cummings Collection*
National Gallery of Art, Washington, D.C., June 28–September 11, 1970, and The Metropolitan Museum of Art, New York, July 1–September 7, 1971, *Selections from the Nathan Cummings Collection,* no. 8
Art Institute of Chicago, October 20–December 9, 1973, *Major Works from the Collection of Nathan Cummings,* no. 10

REPRODUCTIONS
Paul Andre Lemoisne. *Degas et son ouevre,* vol. 3. Paris: Arts et Metiers Graphiques (circa 1946–1949), p. 692.
Franco Russoli and Fiorella Minervino. *L'Opera completa di Degas.* Milan: Rizzoli Editore, 1970, p. 135.
Selections from the Nathan Cummings Collection (exh. cat.). Washington, D.C.: National Gallery of Art, 1970, p. 20.
Major Works from the Collection of Nathan Cummings (exh. cat.). Chicago: Art Institute of Chicago, 1973, p. 19.

SELECTED BIBLIOGRAPHY
Paul Andre Lemoisne. *Degas et son ouevre,* vol. 3. Paris: Arts et Metiers Graphiques (circa 1946–1949).
La collection Cummings: Peintures françaises, XIXe–XXe siècle (exh. cat.). Paris: Musée des Arts Décoratifs, 1956.
Paintings from the Cummings Collection (exh. cat.). Minneapolis: Minneapolis Institute of Arts, 1965.

Franco Russoli and Fiorella Minervino. *L'Opera completa di Degas*. Milan: Rizzoli Editore, 1970.

Selections from the Nathan Cummings Collection (exh. cat.).Washington, D.C.: National Gallery of Art, 1970.

Major Works from the Collection of Nathan Cummings (exh. cat.). Chicago: Art Institute of Chicago, 1973.

EDGAR DEGAS (1834–1917)

Russian Dancers (Les Danseuses russes), 1895
Pastel on two pieces of tracing paper mounted on board; 28½ x 22⅞ in.
Signed lower left: "Degas"; atelier stamp verso
Lemoisne 1190, Minervino 1082
1984.3

PROVENANCE
Ambroise Vollard, Paris
Galerie Georges Petit, Paris
Rothschild Collection, Paris
Nathan Cummings, Chicago

EXHIBITIONS
Minneapolis Institute of Arts, January 14–March 7, 1965, *Paintings from the Cummings Collection*

National Gallery of Art, Washington, D.C., June 28–September 11, 1970, and The Metropolitan Museum of Art, New York, July 1–September 7, 1971, *Selections from the Nathan Cummings Collection*, no. 9

Art Institute of Chicago, October 20–December 9, 1973, *Major Works from the Collection of Nathan Cummings*, no. 11

Reynolda House Museum of American Art, Winston-Salem, North Carolina, September 9–December 25, 1990, and Dixon Gallery and Gardens, Memphis, Tennessee, January 20–March 17, 1991, *An Impressionist Legacy: The Collection of Sara Lee Corporation*

REPRODUCTIONS
Catalogue des Tableaux, Pastels et Dessins par Edgar Degas et provenant de son atelier (sale cat.), vol. 1. Paris: Galerie Georges Petit, 1918, p. 88.

P. A. Lemoisne, *Degas et son oeuvre*, vol. 3, Paris: Paul Braume et C. M. DeHauke, 1946, p. 690.

Fiorella Minervino. *L'Opera completa di Degas*. Milan: Rizzoli Editore, 1970, p. 134.

Selections from the Nathan Cummings Collection (exh. cat.). Washington, D.C.: National Gallery of Art, 1970, p. 21 (color).

SELECTED BIBLIOGRAPHY
Lillian Browse. *Degas Dancers*. London: Faber & Faber, Ltd., 1949.

Ian Dunlop. *Degas*. New York: Harper and Row, Publishers, 1979.

Jacques Lassaigne and Fiorella Minervino. *Degas*. Paris: Flammarion, 1974.

Julius Meier-Graefe. *Degas*. Translated by J. Holroyd-Reece. London: Ernest Benn, Ltd., 1923.

Theodore Reff. Degas: *The Artist's Mind*. New York: The Metropolitan Museum of Art, 1976.

George Schakelford. Degas: *The Dancers* (exh. cat.). Washington, D.C.: National Gallery of Art, 1984.

Ambroise Vollard. Degas: *An Intimate Portrait*. Translated by Randolph T. Weaver. London: George Allen and Unwin, Ltd., 1928.

RAOUL DUFY (1877–1953)

The Allegory of Electricity (La Fée électricité), 1936–37
Watercolor, gouache on paper; 5 panels, overall 38½ x 235 in.
Signed and dated lower center, second panel from left: "Raoul Dufy pinxit 1937"
Guillon-Laffaille 1909–13

PROVENANCE
Artist's collection
Galerie Charpentier, Paris
La Palme, Paris
Nathan Cummings, New York
Mrs. Robert B. Mayer with her son Robert N. Mayer and her daughter Ruth M. Durchslag, Chicago

EXHIBITIONS
National Gallery of Art, Washington, D.C., June 28–September 11, 1970, and The Metropolitan Museum of Art, New York, July 1–September 7, 1971, *Selections from the Nathan Cummings Collection*, nos. 53–57

Dixon Gallery and Gardens, Memphis, Tennessee, January 20–March 17, 1991, *An Impressionist Legacy: The Collection of Sara Lee Corporation*

REPRODUCTIONS
Bernard Dorival. *La belle histoire de la fée électricité de Raoul Dufy*. Paris: La Palme, 1953, n.p.

Selections from the Nathan Cummings Collection (exh. cat.). Washington, D.C.: National Gallery of Art, 1970, pp. 69–73.

Fanny Guillon-Laffaille. *Raoul Dufy: Catalogue raisonné des aquarelles, gouaches, et pastels*. Paris: Editions Louis Carré, 1982, pp. 310–12.

Consolidated Foods Corporation's Nathan Cummings Collection. (Chicago): Consolidated Foods Corporation, 1983, p. 15, fig. 9 (color).

SELECTED BIBLIOGRAPHY
Raymond Cogniat. *Dufy décorateur*. Geneva: Pierre Cailler, 1957.

Pierre Courthion. *Raoul Dufy*. Geneva: Pierre Cailler, 1951.

Bernard Dorival. *La belle histoire de la fée électricité de Raoul Dufy*. Paris: La Palme, 1953.

Fanny Guillon-Laffaille. *Raoul Dufy: Catalogue raisonné des aquarelles, gouaches, et pastels*. Paris: Editions Louis Carré, 1982.

Claude Roger-Marx. *Raoul Dufy*. Paris: Gernand Hazan, 1950.

Alfred Werner. *Dufy*. New York: Harry N. Abrams, Inc., 1953.

RAOUL DUFY (1877–1953)
Gust of Wind (Coup de vent) (Pecheurs a la ligne), 1907
Oil on canvas; 21¼ x 25⅜ in.
Signed lower right: "R. Dufy"
Laffaille 156
1992.2

PROVENANCE
Jacques Zoubaloff, Paris
Galerie Georges Petit, Paris, 17 June 1927
Genia and Charles Zadock, Milwaukee
Museum of Modern Art, New York
Nathan Cummings, New York

EXHIBITIONS
Galerie Georges Petit, Paris, June 14–17, 1927, *Collection Jacques Zoubaloff*, no. 114 (identified as *Plage de Trouville par gros temps* [*Trouville Beach in Heavy Weather*])
Museum of Modern Art, New York, October 8, 1952–January 4, 1953; Minneapolis Institute of Arts January 21–February 22, 1953; San Francisco Museum of Art, March 13–April 12, 1953; and Art Gallery of Toronto, May 1–31, 1953, Les Fauves, no. 50 (identified as *Anglers at Sunset*, circa 1907)
San Francisco Museum of Art, May–June 1954, and Los Angeles County Museum, June–September 1954, Raoul Dufy 1877–1953, no. 7 (identified as *Anglers at Sunset*, circa 1907)
Musée National d'Art Moderne, Paris, January 15–March 6, 1966, and Haus der Kunst, Munich, March 26–May 15, 1966, *Le Fauvisme francais et les debuts de l'Expressionnisme allemand*, no. 45 (as *Pecheurs a la ligne*, circa 1908)

REPRODUCTIONS
Galerie Georges Petit, Paris. *Collection Jacques Zoubaloff* (auction cat.). Paris: Galerie Georges Petit, 1927, n.p. (lot 114).
Georges Duthuit. *Les Fauves*. Geneva: Editions des Trois Collines S.A., 1949, p. 149 (identified as *Les Pecheurs*, 1905, private collection, Paris [color]).
_____. *The Fauvist Painters*. New York: Wittenborn Schulz, Inc. 1950, n.p. (plate 34, identified as *The Fisherman*, 1905 [color]).
Museum of Modern Art Bulletin 20, nos. 3–4 (1953): 19 (identified as *Anglers at Sunset*, circa 1907).
San Francisco Museum of Art. *Raoul Dufy* 1877–1953 (exh. cat.). San Francisco: San Francisco Museum of Art, 1954, p. 23 (color).
Musée National d'Art Moderne. *Le Fauvisme francais et les debuts de l'Expressionnisme allemand* (exh. cat.). Paris: Musée National d'Art Moderne, 1966, p. 89.
Joseph-Marie Muller. *Le Fauvisme*. Paris: Ed. Hazan, 1967, p. 123.

Maurice Laffaille. *Raoul Dufy: Catalogue raisonné de l'oeuvre peint*, vol 1. Geneva: Editions Motte, 1972, p. 138.
Kim Youngna. *The Early Works of Georges Braque, Raoul Dufy and Othon Friesz: The Le Havre Group of Fauvist Painters*. Ann Arbor, Michigan: University Microfilms, 1980, p. 390.

SELECTED BIBLIOGRAPHY
Georges Duthuit. *Les Fauves*. Geneva: Editions des Trois Collines S.A., 1949.
_____. *The Fauvist Painters*. Translated by Ralph Manheim. New York: Wittenborn Schulz, Inc., 1950.
Maurice Laffaille. *Raoul Dufy: Catalogue raisonné de l'oeuvre peint*, vol. 1. Geneva: Editions Motte, 1972.
Joseph-Marie Muller. *Le Fauvisme*. Paris: Ed. Hazan, 1967.
Musée National d'Art Moderne. *Le Fauvisme francais et les debuts de l'Expressionnisme allemand* (exh. cat.). Edited by Michel Hoog and Leopold Reidemeister. Paris: Musée National d'Art Moderne, 1966.
Museum of Modern Art. *Les Fauves* (exh. cat.). New York: Museum of Modern Art, 1952.
San Francisco Museum of Art. *Raoul Dufy* 1877–1953 (exh. cat.). San Francisco: San Francisco Museum of Art, 1954.
Kim Youngna. *The Early Works of Georges Braque, Raoul Dufy and Othon Friesz: The Le Havre Group of Fauvist Painters*. Ann Arbor, Michigan: University Microfilms, 1980.

ROGER DE LA FRESNAYE (1885–1925)
The Bathers (Les Baigneurs), 1912
Oil on canvas; 63½ x 50½ in.
Signed lower right: "R de la Fresnaye"
Seligman 121
1981.2

PROVENANCE
Halvorsen, Stockholm
Richard Bergh, Stockholm
Mrs. Hallström, Stockholm
Svensk-Franska Konstgalleriet, Stockholm
J. K. Thannhauser, New York
Mr. and Mrs. Morton D. May, St. Louis
Washington University and St. Louis Symphony Society, St. Louis
Parke-Bernet, New York (sale of April 6, 1967, no. 63)
Nathan Cummings, Chicago

EXHIBITIONS
Salon d'Automne, Paris, 1912, no. 613
Levesque, 1914, no. 30
Société Interscandinave d'Art Français, Stockholm, Göteborg, Copenhagen, Oslo, 1931
Musée National d'Art Moderne, Paris, 1950, *Roger de La Fresnaye*, no. 47
Liljevalchs Konsthalle, Stockholm, 1954, *Fråan Cézanne till Picasso*
St. Louis Art Museum, 1961, *A Galaxy of Treasures*
San Francisco Museum of Art, November 10, 1964–January 3, 1965, *Man: Glory, Jest and Riddle: A Survey of*

the Human Form through the Ages, no. 259
The Museum of Modern Art, New York, and Museum of
	Fine Arts, Houston, 1965, *The Heroic Years/Paris
	1908–1914*
Stanford University, Palo Alto, California, April 1969
Palais Galliéra, Paris, September 1969
National Gallery of Art, Washington, D.C.,
	June 28–September 11, 1970, and The Metropolitan
	Museum of Art, New York, July 1–September 7, 1971,
	Selections from the Nathan Cummings Collection, no. 22
Los Angeles County Museum of Art, December 15,
	1970–February 1, 1971
Art Institute of Chicago, October 20–December 9, 1973,
	Major Works from the Collection of Nathan Cummings,
	no. 51
Israel Museum, Jerusalem, September 2–December 2,
	1990, *Inaugural Modern Art Exhibition: Nathan Cummings
	Twentieth Century Building*
The David and Alfred Smart Museum of Art, Chicago,
	October 6–December 2, 1991, *Multiple Perspectives:
	Cubism in Chicago Collections*

REPRODUCTIONS
Roger Allard. *R. de La Fresnaye*. Paris: Editions de la
	Nouvelle Revue Française, 1912, p. 27.
Roger de La Fresnaye (exh. cat.). Paris: Musée National d'Art
	Moderne, 1950.
A Galaxy of Treasures (exh. cat.). St. Louis: St. Louis Art
	Museum, 1961.
*Man: Glory, Jest and Riddle: A Survey of the Human Form
	through the Ages* (exh. cat.). San Francisco: San Francisco
	Museum of Art, 1964, n.p.
Germain Seligman. *Roger de La Fresnaye*. London: Thames
	and Hudson, 1969, pp. 45 (color) and 151.
Selections from the Nathan Cummings Collection (exh. cat.).
	Washington, D.C: National Gallery of Art, 1970, p. 37.
Major Works from the Collection of Nathan Cummings (exh.
	cat.). Chicago: Art Institute of Chicago, 1973, p. 60
	(color).
Consolidated Foods Corporation's Nathan Cummings Collection.
	(Chicago): Consolidated Foods Corporation, 1983, p. 17,
	fig. 11 (color).

SELECTED BIBLIOGRAPHY
Roger Allard. *R. de La Fresnaye*. Paris: Editions de la
	Nouvelle Revue Française, 1912.
Raymond Cogniat and Waldemar George. *Oeuvre complète de
	Roger de La Fresnaye*. Paris: Editions Rivarol, 1950.
Edward F. Fry. *Cubism*. New York: Oxford University Press,
	1966.
Germain Seligman. *Roger de La Fresnaye*. London: Thames
	and Hudson, 1969.

PAUL GAUGUIN (1848–1903)
*Clay Jug and Iron Jug (Le Pot de terre et le pot de
fer)*, 1880
Oil on canvas; 35 x 28½ in.
Signed, dated lower left: "P Gauguin 80"
Wildenstein 47, Fezzi 51
1984.4

PROVENANCE
Collection Schuffenecker, Paris
Nathan Cummings, Chicago

EXHIBITIONS
Galerie Charpentier, Paris, 1946, *Tableaux de la vie
	silencieuse*, no. 26
Musée des Beaux-Arts, (Paris?), 1949, *Les Grand Courants de
	la Peinture Contemporaine*, no. 3
Reynolda House Museum of American Art, Winston-
	Salem, North Carolina, September 9–December 25,
	1990, and Dixon Gallery and Gardens, Memphis,
	Tennessee, January 20–March 17, 1991, *An Impressionist
	Legacy: The Collection of Sara Lee Corporation*

REPRODUCTIONS
Raymond Cogniat *Gauguin*. Paris: Editions Pierre Tisné,
	1947, pl. 6.
Georges Wildenstein. *Gauguin*. Paris: Les Beaux-Arts,
	1964, p. 22.
Elda Rezzi. *Gauguin*. Milan: Rizzoli Editore, 1980, p. 21.

SELECTED BIBLIOGRAPHY
Paul Gauguin. *Lettres à sa femme et à ses amis*. Edited by
	Maurice Malingue. Paris: Editions Bernard Grasser,
	1949.
Sven Loevgren. *The Genesis of Modernism: Seurat, Gauguin,
	Van Gogh, and French Symbolism in the 1880s*. Revised
	edition. Bloomington, Indiana: Indiana University
	Press, 1971.
Henri Perruchot. *Gauguin*. Translated by Humphrey Hare.
	Cleveland: The World Publishing Company, 1963.
John Rewald. *The History of Impressionism*. 4th revised
	edition. New York: The Museum of Modern Art, 1963.
_____. *Post-Impressionism from Van Gogh to Gauguin*. New
	York: The Museum of Modern Art, 1962.
Hendrick R. Rookmaader. *Gauguin and Nineteenth Century
	Art Theory*. Amsterdam: Swets and Zeitlinger, 1972.
Georges Wildenstein. *Gauguin*. Paris: Les Beaux-Arts,
	1964.

ALBERTO GIACOMETTI (1901–1966)
Diego, 1954
Bronze: height 24 in.
Annette IV, 1962
Bronze: height 23 in.

PROVENANCE
Galerie Maeght
Mr. and Mrs. Nathan Cummings, Chicago

EXHIBITIONS

National Gallery of Art, Washington, D.C., June 28–
September 11, 1970, and The Metropolitan Museum of
Art, New York, July 1–September 7, 1971, *Selections
from the Nathan Cummings Collection, no. 72*

Art Institute of Chicago, October 20–December 9, 1973,
Major Works from the Collection of Nathan Cummings,
no. 72

Reynolda House Museum of American Art, Winston-
Salem, North Carolina, September 9–December 25,
1990, and Dixon Gallery and Gardens, Memphis,
Tennessee, January 20–March 17, 1991, *An Impressionist
Legacy: The Collection of Sara Lee Corporation*

REPRODUCTIONS (of casts of these sculptures)

Selections from the Nathan Cummings Collection (exh. cat.).
Washington, D.C.: National Gallery of Art, 1970,
p. 88.

Reinhold Hohl. *Alberto Giacometti.* New York: Harry N.
Abrams, Inc., 1971, pp. 263, 265, 267.

Major Works from the Nathan Cummings Collection (exh. cat.).
Chicago: Art Institute of Chicago, 1973, p. 86 and 89.

SELECTED BIBLIOGRAPHY

The Solomon R. Guggenheim Museum. *Alberto Giacometti:
A Retrospective Exhibition* (exh. cat.). New York, 1974.

Reinhold Hohl. *Alberto Giacometti.* New York: Harry N.
Abrams, Inc., 1971.

James Lord. *A Giacometti Portrait.* New York: The Museum
of Modern Art, 1965.

_____. *Giacometti: A Biography.* New York: Farrar, Straus,
Giroux, 1985.

The Museum of Modern Art. *Alberto Giacometti* (exh. cat.).
Introduction by Peter Selz. Statement by the artist. New
York, 1965.

WASSILY KANDINSKY (1866–1944)

Layers (Schichten), 1932 (also known as
Composition en rose and *Pink Layers*)
Tempera, oil on wood; 19¾ x 15⅝ in.
Signed, dated lower left: "Vk/32"
Grohmann 569
1984.5

PROVENANCE

Mrs. Hildegarde J. Prytek, New York
The Solomon R. Guggenheim Foundation, New York
Sotheby and Co., New York
Nathan Cummings, New York

EXHIBITIONS

Kunsthalle Bern, February 21—March 29, 1937, *Wassily
Kandinsky/Französische Meister des Gegenwart,* no. 49

The Solomon R. Guggenheim Museum, New York, May
31–October 9, 1949, *Tenth Anniversary Exhibition*

Minneapolis Institute of Arts, January 14–March 7, 1965,
Paintings from the Cummings Collection

National Gallery of Art, Washington D.C., June 28–
September 11, 1970, and The Metropolitan Museum of

Art, New York, July 1–September 7, 1971, *Selections
from the Nathan Cummings Collection,* no. 30

Art Institute of Chicago, October 20–December 9, 1973,
Major Works from the Collection of Nathan Cummings,
no. 64

High Museum of Art, Atlanta, January 31–March 14,
1976; Museum of Fine Arts, Houston, April 8–May 30,
1976; Fine Arts Gallery of San Diego, August 1–
September 21, 1976, *Bauhaus Color*

The Solomon R. Guggenheim Museum, New York,
December 9, 1983–February 12, 1984, *Kandinsky:
Russian and Bauhaus Years,* no. 309

Reynolda House Museum of American Art, Winston-
Salem, North Carolina, September 9–December 25,
1990, and Dixon Gallery and Gardens, Memphis,
Tennessee, January 20–March 17, 1991, *An Impressionist
Legacy: The Collection of Sara Lee Corporation*

REPRODUCTIONS

Catalogue of Fifty Paintings by Wassily Kandinsky (sale cat.).
London: Sotheby and Co., 1964, p. 44 (color).

Paul Overy. *Kandinsky: The Language of the Eye.* New York:
Praeger Publishers, 1969 (color).

Selections from the Nathan Cummings Collection (exh. cat.).
Washington D.C.: National Gallery of Art, 1970, p. 44.

Major Works from the Collection of Nathan Cummings (exh.
cat.). Chicago: Art Institute of Chicago, 1973, p. 73.

Clark Poling. *Bauhaus Color.* (exh. cat.). Atlanta: High
Museum of Art, 1975, p. 23 (color).

Kandinsky: Russian and Bauhaus Years 1915–1933 (exh.
cat.). New York: The Solomon R. Guggenheim
Museum, 1983, p. 340.

David R. Cunningham and John A. Stuller. *Basic Circuit
Analysis.* Boston: Houghton Mifflin Company, 1991,
cover.

SELECTED BIBLIOGRAPHY

Vivian Endicott Barnett. *Kandinsky at the Guggenheim* (exh.
cat.). New York: Abbeville Press, 1983.

Will Grohmann. *Wassily Kandinsky: Life and Work.* New
York: Harry N. Abrams, Inc., 1958.

Kandinsky: Russian and Bauhaus Years 1915–1933 (exh.
cat.). New York: The Solomon R. Guggenheim
Museum, 1983.

Wassily Kandinsky. *Kandinsky: Complete Writings on Art.*
Edited by Kenneth C. Lindsay and Peter Vergo. Boston:
G. H. Hall and Co., 1982.

Paul Overy. *Kandinsky: The Language of the Eye.* New York:
Praeger Publishers, 1969.

MARIE LAURENCIN (1885–1956)

*Young Girl with a Guitar (La jeune fille a la
guitare),* 1945
Oil on canvas; 24 x 19¾ in.
Signed upper right: "Marie Laurencin"
Marchesseau 1173
1991.4

PROVENANCE

Nathan Cummings, New York
Mr. and Mrs. V. de Margoulies
Kende Gallery, New York, Auction, March 24, 1949
French & Co., Inc., Auction, May 1952
Loaned to Mr. and Mrs. Norman Cahners, 1952
Loaned to Mr. and Mrs. Robert B. Mayer, Chicago
University of New Brunswick, Fredericton, Canada, 1967

EXHIBITIONS

Kende Galleries, New York, March 19–24, 1949, *French Modern Paintings from the Collection of Mr. and Mrs. V. de Margoulies*, no. 30

REPRODUCTIONS

Advertisement for Kende Galleries, New York. *The Arts Digest* 23 (March 15, 1949), 23.
French Modern Paintings from the Collection of Mr. and Mrs. V. de Margoulies (auction cat.). New York: Kende Galleries, Inc., 1949, p. 20.
Advertisement for French & Co., Inc., New York) *ARTnews* 51 (May 1952), 4.
David Marchesseau. *Marie Laurencin, 1883–1956: Catalogue raisonné du l'oeuvre peint,* vol. 1. Tokyo: Editions du Musée Marie Laurencin, 1986, p. 476.

SELECTED BIBILIOGRAPHY

French Modern Paintings from the Collection of Mr. and Mrs. V. de Margoulies (auction cat.). New York: Kende Galleries, Inc., 1949.
Daniel Marchesseau. *Marie Laurencin, 1883-1956: Catalogue raisonné du l'oeuvre peint,* vol. 1. Tokyo: Editions du Musée Marie Laurencin, 1986.

FERNAND LÉGER (1881–1955)

Constructors with Tree (Constructeurs avec arbre), 1951
Oil on canvas; 42½ x 54 ¼ in.
Signed and dated lower right
1987.1

PROVENANCE

Galerie Louise Leiris, Paris
Nathan Cummings, Chicago
Joel Friedland, Miami Beach

EXHIBITIONS

Galerie Louis Carré, Paris, 1953
Kunsthalle Basel, 1957
Kunsthaus Zürich, July 6–August 17, 1957, *Fernand Léger* (not in cat.)
National Gallery of Art, Washington, D.C., June 28–September 11, 1970, and The Metropolitan Museum of Art, New York, July 1–September 7, 1971, *Selections from the Nathan Cummings Collection,* no. 46
Art Institute of Chicago, October 20–December 9, 1973, *Major Works from the Collection of Nathan Cummings,* no. 59
Reynolda House Museum of American Art, Winston-

Salem, North Carolina, September 9–December 25, 1990, and Dixon Gallery and Gardens, Memphis, Tennessee, January 20–March 17, 1991, *An Impressionist Legacy: The Collection of Sara Lee Corporation*

REPRODUCTIONS

Selections from the Nathan Cummings Collection (exh. cat.). Washington, D.C.: National Gallery of Art, 1970, p. 61.
Major Works from the Collection of Nathan Cummings (exh. cat.). Chicago: Art Institute of Chicago, 1973, p. 68.

SELECTED BIBLIOGRAPHY

Peter De Francia. *Fernand Léger.* Especially chapter 9, "Ideological Struggles of the 1950s: *Les Constructeurs.*" New Haven, Connecticut: Yale University Press, 1983.
Fernand Léger (exh. cat.). Essays by Robert T. Buck, Edward F. Fry, Charlotta Kotik. New York: Abbeville Press, 1982.
Fernand Léger: Five Themes and Variations (exh. cat.). Especially chapter 3, "The Constructors." New York: Solomon R. Guggenheim Museum, 1962.
Claude Roy. *Les Constructeurs de Fernand Léger.* Paris: Editions de la Falaise, 1951.
Christian Zervos. *Léger: Ouevres de 1905 à 1952.* Paris: Editions Cahiers d'Art, 1952.

FERNAND LÉGER (1881–1955)

Reclining Figure (Femme couchee), 1922
Oil on canvas; 25½ x 36¼ in.
1991.3

PROVENANCE

Galerie Simon, Paris
Gimpel and Hanover: Anne Rotzler, Switzerland
Galerie Beyeler, Basel
Nathan Cummings, United States
Beadleston Fine Art, New York, 1979
Galerie Louise Leiris, Paris, 1981
Private collection, United States

EXHIBITIONS

Minneapolis Institute of Arts, January 14–March 7, 1965, *Paintings from the Cummings Collection*
National Gallery of Art, Washington, D.C., June 28–September 11, 1970, and The Metropolitan Museum of Art, New York, July 1–September 7, 1971, *Selections from the Nathan Cummings Collection,* no. 43

REPRODUCTIONS

Douglas Cooper. "Cummings Event in Washington." *ARTnews* 69 (Summer 1970), p. 36 (color).
Selections from the Nathan Cummings Collection (exh. cat.). Washington, D.C.: National Gallery of Art, 1970, p. 58 (color).
Frank Elgar. "Le primitif des temps modernes." In *Hommage a Fernand Léger.* Paris: XXe siecle, 1971, n.p. [32].
Claude Laugier and Michele Richet. *Leger: Oeuvres de Fernand Léger (1881–1955).* Paris: Musée National d'Art Moderne and Centre Georges Pompidou, 1981, p. 51.

153

SELECTED BIBLIOGRAPHY
Claude Laugier and Michele Richeto. *Léger: Oeuvres de Fernand Léger (1881–1955)*. Paris: Musée National d'Art Moderne and Centre Georges Pompidou, 1981.
Minneapolis Institute of Arts. *Paintings from the Cummings Collection* (exh. cat.). Minneapolis: Minneapolis Institute of Arts, 1965.

Katharine Kuh. *Léger.* Urbana: The University of Illinois Press, 1953.
Werner Schmalenbach. *Fernand Léger.* Translated by Robert Allen with James Emmons. New York: Harry N. Abrams, Inc., 1976.
Christian Zervos. *Léger: Oeuvres de 1905 à 1952.* Paris: Editions Cahiers d'Art, 1952.

FERNAND LÉGER (1881–1955)
Still Life with a Compass (Nature Morte au Compas), 1926
Oil on canvas; 36¼ x 28¾ in.
Signed, dated lower right: "F Léger .26"; inscribed verso: "Nature-Morte/F Léger/26"
1984.6

PROVENANCE
Galerie Louise Leiris, Paris
Galerie Simon, Paris
G. David Thompson, Pittsburgh
Buchholz Gallery, New York
Parke-Bernet Galleries, New York
Nathan Cummings, New York

EXHIBITIONS
Kunsthalle Bern, April 10–May 25, 1952, *Fernand Léger,* no. 35
Haags Gemeentemuseum, *The Hague,* 1961, no. 110
Turin Galleria Civica d'Arte Moderna, 1961, no. 77
The Solomon R. Guggenheim Museum, New York, 1961
Carnegie Institute, Pittsburgh, 1961
Joanne and Nathan Cummings Art Center, Connecticut College, New London, April 1969
Palais Galliéra, Paris, September 1969
National Gallery of Art, Washington, D.C., June 28–September 11, 1970, and The Metropolitan Museum of Art, New York, July 1–September 7, 1971, *Selections from the Nathan Cummings Collection,* no. 42
Art Institute of Chicago, October 20–December 9, 1973, *Major Works from the Collection of Nathan Cummings,* no. 55
Reynolda House Museum of American Art, Winston-Salem, North Carolina, September 9–December 25, 1990, and Dixon Gallery and Gardens, Memphis, Tennessee, January 20–March 17, 1991, *An Impressionist Legacy: The Collection of Sara Lee Corporation*

REPRODUCTIONS
E. Tériade. *Fernand Léger.* Paris: Editions Cahiers d'Art, 1928, p. 76.
Selections from the Nathan Cummings Collection (exh. cat.). Washington, D.C.: National Gallery of Art, 1970, p. 57.
Major Works from the Collection of Nathan Cummings (exh. cat.). Chicago: Art Institute of Chicago, 1973, p. 64 (color).

SELECTED BIBLIOGRAPHY
Fernand Léger (exh. cat.). Essays by Robert T. Buck, Edward F. Fry, Charlotta Kotik. New York: Abbeville Press, 1982.

ARISTIDE MAILLOL (1861–1944)
Phryne, 1903
Terra-cotta; height 15⅜ in.

PROVENANCE
Madame Andre, Paris
Nathan Cummings, Chicago

EXHIBITIONS
National Gallery of Art, Washington, D.C., June 28–September 11, 1970, and The Metropolitan Museum of Art, New York, July 1–September 7, 1971, *Selections from the Nathan Cummings Collection,* no. 65
Reynolda House Museum of American Art, Winston-Salem, North Carolina, September 9–December 25, 1990, and Dixon Gallery and Gardens, Memphis, Tennessee, January 20–March 17, 1991, *An Impressionist Legacy: The Collection of Sara Lee Corporation*

REPRODUCTIONS
Selections from the Nathan Cummings Collection (exh. cat.). Washington, D.C.: National Gallery of Art, 1970, p. 81.

SELECTED BIBLIOGRAPHY
Marguette Bouvier. *Aristide Maillol.* Lausanne: Editions Marguerat, 1945.
Roger E. Fry. "The Sculpture of Maillol." In *The Burlington Magazine,* vol. 17, 1910, pp. 26–34.
Waldemar George. *Aristide Maillol.* Biographical essay by Dina Vierny. Translated by Diana Imber. Greenwich, Connecticut: New York Graphic Society, Ltd., 1965.
John Rewald. *Maillol.* New York: The Hyperion Press, 1939.
Paul Rosenberg and Company, New York. *An Exhibition of Original Pieces of Sculpture by Aristide Maillol: 1861–1944* (exh. cat.). Foreword by John Rewald. New York, 1958.

GIACOMO MANZÙ (1908–1991)
Skating Girl, 1959
Bronze; 68½ in.ù
Stamped with signature and foundry mark
1981.4

PROVENANCE
Artist's collection

EXHIBITIONS
Tate Gallery, London, October 1–November 6, 1960, *Giacomo Manzù Sculpture and Drawings,* no. 51
Reynolda House Museum of American Art, Winston-

Salem, North Carolina, September 9–December 25, 1990, and Dixon Gallery and Gardens, Memphis, Tennessee, January 20–March 17, 1991, *An Impressionist Legacy: The Collection of Sara Lee Corporation*

REPRODUCTIONS
Giacomo Manzù Sculpture and Drawings (exh. cat.). London: Arts Council of Great Britain, 1960, pl. V.
National Galerie Berlin. *Giacomo Manzù: Skulpturen Zeichnungen* (exh. cat.). West Berlin: Staatliche Museen zu Berlin, 1960, p. 40.

SELECTED BIBLIOGRAPHY
Nino Bertocchi. *Manzù.* Milan: Editoriale Domus, 1943.
Hanover Gallery, London. *Giacomo Manzù: Sculpture and Drawings* (exh. cat.) by J. P. Howdin. London, 1969.
Curtis Bill Pepper. *An Artist and the Pope.* New York: Madison Square Press, Grosset & Dunlap, 1968.
C. L. Ragghianti. *Giacomo Manzù, Sculptor.* Milan: Editoriale del Milione, 1957.

HENRI MATISSE (1869–1954)
Henriette I (Gross Tête), 1925
Bronze; height 11½ in.

PROVENANCE
Ahrenberg Collection
Parke-Bernet Galleries, Inc., New York
Mr. and Mrs. Nathan Cummings, New York

EXHIBITIONS
Parke-Bernet Galleries, Inc., New York, April 8–13, 1965, *Impressionist and Modern Paintings, Sculptures, Drawings,* lot no. 19
Lyman Allyn Museum, New London, Connecticut, January 19–February 18, 1968, *Paintings and Sculpture from the Collection of Mr. and Mrs. Nathan Cummings*
National Gallery of Art, Washington, D.C., June 28–September 11, 1970, and The Metropolitan Museum of Art, New York, July 1–September 7, 1971, *Selections from the Nathan Cummings Collection,* no. 67
Museum of Modern Art, New York, February 24–May 8, 1972; Walker Art Center, Minneapolis, June 20–August 6, 1972; and University Art Museum, University of California, Berkeley, *The Sculpture of Henri Matisse,* no. 56
Art Institute of Chicago, October 20–December 9, 1973, *Major Works from the Collection of Nathan Cummings,* no. 30 (as *Large Head of Henriette*)
Reynolda House Museum of American Art, Winston-Salem, North Carolina, September 9–December 25, 1990, and Dixon Gallery and Gardens, Memphis, Tennessee, January 20–March 17, 1991, *An Impressionist Legacy: The Collection of Sara Lee Corporation*

REPRODUCTIONS (of this cast* or others)
*Parke-Bernet Galleries, Inc. *Impressionist and Modern Paintings, Sculptures, Drawings* (sale cat.). New York: Parke-Bernet Galleries, Inc., 1965, p. 17.
Selections from the Nathan Cummings Collection (exh. cat.). Washington, D.C.: National Gallery of Art, 1970, p. 83.
*Albert E. Elsen. *The Sculpture of Henri Matisse.* New York: Harry N. Abrams, Inc., 1972, no. 219.
*Alicia Legg. *The Sculpture of Henri Matisse* (exh. cat.). New York: Museum of Modern Art, 1972, 36.
Major Works from the Nathan Cummings Collection (exh. cat.). Chicago: Art Institute of Chicago, 1973, p. 39.
Isabelle Monod-Fontaine. *The Sculpture of Henri Matisse.* Edited by Catherine Lampert, translated by David Macey. London: Thames and Hudson, no. 57.
Pierre Schneider. *Matisse.* Translated by Michael Taylor and Bridget Strevens Romer. New York: Rizzoli International Publications, Inc., 1984, p. 560.

SELECTED BIBLIOGRAPHY
See entries for Henri Matisse, *Standing Nude,* 1911

HENRI MATISSE (1869–1954)
Standing Nude, 1911
18½ in. with wood pedestal and base

PROVENANCE
Seven Arts, Ltd., London
Mr. and Mrs. Nathan Cummings, New York

EXHIBITIONS
National Gallery of Art, Washington, D.C., June 28–September 11, 1970, and The Metropolitan Museum of Art, New York, July 1–September 7, 1971, *Selections from the Nathan Cummings Collection,* no. 66
Art Institute of Chicago, October 20–December 9, 1973, *Major Works from the Collection of Nathan Cummings,* no. 9
Reynolda House Museum of American Art, Winston-Salem, North Carolina, September 9–December 25, 1990, and Dixon Gallery and Gardens, Memphis, Tennessee, January 20–March 17, 1991, *An Impressionist Legacy: The Collection of Sara Lee Corporation*

REPRODUCTIONS (of casts of this sculpture)
Selections from the Nathan Cummings Collection (exh. cat.). Washington, D.C.: National Gallery of Art, 1970, p.82.
Albert E. Elsen. *The Sculpture of Henri Matisse.* New York: Harry N. Abrams, Inc., 1972, no. 133.
Major Works from the Nathan Cummings Collection (exh. cat.). Chicago: Art Institute of Chicago, 1973, p. 38.

SELECTED BIBLIOGRAPHY
Alfred H. Barr, Jr. *Matisse: His Art and His Public.* New York: The Museum of Modern Art, 1951.
John Elderfield. *Matisse in the Collection of the Museum of Modern Art.* With additional texts by William S. Lieberman and Riva Castleman. New York: The Museum of Modern Art, 1978.
Albert E. Elsen. *The Sculpture of Matisse.* New York: Harry N. Abrams, Inc., 1972.
Alicia Legg. *The Sculpture of Matisse.* New York: The Museum of Modern Art, 1972.
Isabelle Monod-Fontaine. *The Sculpture of Henri Matisse.* London: Thames and Hudson, 1984.

Pierre Schneider. *Matisse.* Translated by Michael Taylor and
 Bridget Strevens Romer. New York: Rizzoli, 1984.
William Tucker. *Early Modern Sculpture: Rodin, Degas,*
 Matisse, Brancusi, Picasso, Gonzalez. New York: Oxford
 University Press, 1974.

JEAN METZINGER (1883–1956)
The Harbor (Le Port), 1912
Oil on canvas; 33½ x 39½ in.
Signed lower right: "Metzinger"
1981.10

PROVENANCE
Nathan Cummings, Chicago

EXHIBITIONS
New York Graphic Society, Greenwich, Connecticut,
 December 19–29, 1967
Elvehjem Museum of Art, Madison, Wisconsin, September
 11–November 8, 1970, *Inaugural Exhibition: 19th and*
 20th Century Art from Collections of Alumni and Friends,
 no. 58
Art Institute of Chicago, October 20–December 9, 1973,
 Major Works from the Collection of Nathan Cummings,
 no. 49
David and Alfred Smart Gallery, University of Chicago,
 January 23–March 9, 1986, *Jean Metzinger in Retrospect*
 (not in catalogue)
Reynolda House Museum of American Art, Winston-
 Salem, North Carolina, September 9–December 25,
 1990, and Dixon Gallery and Gardens, Memphis,
 Tennessee, January 20–March 17, 1991, *An Impressionist*
 Legacy: The Collection of Sara Lee Corporation

REPRODUCTIONS
Major Works from the Collections of Nathan Cummings (exh.
 cat.). Chicago: Art Institute of Chicago, 1973, p. 58.
Consolidated Foods Corporation's Nathan Cummings Collection.
 (Chicago): Consolidated Foods Corporation, 1983, p. 23,
 fig. 18 (color).

SELECTED BIBLIOGRAPHY
Albert Gleizes and Jean Metzinger. *Cubism.* London:
 T. Fisher Unwin, 1913.
Jean Metzinger in Retrospect (exh. cat.). Iowa City: University
 of Iowa Museum of Art, 1985.
Metzinger: Pre-Cubist and Cubist Works. 1900-1930 (exh.
 cat.). Chicago: International Galleries, 1964.
Painters of the Section D'Or: The Alternatives to Cubism (exh.
 cat.). Buffalo, New York: Albright-Knox Art Gallery,
 1967.
Robert Rosenblum. *Cubism and Twentieth-Century Art.* New
 York: Harry N. Abrams, Inc., 1976.

HENRY MOORE (1898–1986)
Falling Warrior, 1956–57
Bronze; 3/10
Length 58 in.
LH 405
1989. 1

PROVENANCE
Marlborough Fine Art, London
Mr. and Mrs. Cooke, Wales
New Art Centre, London
Nathan Cummings owned a cast of this sculpture

EXHIBITIONS
National Museum of Wales, *Sculpture 1961,* and Swansea,
 Aberystwyth, and Bangor, 1961, no. 43
Reynolda House Museum of American Art, Winston-
 Salem, North Carolina, September 9–December 25,
 1990, and Dixon Gallery and Gardens, Memphis,
 Tennessee, January 20–March 17, 1991, *An Impressionist*
 Legacy: The Collection of Sara Lee Corporation

REPRODUCTIONS (of casts of this sculpture)
Will Grohmann. *The Art of Henry Moore.* London: Thames
 and Hudson, 1960, pls. 166–68.
Henry Moore: An Exhibition of Sculpture from 1950–1960 (exh.
 cat.). London: Whitechapel Art Gallery, 1960, cat. no.
 50.
Henry Moore (exh. cat.). Paris: Musée Rodin, 1961, pl. 30 (as
 Guerrier tombant).
Henry Moore (exh. cat.). New York: M. Knoedler and Co.;
 London: Marlborough Fine Art, 1962, n.p.
Robert Melville. "Moore at Lynn." *Architectural Review* 136
 (November 1964), p. 369.
Herbert Edward Read. *Henry Moore: A Study of His Life and*
 Work. London: Thames and Hudson, 1965, pl. 192.
John Hedgecoe, ed. *Henry Moore.* New York: Simon and
 Schuster, 1968, pp. 267–69.
Ionel Jianou. *Henry Moore.* Translated by Geoffrey Skelding.
 New York: Tudor Publishing Co., 1968, pl. 68.
John Russell. *Henry Moore.* London: Allan Lane, The
 Penguin Press, 1968, pl. 136.
David Sylvester. *Henry Moore* (exh. cat.). London: The Arts
 Council of Great Britain, 1968, pp. 133, 135, figs. 120,
 122, cat. no. 99.
Keith Roberts. "Current and Forthcoming Exhibitions:
 London." *Burlington Magazine* 110 (September 1968), p.
 528, fig. 52.
Robert Melville. *Henry Moore: Sculpture and Drawings*
 1921–1969. London: Thames and Hudson, 1970, figs.
 538–40.
Georgia Masson. "Moore in Florence." *Architectural Review*
 152 (August 1972), p. 126, fig. 4.
Giulio Carlo Argan. *Henry Moore.* Translated by Daniel
 Dichter. New York: Harry N. Abrams, Inc., 1973, pls.
 135–36.
Alan Bowness, ed. *Henry Moore: Sculpture and Drawings* (cat.
 raisonné), vol. 3. New York: George Wittenborn, Inc.,
 1977 (1st ed. London: Lund Humphries, 1965), pls.
 27–30, cat. no. 405.

David Mitchinson, ed. *Henry Moore Sculpture*. New York: Rizzoli, 1981, pp. 138–39, figs. 278–79.

Edward H. Teague. *Henry Moore: Bibliography and Reproductions Index*. Jefferson, North Carolina: McFarland & Company, Inc., 1981, p. 7.

William S. Lieberman. *Henry Moore: 60 Years of His Art* (exh. cat.). London: Thames and Hudson; New York: The Metropolitan Museum of Art, 1983, p. 84.

Henry Moore: The Reclining Figure (exh. cat.). Columbus, Ohio: Columbus Museum of Art, 1984, p. 143, fig. 33.

Susan Compton. *Henry Moore*. New York: Charles Scribner's Sons, 1988, p. 239, no. 138.

SELECTED BIBLIOGRAPHY

Alan Bowness. *Modern Sculpture*. London: Studio Vista, 1965.

Columbus Museum of Art. *Henry Moore: The Reclining Figure* (exh. cat.). Columbus, Ohio: Columbus Museum of Art, 1984.

Will Grohmann. *The Art of Henry Moore*. London: Thames and Hudson, 1960.

Herbert Edward Read. *Henry Moore: A Study of His Life and Work*. London: Thames and Hudson, 1965.

HENRY MOORE (1898–1986)
Moon Head, 1964
Bronze; 9/9 - LH 521
Height with base 22½ in.
1989.2

PROVENANCE
New Art Centre, London
Nathan Cummings owned a cast of this sculpture

EXHIBITIONS
Rijksmuseum Kröller-Müller, Otterlo, May 4–July 7, 1968, *Henry Moore*, cat. no. 116

Tate Gallery, London, July 17–September 22, 1968, *Henry Moore*

Forte di Belvedere, Florence, *Mostra de Henry Moore*, 1972

Palacio de Velazquez, Madrid, May–August 1981, *Henry Moore. Exposición Retrospectiva: Esculturas, Dibujos y Grabados 1921–1981*, cat. no. 42

National Gallery of Modern Art, New Delhi, October–November 1987

Reynolda House Museum of American Art, Winston-Salem, North Carolina, September 9–December 25, 1990, and Dixon Gallery and Gardens, Memphis, Tennessee, January 20–March 17, 1991, *An Impressionist Legacy: The Collection of Sara Lee Corporation*

REPRODUCTIONS (of casts of this sculpture)
Henry Moore (exh. cat.). Rome: Marlborough Galleria d'Arte, 1965, n.p.

Herbert Edward Read. *Henry Moore: A Study of His Life and Work*. London: Thames and Hudson, 1965, pl. 234.

Art Aujourd'hui 9 (July 1965), p. 59.

Domus 428 (July 1965), p. 54 (as *Testa lunare*).

John Hedgecoe, ed. *Henry Moore*. New York: Simon and Schuster, 1968, pp. 466–67.

Ionel Jianou. *Henry Moore*. Translated by Geoffrey Skelding. New York: Tudor Publishing Co., 1968, pls. 24–25.

Rijksmuseum Kröller-Müller, Otterlo. *Henry Moore* (exh. cat.). Hilverstrum, Netherlands: Steendrukkerij de Jong and Co., 1968, n.p., cat. no. 116.

John Russell. *Henry Moore*. London: Allan Lane, The Penguin Press, 1968, pls. 218–19.

Henry Moore: Carvings/Bronzes (exh. cat.). New York: M. Knoedler and Co., and Marlborough Gallery, Inc., 170, pp. 52–53.

Robert Melville. *Henry Moore: Sculpture and Drawings 1921–1969*. London: Thames and Hudson, 1970, figs. 683–85.

Selections from the Nathan Cummings Collection (exh. cat.). Washington, D.C.: National Gallery of Art, 1970, p. 90.

Alan Bowness, ed. *Henry Moore: Sculpture and Drawings* (cat. raisonné), vol. 4. London: Lund Humphries, 1977, p. 38, cat. no. 521.

Henry Moore: 80th Birthday Exhibition (exh. cat.). Bradford, England: City of Bradford Art Galleries and Museums, 1978, n.p., no. 37.

British Council, Fundación Henry Moore, and Ministerio de Cultura. *Henry Moore: Exposición Retrospectiva: Esculturas, Dibujos y Grabados 1921–1981* (exh. cat.). Madrid: Ministerio de Cultura, 1981, p. 177, fig. 177 (as *Cabeza de luna*).

David Mitchinson, ed. *Henry Moore Sculpture*. New York: Rizzoli, 1981, p. 177.

William S. Lieberman. *Henry Moore: 60 Years of His Art* (exh. cat.). London: Thames and Hudson; New York: The Metropolitan Museum of Art, 1983, p. 94.

SELECTED BIBLIOGRAPHY

Alan Bowness. *Modern Sculpture*. London: Studio Vista, 1965.

David Mitchinson, ed. *Henry Moore Sculpture*. New York: Rizzoli, 1981.

Herbert Edward Read. *Henry Moore: A Study of His Life and Work*. London: Thames and Hudson, 1965.

HENRY MOORE (1898–1986)
Upright Motive, 1955–56
Bronze, height 83 in.

PROVENANCE
Dominion Gallery, Montreal

REPRODUCTIONS
Will Grohmann. *The Art of Henry Moore*. London: Thames and Hudson, 1960, pl. 159.

Henry Moore (exh. cat.). New York: M. Knoedler and Co.; London: Marlborough Fine Art, 1962, pp. 18-19.

Henry Moore: A Retrospective Exhibition of Sculpture and Drawing (exh. cat.). Tucson: University of Arizona Art Gallery, 1965, n.p.

Ionel Jianou. *Henry Moore*. Translated by Geoffrey Skelding. New York: Tudor Publishing Co., 1968, pl. 48.

70 Years of Henry Moore (exh. cat.). Edited by David

Mitchinson. Otterlo: Rijksmuseum Kröller-Müller, 1968, no. 89.

Robert Melville. *Henry Moore: Sculpture and Drawings 1921–1969.* London: Thames and Hudson, 1970, fig. 506.

Henry J. Seldis. *Henry Moore in America* (exh. cat.). New York: Praeger Publishers in association with the Los Angeles County Museum of Art, 1973, p. 150.

Alan Bowness ed. *Henry Moore: Sculpture and Drawings* (cat. raisonné). Vol. 3. New York: George Wittenborn, Inc., 1977 (1st ed. London: Lund Humphries, 1965), pls. 23-24, cat. no. 388.

David Mitchinson ed. *Henry Moore Sculpture.* Introduction by Franco Russoli. New York: Rizzoli International Publications, 1981, p. 135, fig. 271.

Edward H. Teague. *Henry Moore: Bibliography and Reproductions Index.* Jefferson, North Carolina: McFarland & Company, Inc., 1981, pl. 6.

SELECTED BIBLIOGRAPHY

Giulio Carlo Argan. *Henry Moore.* Translated by Daniel Dichter. New York: Harry N. Abrams, Inc., 1971.

Art Gallery of Ontario. *The Moore Collection in the Art Gallery of Ontario.* Text by Alan G. Wilkinson. Toronto: The Art Gallery of Ontario, 1979.

David Finn. *Henry Moore: Sculpture and Environment.* Foreword by Kenneth Clark. Commentaries by Henry Moore. New York: Harry N. Abrams, Inc., 1976.

Robert Melville. *Henry Moore: Sculpture and Drawings 1921–1969.* New York: Harry N. Abrams, Inc., 1970.

Henry Moore. *Henry Moore on Sculpture: A Collection of the Sculptor's Writings and Spoken Words.* Edited with an introduction by Philip James. New York: Viking Press, 1971.

Herbert Edward Read. *Henry Moore: A Study of His Life and Work.* New York: Praeger Publishers, 1966.

John Russell. *Henry Moore.* London: Allan Lane, The Penguin Press, 1968.

Henry J. Seldis. *Henry Moore in America.* New York: Praeger Publishers, 1973.

James Johnson Sweeney. *Henry Moore.* New York: The Museum of Modern Art, 1947.

Anthony David Bernard Sylvester. *Henry Moore.* New York: Praeger Publishers, 1968.

BERTHE MORISOT (1841–1895)

Young Woman in a Garden (Jeune fille dans un jardin), 1883

Oil on canvas; 48½ x 37 in.
Angoulvent 155, Bataille-Wildenstein 14
1983.1

PROVENANCE

Ernst Rouart and Julie Morisot Rouart, Paris
Denis Rouart, Paris
Nathan Cummings, New York
Mrs. Robert B. Mayer with her son Robert N. Mayer and her daughter Ruth M. Durchslag, Chicago

EXHIBITIONS

Dowdeswell and Dowdeswell, London, 1883, Impressionist exhibition organized by Durand-Ruel

Galerie Durand-Ruel, Paris, March 5–21, 1896, *Berthe Morisot (Madame Eugène Manet): Exposition de son oeuvre,* no. 1

Salon d'Automne, Paris, 1907, no. 1

Bernheim-Jeune, Paris, November 7–22, 1919, *Cent oeuvres de Berthe Morisot (1841–1895),* no. 21

Galerie Marcel Bernheim, Paris, June 20–July 8, 1922, *Réunion d'oeuvres, par Berthe Morisot,* no. 1

Bernheim-Jeune, Paris, May 6–24, 1929, *Exposition d'oeuvres de Berthe Morisot,* no. 1

Musée de l'Orangerie, Paris, 1941, *Exposition Berthe Morisot,* no. 43

Ny Carlsberg Glyptotek, Copenhagen, August 20–September 18, 1949, *Berthe Morisot: Malerier, Akvareller og Tegningen,* no. 24

The Arts Council of Great Britain, London, 1950, *Berthe Morisot: An Exhibition of Paintings and Drawings,* no. 27

Art Gallery of Toronto; The Metropolitan Museum of Art, New York; Toledo Museum of Art; The Phillips Collection, Washington, D.C.; California Palace of the Legion of Honor, San Francisco; Portland Museum of Art, Portland, Oregon, September 1952–October 1954, *Berthe Morisot and Her Circle—Paintings from the Rouart Collection* (exhibited as *The Garden*), no. 5

Musée des Arts Décoratifs, Paris, March–May 1956, *Collection Nathan Cummings d'Art Ancien du Perou et Peintures Françaises XIXe et XXe Siècle*

National Gallery of Art, Washington, D.C., June 28–September 11, 1970, and The Metropolitan Museum of Art, New York, July 1–September 7, 1971, *Selections from the Nathan Cummings Collection,* no. 15

Art Institute of Chicago, October 20–December 9, 1973, *Major Works from the Collection of Nathan Cummings* (exhibited as *In the Garden*), no. 12

National Gallery of Art, Washington, D.C., September 6–November 29, 1987; Kimbell Art Museum, Fort Worth, Texas, December 14, 1987–February 22, 1988, and Mount Holyoke College Art Museum, South Hadley, Massachusetts, March 14–May 9, 1988, *Berthe Morisot, Impressionist,* no. 45

Reynolda House Museum of American Art, Winston-Salem, North Carolina, September 9–December 25, 1990, and Dixon Gallery and Gardens, Memphis, Tennessee, January 20–March 17, 1991, *An Impressionist Legacy: The Collection of Sara Lee Corporation*

REPRODUCTIONS

Monique Angoulvent. *Berthe Morisot.* Paris: Editions Albert Morancé, 1933, pl. 54.

Berthe Morisot and Her Circle—Paintings from the Rouart Collection (exh. cat.). Toronto: Art Gallery of Toronto, 1952, n.p.

Marie-Louise Bataille and Georges Wildenstein. *Berthe Morisot: Catalogue des peintures, pastels et aquarelles.* Paris: Les Beaux-Arts, 1961, pl. 54.

Selections from the Nathan Cummings Collection (exh. cat.). Washington, D.C.: National Gallery of Art, 1970, p. 28.

Major Works from the Nathan Cummings Collection (exh. cat.).

Chicago: Art Institute of Chicago, 1973, p. 21 (color).
Consolidated Foods Corporation's Nathan Cummings Collection.
(Chicago): Consolidated Foods Corporation, 1983, p. 12,
fig. 7 (color).
Charles F. Stuckey and William P. Scott. *Berthe Morisot,*
Impressionist (exh. cat.). New York: Hudson Hills Press in
association with Mount Holyoke College Art Museum
and the National Gallery of Art, 1987, p. 96, cat. no. 45
(color).

SELECTED BIBLIOGRAPHY
Monique Angoulvent. *Berthe Morisot.* Paris: Editions Albert
Morancé, 1933.
Marie-Louise Bataille and Georges Wildenstein. *Berthe*
Morisot: Catalogue des peintures, pastels et aquarelles. Paris:
Les Beaux-Arts, 1961.
Berthe Morisot: Drawings, Pastels, Watercolors, Paintings (exh.
cat.). Introduction by Elizabeth Mongan, preface by
Denis Rouart. New York: Tudor Publishing Company,
1960.
Berthe Morisot. *The Correspondence of Berthe Morisot, with Her*
Family and Her Friends. Edited by Denis Rouart,
translated by Betty W. Hubbard. London: Lund
Humphries, 1957.

PABLO PICASSO (1881–1973)
Female Torso (Torse de femme), 1908
Gouache on paper; 24⅜ x 18¾ in.
Signed upper right
Zervos II.57
1988.2

PROVENANCE
Galerie Kahnweiler, Paris
Joseph Muller, Soleure
Galerie de Berri, Paris
Nathan Cummings, New York
Sotheby's, New York

EXHIBITIONS
Galerie de Berri, Paris, 1951
National Museum of Modern Art, Tokyo, May 23–July 5,
1964; National Museum of Modern Art, Kyoto, July
10–August 2, 1964; and Prefectural Museum of Art,
Nagoya, August 7–18, 1964, *Pablo Picasso*
Exhibition/Japan, no. 10
Minneapolis Institute of Arts, January 14–March 7, 1965,
Paintings from the Cummings Collection (exhibited as *Torse*
d'une jeune fille)
Tel Aviv Museum, 1966, *Pablo Picasso,* no. 7
National Gallery of Art, Washington, D.C., June
28–September 11, 1970, and The Metropolitan
Museum of Art, New York, July l–September 7, 1971,
Selections from the Nathan Cummings Collection (exhibited
as *Torso of a Young Girl*), no. 38
Art Institute of Chicago, October 20–December 9, 1973,
Major Works from the Collection of Nathan Cummings
(exhibited as *Portrait of a Young Person*), no. 45
Seibu Bijutsukan, Tokyo; Navio Gallery, Osaka; Kyoto

Shimbun Gallery; Takashimaya Art Gallery, Yokohama;
Ishibashi Museum, Kurume; National Museum of Art,
Seoul; Niigata Daiei Art Gallery, Niigata; Toden Seibu
Gallery, Koochi; Onomichi City Museum, Onomichi;
Hong Kong Museum of Art, 1982–83, *Picasso intime,*
no. 69
Reynolda House Museum of American Art, Winston-
Salem, North Carolina, September 9–December
25,1990, and Dixon Gallery and Gardens, Memphis,
Tennessee, January 20–March 17, 1991, *An Impressionist*
Legacy: The Collection of Sara Lee Corporation

REPRODUCTIONS
Pablo Picasso Exhibition/Japan (exh. cat.). Tokyo: National
Museum of Modern Art, 1964, p. 37.
Pablo Picasso (exh. cat.). Tel Aviv: Tel Aviv Museum, 1966.
Christian Zervos. *Pablo Picasso,* vol. 2. Paris: Editions
Cahiers d'Art, 1967 .
Selections from the Nathan Cummings Collection (exh. cat.).
Washington, D.C.: National Gallery of Art, 1970, p. 52.
Franco Russoli and Fiorella Minervino. *L'Opera completa di*
Picasso cubista. Milan: Rizzoli Editore, 1972, p. 93.
Major Works from the Nathan Cummings Collection (exh. cat.).
Chicago: Art Institute of Chicago, 1973, p. 54.
Pierre Daix and Joan Rosselet. *Picasso: The Cubist Years,*
1907–1916. Translated by Dorothy S. Blair. London:
Thames and Hudson, 1979, p. 211.
Picasso intime (exh. cat.). Tokyo: Seibu Bijutsukan, 1982
(color).

SELECTED BIBLIOGRAPHY
Pierre Daix and Joan Rosselet. *Picasso: The Cubist Years,*
1907–1916. Translated by Dorothy S. Blair. London:
Thames and Hudson, 1979.
Edward Fry. *Cubism.* New York: Oxford University Press,
1966.
William Rubin. "Picasso." In *"Primitivism" in 20th Century*
Art: Affinity of the Tribal and the Modern (exh. cat.),
vol. 1. New York: The Museum of Modern Art, 1984,
pp. 240–343.
_____, ed. *Pablo Picasso: A Retrospective* (exh. cat.). New
York: The Museum of Modern Art, 1980.
Leo Steinberg. "The Polemical Part." In *Art in America,*
vol. 67, March/April 1979, pp. 114–27.
_____. "Resisting Cezanne: Picasso's 'Three Women.'" In
Art in America, vol. 66, November/December 1978,
pp. 114–33.

CAMILLE PISSARRO (1830–1903)
Bountiful Harvest (Belle Moisson), 1893
(also known as *La Mietitura* and *The Hayrakers*)
Oil on canvas; 17¼ x 21¼ in.
Signed, dated lower right: "C. Pissarro .93" (does not
appear in Pissarro-Venturi)
1980.2

PROVENANCE
Nathan Cummings, Chicago
Alan H. Cummings, Palm Beach

EXHIBITIONS

Musée des Arts Décoratifs, Paris, March–May 1956,
 *Collection Nathan Cummings d'Art Ancien du Perou et
 Peintures Françaises XIXe et XXe Siècle,* no. 1
The Joe and Emily Lowe Art Gallery of the University of
 Miami, Coral Gables, Florida, February 8–March 10,
 1963, *Renoir to Picasso 1914,* no. 29
Reynolda House Museum of American Art, Winston-
 Salem, North Carolina, September–December 25, 1990,
 and Dixon Gallery and Gardens, Memphis, Tennessee,
 January 20—March 17, 1991, *An Impressionist Legacy:
 The Collection of Sara Lee Corporation*

REPRODUCTIONS

*Collection Nathan Cummings d'Art Ancien du Perou et Peintures
 Françaises XIXe et XXe Siècle* (exh. cat.). Paris: Musée des
 Arts Décoratifs, 1956, n.p.
Renoir to Picasso 1914 (exh. cat.). Coral Gables, Florida: The
 Joe and Emily Lowe Art Gallery of the University of
 Miami, 1963, p. 31.
Consolidated Foods Corporation's Nathan Cummings Collection.
 (Chicago): Consolidated Foods Corporation, 1983, p. 9,
 fig. 3 (color).

SELECTED BIBLIOGRAPHY

See entry for Camille Pissarro, *Vase of Flowers,* 1878

CAMILLE PISSARRO (1830–1903)

*Vase of Flowers (Bouquet de fleurs—Pivoines et
 seringas),* 1878
Oil on canvas; 32 x 25½ in.
Pissarro-Venturi 467
1981.22

PROVENANCE

Ludovic Rodo Pissarro, Rouen
Richard Semmel, New York
Sam Salz, New York
Nathan Cummings, New York
Mrs. Robert B. Mayer, Chicago

EXHIBITIONS

Galerie Durand-Ruel, Paris, February–March 1898,
 C. Pissarro
Musée de l'Orangerie, Paris, February-March 1930,
 Centenaire de la naissance de Camille Pissarro, no. 138
Galerie Charpentier, Paris, 1946, *Tableaux de la vie silencieuse*
Art Gallery of Toronto, September 10–October 16, 1955,
 *Nathan Cummings Collection of Ancient Peruvian Art and
 XIX and XX Century French Painting*
Minneapolis Institute of Arts, January 14–March 7, 1965,
 Paintings from the Cummings Collection
Davenport Municipal Art Gallery, Davenport, Iowa, March
 21–April 11, 1965, *Collection of Masterpieces Courtesy of
 Mr. and Mrs. Nathan Cummings*
Lyman Allyn Museum, New London, Connecticut, January
 19–February 18, 1968, *Paintings and Sculpture from the
 Collection of Mr. and Mrs. Nathan Cummings*

National Gallery of Art, Washington, D.C., June
 28–September 11, 1970, and The Metropolitan
 Museum of Art, New York, July 1–September 7, 1971,
 Selections from the Nathan Cummings Collection, no. 4
Reynolda House Museum of American Art, Winston-
 Salem, North Carolina, September 9–December 25,
 1990, and Dixon Gallery and Gardens, Memphis,
 Tennessee, January 20–March 17, 1991, *An Impressionist
 Legacy: The Collection of Sara Lee Corporation*

REPRODUCTIONS

Ludovic Rodo Pissarro and Lionello Venturi. *Camille
 Pissarro: Son art, son oeuvre,* vol. 2. Paris: Paul Rosenberg,
 1939, pl. 95.
Paintings from the Cummings Collection (exh. cat.).
 Minneapolis: Minneapolis Institute of Arts, 1965, cover.
Selections from the Nathan Cummings Collection (exh. cat.).
 Washington, D.C.: National Gallery of Art, 1970, p. 16.
Consolidated Foods Corporation's Nathan Cummings Collection.
 (Chicago): Consolidated Foods Corporation, 1983, p. 8,
 fig. 2.

SELECTED BIBLIOGRAPHY

Kathleen Adler. *Camille Pissarro—A Biography.* New York:
 St. Martin's Press, 1977.
Camille Pissarro: Letters to His Son Lucien. Edited by John
 Rewald and Lucien Pissarro. Mamaroneck, New York:
 Peregrine Smith, Inc., 1972.
Christopher Lloyd. *Camille Pissarro.* New York: Rizzoli,
 1981.
Pissarro (exh. cat.). London: The Arts Council of Great
 Britain, 1981.
John Rewald. *Camille Pissarro.* New York: Harry N.
 Abrams, Inc., 1963.
Ralph E. Shikes and Paula Harper. *Pissarro: His Life and
 Work.* New York: Horizon Press, 1980.

CAMILLE PISSARRO (1830–1903)

*Young Woman Bathing Her Feet in a Brook (Le
 Bain de pieds),* 1895
Oil on canvas; 28¾ x 36½ in.
Signed and dated lower left: "C. Pissarro 1895"
Pissarro-Venturi 903
1980.3

PROVENANCE

Albert Pontremoli, Paris
Dr. Janos Plesch, Berlin
Paul Rosenberg and Company, New York
Mrs. John Astor, New York
E. and A. Silberman Gallery, New York
Nathan Cummings, Chicago

EXHIBITIONS

Galerie Durand-Ruel, Paris, April 7–30,1904, *L'Oeuvre de
 C. Pissarro* (exhibited as *Femme au bord de l'eau*), no. 93
E. and A. Silberman Gallery, New York, April–May 1955
Art Institute of Chicago, April 15–May 7, 1961, *Treasures of
 Chicago Collectors* (exhibited as *Girl Beside a Stream*)

Institute of Fine Arts, Paris, 1962
Wildenstein Gallery, New York, April 1962
Brandeis University, Waltham, Massachusetts, May
 10–June 13, 1962
Union of American Hebrew Congregations, Chicago,
 November 16–21, 1963
Minneapolis Institute of Arts, January 14–March 7, 1965,
 Paintings from the Cummings Collection
Lyman Allyn Museum, New London, Connecticut, January
 19–February 18, 1968, *Paintings and Sculpture from the
 Collection of Mr. and Mrs. Nathan Cummings*
Reynolda House Museum of American Art, Winston-
 Salem, North Carolina, September 9–December 25,
 1990, and Dixon Gallery and Gardens, Memphis,
 Tennessee, January 20–March 17, 1991, *An Impressionist
 Legacy: The Collection of Sara Lee Corporation*

REPRODUCTIONS

Catalogue de l'exposition de l'oeuvre de Camille Pissarro (exh.
 cat.). Paris: Galerie Durand-Ruel, 1904, p. 18.
Ludovic Rodo Pissarro and Lionello Venturi. *Camille
 Pissarro: Son art, son oeuvre,* vol. 2. Paris: Paul Rosenberg,
 1939, pl. 183.
*Catalogue des tableaux modernes . . . aquarelles, dessins, sculptures
 (156) numeros, composant la collection Albert Pontremoli,* sale
 of June 11, 1924, lot no. 136.
Christopher Lloyd. *Camille Pissarro.* New York: Rizzoli,
 1981, p. 119 and dustcover (color).
Consolidated Foods Corporation's Nathan Cummings Collection.
 (Chicago): Consolidated Foods Corporation, 1983, p. 7,
 fig. 1 (color).

SELECTED BIBLIOGRAPHY

See entry for Camille Pissarro, *Vase of Flowers,* 1878

CAMILLE PISSARRO (1830–1903)

*Young Woman Tending Cows, Eragny (Gardeuse de
 Vaches, Eragny),* 1887
Gouache on paper; 20½ x 24¾ in.
Pissarro-Venturi 1416
1984.10

PROVENANCE

Galerie Durand-Ruel, Paris
Sam Salz, New York
Nathan Cummings, Chicago

EXHIBITIONS

Galerie Durand-Ruel, Paris, 1892
Galerie Durand-Ruel, Paris, March 1894, *Exposition Camille
 Pissarro, Tableaux, Aquarelles, Pastels, Gouaches,* no. 84
Galerie Durand-Ruel, Paris, 1922
Galerie Durand-Ruel, Paris, February–March 1928, *Camille
 Pissarro,* no. 122
Durand-Ruel Galleries, New York, n.d., *Camille Pissarro in
 Retrospect,* no. 14
Art Institute of Chicago, October 20–December 9, 1973,
 Major Works from the Collection of Nathan Cummings,
 no. 14

Reynolda House Museum of American Art, Winston-
 Salem, North Carolina, September 9–December 25,
 1990, and Dixon Gallery and Gardens, Memphis,
 Tennessee, January 20–March 17, 1991, *An Impressionist
 Legacy: The Collection of Sara Lee Corporation*

REPRODUCTIONS

Ludovic Rodo Pissarro and Lionello Venturi. *Camille
 Pissarro: Son art, son oeuvre,* vol. 2. Paris: Paul Rosenberg,
 1939, pl. 276.
Major Works from the Collection of Nathan Cummings (exh.
 cat.). Chicago: Art Institute of Chicago, 1973, p. 22.

SELECTED BIBLIOGRAPHY

See entry for Camille Pissarro, *Vase of Flowers,* 1878

PIERRE AUGUSTE RENOIR (1841–1919)

The Laundress, 1916
Bronze; height 10⅝ in.
The Blacksmith (Le Forgeron {Le Feu}), 1916
Bronze, 11 in.

PROVENANCE

Private collection, Canada
Parke-Bernet Galleries, Inc., New York
Nathan Cummings, Chicago

EXHIBITIONS

Parke-Bernet Galleries, Inc., New York, January 21–25,
 1961, *Paintings and Drawings, Modernist Sculptures,* lot
 no. 39
National Gallery of Art, Washington, D.C., June 28–
 September 11, 1970, and The Metropolitan Museum of
 Art, New York, July 1–September 7, 1971, *Selections
 from the Nathan Cummings Collection,* no. 63
Reynolda House Museum of American Art, Winston-
 Salem, North Carolina, September 9–December 25,
 1990, and Dixon Gallery and Gardens, Memphis,
 Tennessee, January 20–March 17, 1991, *An Impressionist
 Legacy: The Collection of Sara Lee Corporation*

REPRODUCTIONS

Paintings and Drawings, Modernist Sculptures (sale cat.). New
 York: Parke-Bernet Galleries, 1961, p. 26.
Renoir Peintre et Sculpteur (exh. cat.). Marseilles: Musée
 Cantini, 1963, n.p., fig. 67.
Selections from the Nathan Cummings Collection (exh. cat.).
 Washington, D.C.: National Gallery of Art, 1970, p. 80.

SELECTED BIBLIOGRAPHY

W. George. "L'oeuvre sculpté de Renoir." In *L'Amour de
 l'Art,* November 1924.
Richard Guino. *Sculptures et dessins: Pierre Auguste Renoir.*
 Nice: Imprimix, 1974.
P. Haesaerts. *Renoir Sculpteur.* Belgium, n.d.
Los Angeles County Museum of Art and San Francisco
 Museum of Art. *Pierre Auguste Renoir: Paintings,
 Drawings, Prints, and Sculpture.* Texts by G. L. McCann
 Morley, Jean Renoir, R. F. Brown. Los Angeles and San
 Francisco, 1955.

Musée Cantini. *Renoir: Peintre et sculpteur.* Marseilles, 1963.
Charles E. Slatkin Galleries, New York. *Renoir-Degas: Drawings, Pastels, Sculptures.* Foreword by V. Price. New York, 1958.

GEORGES ROUAULT (1871–1958)
The Circus (Le Cirque), 1936
Oil on canvas; 27½ x 42¼ in.
Signed center right: "G. Rouault"
1984.11

PROVENANCE
Ambroise Vollard, Paris
Mme. Seifert, Paris
Galerie Charpentier, Paris
Daniel Varenne, Paris
Nathan Cummings, Chicago

EXHIBITIONS
Galerie Charpentier, Paris, 1965, *Rouault: Peintures inconnus ou célèbres*
Lyman Allyn Museum, New London, Connecticut, January 19–February 18, 1968, *Paintings and Sculpture from the Collection of Mr. and Mrs. Nathan Cummings*
National Gallery of Art, Washington, D.C., June 28–September 11, 1970, and The Metropolitan Museum of Art, New York, July 1–September 7, 1971, *Selections from the Nathan Cummings Collection,* no. 36
Art Institute of Chicago, October 20–December 9, 1973, *Major Works from the Collection of Nathan Cummings,* no. 33
Reynolda House Museum of American Art, Winston-Salem, North Carolina, September 9–December 25,1990, and Dixon Gallery and Gardens, Memphis, Tennessee, January 20–March 17, 1991, *An Impressionist Legacy: The Collection of Sara Lee Corporation*

REPRODUCTIONS
Selections from the Nathan Cummings Collection (exh. cat.). Washington, D.C.: National Gallery of Art, 1970, p. 50.
Major Works from the Collection of Nathan Cummings (exh. cat.). Chicago: Art Institute of Chicago, 1973, p. 42.

SELECTED BIBLIOGRAPHY
Pierre Courthion. *Georges Rouault.* New York: Harry N. Abrams, Inc., 1961.
Bernard Dorival. *Rouault.* Paris: Editions Universitaire, 1963.
James Thrall Soby. *Georges Rouault: Paintings and Prints* (exh. cat.). New York: The Museum of Modern Art, 1945.
Lionello Venturi. *Rouault.* Geneva: Skira, 1959.

GEORGES ROUAULT (1871–1958)
Pierrot, ca. 1937–38
Oil on canvas; 35 x 24½ in.
Signed lower right: "G Rouault"
Courthion 293
1983.2

PROVENANCE
Ambroise Vollard, Paris
De Gallea, Paris
Nathan Cummings, New York
Mrs. Robert B. Mayer with her son Robert N. Mayer and her daughter Ruth M. Durchslag, Chicago

EXHIBITIONS
M. H. de Young Memorial Museum, San Francisco, 1953, *The Nathan Cummings Collection*
Art Gallery of Toronto, September 10–October 16, 1955, and Musée des Arts Décoratifs, Paris, March–May 1956, *Collection Nathan Cummings d'art ancien du Perou et Peintures Françaises XIXe et XXe Siècle,* no. 21
New Brunswick Museum, St. John, Canada, April 22–May 21, 1958
Minneapolis Institute of Arts, January 14–March 7, 1965, *Paintings from the Cummings Collection*
Davenport Municipal Art Gallery, Davenport, Iowa, March 21–April 11, 1965, *Collection of Masterpieces—Courtesy of Mr. and Mrs. Nathan Cummings*
American Embassy, Paris, 1968, *Art in Embassies* (organized by the Museum of Modern Art, New York)
Lyman Allyn Museum, New London, Connecticut, January 19–February 18, 1968, *Paintings and Sculpture from the Collection of Mr. and Mrs. Nathan Cummings*
Palais Galliéra, Paris, September 1969
National Gallery of Art, Washington, D.C., June 28–September 11, 1970, and The Metropolitan Museum of Art, New York, July 1–September 7, 1971, *Selections from the Nathan Cummings Collection,* no. 35
Art Institute of Chicago, October 20–December 9, 1973, *Major Works from the Collection of Nathan Cummings,* no. 35
Reynolda House Museum of American Art, Winston-Salem, North Carolina, September 9–December 25, 1990, and Dixon Gallery and Gardens, Memphis, Tennessee, January 20–March 17, 1991, *An Impressionist Legacy: The Collection of Sara Lee Corporation*

REPRODUCTIONS
Collection Nathan Cummings d'art ancien du Perou et Peintures Françaises XIXe et XXe Siècle (exh. cat.). Paris: Musée des Arts Décoratifs, 1956, n.p.
Pierre Courthion. *Georges Rouault.* New York: Harry N. Abrams, Inc., 1961, p. 432.
Collection of Masterpieces—Courtesy of Mr. and Mrs. Nathan Cummings (exh. cat.). Davenport, Iowa: Davenport Municipal Art Gallery, 1965, cover.
Paintings and Sculpture from the Collection of Mr. and Mrs. Nathan Cummings (exh. cat.). New London, Connecticut: Lyman Allyn Museum, 1968, n.p.
Selections from the Nathan Cummings Collection (exh. cat.). Washington, D.C.: National Gallery of Art, 1970, p. 49.
Major Works from the Collection of Nathan Cummings (exh. cat.). Chicago: Art Institute of Chicago, 1973, p. 43.
Consolidated Foods Corporation's Nathan Cummings Collection. (Chicago): Consolidated Foods Corporation, 1983, p. 11, fig. 5 (color).

SELECTED BIBLIOGRAPHY
See entry for Georges Rouault, *The Circus,* 1936

ALFRED SISLEY (1839–1899)

Saintes-Mammès—Morning (Saintes-Mammès—le matin), ca. 1884
Oil on canvas; 25 x 34½ in.
Signed lower right: "Sisley"
Daulte 369
1984.12

PROVENANCE
Durand-Ruel, Paris
MM. Boussod, Valadon and Company, Paris
Colonel Henry B. Wilson, New York
Mrs. Winifred C. Bowman, New York
Parke-Bernet, New York
French and Co., New York
Nathan Cummings, Chicago

EXHIBITIONS
Galerie Georges Petit, Paris, February 1897, *Exposition A. Sisley,* no. 51
On loan to President Dwight D. Eisenhower, 1953
Montreal Museum of Fine Arts, November 1955
New Brunswick Museum, St. John, Canada, April 24–May 31, 1958
Columbia Museum of Art, Columbia, South Carolina, April 3–May 8, 1960, *Impressionism: An Exhibition Commemorative of the Tenth Anniversary of the Columbia Museum of Art,* no. 28
Paul Rosenberg and Company, New York, *Loan Exhibition of Paintings by Alfred Sisley,* October 30–November 25, 1961, no. 15
Minneapolis Institute of Arts, January 14–March 7, 1965, *Paintings from the Cummings Collection*
Wildenstein and Co., New York, October 27–December 3, 1966, *Sisley,* no. 41
Lyman Allyn Museum, New London, Connecticut, January 19–February 18, 1968, *Paintings and Sculpture from the Collection of Mr. and Mrs. Nathan Cummings*
Art Institute of Chicago, July 12–August 31, 1969, *Masterpieces from Private Collections in Chicago*
Art Institute of Chicago, October 20–December 9, 1973, *Major Works from the Collection of Nathan Cummings* (exhibited as *St. Mannes* [sic], *Morning*), no. 16
Reynolda House Museum of American Art, Winston-Salem, North Carolina, September 9–December 25,1990, and Dixon Gallery and Gardens, Memphis, Tennessee, January 20–March 17, 1991, *An Impressionist Legacy: The Collection of Sara Lee Corporation*

REPRODUCTIONS
François Daulte. *Alfred Sisley: Catalogue raisonné de l'oeuvre peint.* Paris: Editions Durand-Ruel, 1959, n.p., no. 369.
Impressionism: An Exhibition Commemorative of the Tenth Anniversary of the Columbia Museum of Art (exh. cat.). Columbia, South Carolina: Columbia Museum of Art, 1960, n.p.
Paul Rosenberg and Company. *Loan Exhibition of Paintings by Alfred Sisley* (exh. cat.). New York: Paul Rosenberg and Company, 1961, p. 12.
Wildenstein and Co. *Sisley* (exh. cat.). New York: Wildenstein and Co., 1966, n.p., no. 41 (color).
Major Works from the Collection of Nathan Cummings (exh. cat.). Chicago: Art Institute of Chicago, 1973, p. 25 (color).

SELECTED BIBLIOGRAPHY
Raymond Cogniat. *Sisley.* Paris: Flammarion, 1978.
François Daulte. *Alfred Sisley: Catalogue raisonné de l'oeuvre peint.* Paris: Editions Durand-Ruel, 1959.
A Day in the Country: Impressionism and the French Landscape (exh. cat.). Los Angeles: Los Angeles County Museum of Art, 1984.
Jacques Lassaigne and Sylvie Gache-Patin. *Sisley.* Paris: Nouvelles Editions Françaises, 1983.

ALFRED SISLEY (1839–1899)

A Path at Les Sablons (Un Sentier aux Sablons), ca. 1883
Oil on canvas; 18¼ x 22 in.
Signed bottom right: "Sisley"
Daulte 492
1990.1

PROVENANCE
Lucienne Fribourg, New York and Paris
Parke-Bernet, New York
Justin K. Thannhauser, Munich and New York
Nathan Cummings, New York
Christie's, New York

EXHIBITIONS
Wildenstein and Co., New York, October 27–December 3, 1966, *Sisley,* no. 49
Reynolda House Museum of American Art, Winston-Salem, North Carolina, September 9–December 25, 1990, and Dixon Gallery and Gardens, Memphis, Tennessee, January 20–March 17, 1991, *An Impressionist Legacy: The Collection of Sara Lee Corporation*

REPRODUCTIONS
François Daulte. *Alfred Sisley: Catalogue raisonné de l'oeuvre peint.* Paris: Editions Durand-Ruel, 1959, n.p., no. 492.
Wildenstein and Co. *Sisley* (exh. cat.). New York: Wildenstein and Co., 1966, n.p., no. 49.

SELECTED BIBLIOGRAPHY
See entry for Alfred Sisley, *Saintes-Mammès—Morning,* ca. 1884

CHAIM SOUTINE (1893–1943)

View of Céret (Vue de Céret), ca. 1919–20
Oil on canvas; 20½ x 28¼ in.
Signed lower right: "Soutine"
1981.11

PROVENANCE
Kunstmuseum, Lucerne
Perls Galleries, New York

Glenway Wescott, New York
Barnes Collection, Merion Station, Pennsylvania
Parke-Bernet, New York
Nathan Cummings, Chicago

EXHIBITIONS

The Museum of Modern Art, New York, October 31,
1950–January 7, 1951, and The Cleveland Museum of
Art, January 30–March 18, 1951, *Soutine*
Los Angeles County Museum of Art, February 20–April 14,
1968, and The Israel Museum, Jerusalem, 1968, *Chaim
Soutine 1893–1943*, no. 12
National Gallery of Art, Washington, D.C., June
28–September 11, 1970, and The Metropolitan
Museum of Art, New York, July 1–September 7, 1971,
Selections from the Nathan Cummings Collection (exhibited
as *Landscape at Céret*), no. 58
Art Institute of Chicago, October 20–December 9, 1973,
Major Works from the Collection of Nathan Cummings
(exhibited as *Landscape at Céret*), no. 37
The Jewish Museum, New York, September 2, 1975–
January 25, 1976
Reynolda House Museum of American Art, Winston-
Salem, North Carolina, September 9–December 25,
1990, and Dixon Gallery and Gardens, Memphis,
Tennessee, January 20–March 17, 1991, *An Impressionist
Legacy: The Collection of Sara Lee Corporation*
Odakyu Grand Gallery, Tokyo, November 18–December 7,
1992; Nara Sogo Museum of Art, January 27–February
28, 1993; Kasama Nichido Museum of Art, Ibaraki,
March 5–April 4, 1993; Hokkaido Museum of Modern
Art, April 10–May 16, 1993, *Chaim Soutine Centenary
Exhibition*

REPRODUCTIONS

Monroe Wheeler. *Soutine* (exh. cat.). New York: The
Museum of Modern Art, 1950, p. 43.
Maurice Tuchman. *Chaim Soutine 1893–1943* (exh. cat.).
Los Angeles: Los Angeles County Museum of Art, 1968,
p. 24 and pl.12.
Selections from the Nathan Cummings Collection (exh. cat.).
Washington, D.C.: National Gallery of Art, 1970, p. 74.
Major Works from the Collection of Nathan Cummings (exh.
cat.). Chicago: Art Institute of Chicago, 1973, p. 46.
Alfred Werner. *Chaim Soutine.* New York: Harry N.
Abrams, Inc., 1977, p. 15.
C. Soutine: 1893–1943. Edited by Ernst-Gerhard Guse.
London: The Arts Council of Great Britain, 1981, p. 56.
Consolidated Foods Corporation's Nathan Cummings Collection.
(Chicago): Consolidated Foods Corporation, 1983, p. 12,
fig. 6 (color).
Chaim Soutine Centenary Exhibition (exh. cat.). Odakyu
Grand Gallery, Tokyo, November 18–December 7,
1992; Nara Sogo Museum of Art, January 27–February
28, 1993; Kasama Nichido Museum of Art, Ibaraki,
March 5–April 4, 1993; Hokkaido Museum of Modern
Art, April 10–May 16, 1993, p. 58.

SELECTED BIBLIOGRAPHY

C. Soutine: 1893–1943. Edited by Ernst-Gerhard Guse.
London: The Arts Council of Great Britain, 1981.

Andrew Forge. *Soutine.* London: Spring Books, 1965.
Maurice Tuchman. *Chaim Soutine 1893–1943* (exh. cat.).
Los Angeles: Los Angeles County Museum of Art, 1968.
Alfred Werner. *Chaim Soutine.* New York: Harry N.
Abrams, Inc., 1977.
Monroe Wheeler. *Soutine* (exh. cat.). New York: The
Museum of Modern Art, 1950.

CHAIM SOUTINE (1893–1943)

Valet (Le Valet de Chambre), 1928
Oil on canvas; 25⅛ x 19⅝ in.
Signed upper right: "Soutine"
1991.2

PROVENANCE

Nathan Cummings, Chicago
Mrs. Robert B. Mayer, Chicago

EXHIBITIONS

Los Angeles County Museum of Art, February 20–April 14,
1968, *Chaim Soutine 1893–1943,* no. 52
National Gallery of Art, Washington, D.C., June 28–
September 11, 1970, and The Metropolitan Museum of
Art, New York, July 1–September 7, 1971, *Selections
from the Nathan Cummings Collection,* no. 59
Art Institute of Chicago, October 20–December 9, 1973,
Major Works from the Collection of Nathan Cummings,
no. 38

REPRODUCTIONS

Maurice Tuchman. *Chaim Soutine 1893–1943* (exh. cat.).
Los Angeles: Los Angeles County Museum of Art, 1968,
p. 106.
Selections from the Nathan Cummings Collection (exh. cat.).
Washington, D.C.: National Gallery of Art, 1970,
p. 75.
Pierre Courthion. *Soutine: Peintre du dechirant.* Lausanne:
Edita S.A., 1972, p. 266.
Major Works from the Nathan Cummings Collection (exh. cat.).
Chicago: Art Institute of Chicago, 1973, p. 47.

SELECTED BIBLIOGRAPHY

See entry for Chaim Soutine, *View of Céret,* ca. 1919–20

HENRI DE TOULOUSE-LAUTREC (1864–1901)

*Dancer Seated on a Pink Divan (Danseuse assise sur
un divan rose),* 1886
Oil on canvas; 17¾ x 13¼ in.
Dortu P248
1984.13

PROVENANCE

Count Odon de Toulouse-Lautrec, Paris**
Count Robert de Toulouse-Lautrec, Paris
Palais Galliéra, Paris
Nathan Cummings, New York

EXHIBITIONS

Musée des Arts Décoratifs, Paris, April 9–May 17, 1931, *Exposition H. de Toulouse-Lautrec,* no. 38
Musée de l'Orangerie, Paris, May–August 1951, *Toulouse Lautrec: Exposition en l'honneur du cinquantième anniversaire de sa mort,* no. 11
Musée d'Albi, August 11–October 28, 1951, *Toulouse Lautrec: ses amis et ses maîtres,* no. 35
Musée de Rennes, February 5–March 17, 1963, *Toulouse Lautrec et son milieu familial,* no. 48
Palais de la Berbie, Albi, June–September 1964, and Petit Palais, Paris, October–December 1964, *Centenaire de Toulouse-Lautrec,* no.19
Art Institute of Chicago, October 4–December 2, 1979, *Toulouse-Lautrec,* no. 23
Dixon Gallery and Gardens, Memphis, Tennessee, September 10–October 29, 1989, *The World of Toulouse-Lautrec,* no. 110
Reynolda House Museum of American Art, Winston-Salem, North Carolina, September 9–December 25, 1990, and Dixon Gallery and Gardens, Memphis, Tennessee, January 20–March 17, 1991, *An Impressionist Legacy: The Collection of Sara Lee Corporation*

REPRODUCTIONS

Toulouse-Lautrec et son milieu familial (exh. cat.). Rennes: Musée de Rennes, 1963, p. 50.
M. G. Dortu. *Toulouse-Lautrec et son oeuvre,* vol. 2. New York: Collectors Editions, 1971, n.p.
Major Works from the Collection of Nathan Cummings (exh. cat.). Chicago: Art Institute of Chicago, 1973, p. 28 (color).
Charles F. Stuckey. *Toulouse-Lautrec: Paintings* (exh. cat.). Chicago: Art Institute of Chicago, 1979, p. 100.

SELECTED BIBLIOGRAPHY

Douglas Cooper. *Henri de Toulouse-Lautrec.* New York: Harry N. Abrams, Inc., 1956.
M. G. Dortu. *Toulouse-Lautrec et son oeuvre.* New York: Collectors Editions, 1971.
François Jourdain. *Toulouse-Lautrec.* Paris: Editions Pierre Tisné, 1952.
Maurice Joyant. *Henri de Toulouse-Lautrec 1864–1901, peintre.* Paris: H. Floury, 1926 (reprinted by Arno Press, Inc., New York, 1968).
Charles F. Stuckey. *Toulouse-Lautrec: Paintings* (exh. cat.). Chicago: Art Institute of Chicago, 1979.
Toulouse-Lautrec (exh. cat.). London: Hayward Gallery, 1991–1992 and Paris: Galeries Nationales du Grand Palais, 1992.

** Note: Verso, on stretcher, is inscribed "Donné par Henri de Toulouse-Lautrec, mon neveu, vers l'année 1886/j'habitais alors 105 bis. Boulevard Saint-Germain, Comte Odon de Toulouse-Lauctrec."

MAURICE DE VLAMINCK (1876–1958)

Landscape—The Seine at Chatou (La Seine à Chatou), ca. 1912
Oil on canvas; 26½ x 28¾ in.
Signed lower right: "Vlaminck"
1981.12

PROVENANCE

Ambroise Vollard, Paris
Christian de Gales, Paris
Nicole Bertagna, Paris
Nathan Cummings, Chicago

EXHIBITIONS

Nicole Bertagna, Paris, *Tableaux de Maîtres XIVe–XXe Siècle,* n.d.
Reynolda House Museum of American Art, Winston-Salem, North Carolina, September 9–December 25, 1990, and Dixon Gallery and Gardens, Memphis, Tennessee, January 20–March 17, 1991, *An Impressionist Legacy: The Collection of Sara Lee Corporation*

REPRODUCTIONS

Consolidated Foods Corporation's Nathan Cummings Collection. (Chicago): Consolidated Foods Corporation, 1983, p. 27, fig. 23 (color).

SELECTED BIBLIOGRAPHY

Jean-Paul Crespelle. *The Fauves.* Translated by Anita Brookner. Greenwich, Connecticut: New York Graphic Society, Ltd., 1962.
_____. *Vlaminck: Fauve de la peinture.* Paris: Gallimard, 1968.
Maurice Genevoix. *Vlaminck.* Paris: Flammarion, 1954.
Marcel Sauvage. *Vlaminck: Sa vie et son message.* Geneva: Pierre Cailler, 1956.
Maurice de Vlaminck. *Dangerous Corner.* Translated by Michael Ross. New York: Abelard-Schuman, 1966.

ÉDOUARD VUILLARD (1868–1940)

The Bay Window at Pouliguen near La Baule (La Baile Vitrée au Pouliguen près de La Baule), 1908
Distemper on paper, laid down on canvas; 35 x 65 in.
Signed lower right
1988.1

PROVENANCE

Galerie Bernheim-Jeune, Paris
M. L. Rothschild, Brussels
Antoine Salomon, Paris
Thomas Gibson Ltd., London
Nathan Cummings, New York
Michael Owen, Inc., New York

EXHIBITIONS

Galerie Bernheim-Jeune, Paris, 1908, no. 12
Palais des Beaux-Arts, Brussels, 1946, *Exhibition Vuillard,* no. 39

Galerie Georges Giroux, Brussels, September–October 1946, *Exposition anniversaire, 1911–1946: 35 Ans d'activité,* no. 168

Galerie Georges Giroux, Brussels, June–August 1947, *Exposition de l'art vivant dans les collections privés belges,* no. 84

Guillaume Campo Gallery, Antwerp, 1977, *Édouard Vuillard,* no. 342C

Reynolda House Museum of American Art, Winston-Salem, North Carolina, September 9–December 25, 1990, and Dixon Gallery and Gardens, Memphis, Tennessee, January 20–March 17, 1991, *An Impressionist Legacy: The Collection of Sara Lee Corporation*

SELECTED BIBLIOGRAPHY

André Chastel. *Vuillard, 1868–1940.* Paris: Floury, 1946.

Claude Roger-Marx. *Vuillard: His Life and Work.* Translated by E. B. D'Auvergne. London: P. Elek, 1946.

John Russell. *Édouard Vuillard, 1868–1940* (exh. cat.). Toronto: Art Gallery of Toronto, 1971.

Jacques Salomon. *Vuillard.* Paris: Gallimard, 1968.

Belinda Thomson. *Vuillard.* New York: Abbeville Press, 1988.

ÉDOUARD VUILLARD (1868–1940)

Foliage—Oak Tree and Fruit Seller (Verdure— Chêne et fruitière), 1918
Distemper on canvas; 76 x 111½ in.
Signed and dated lower left: "E. Vuillard/1918"
1981.1

PROVENANCE

Georges Bernheim, Paris
Mr. and Mrs. Roger Darnetal

Daniel Varenne, Geneva
Nathan Cummings, Chicago

EXHIBITIONS

Musée des Arts Décoratifs, Paris, May–July 1938, *Exposition É. Vuillard,* no. 163

The Metropolitan Museum of Art, New York, March 1968

American Embassy, Paris, on loan December 1969–May 1970

National Gallery of Art, Washington, D.C., June 28–September 11, 1970, and The Metropolitan Museum of Art, New York, July 1–September 7, 1971, *Selections from the Nathan Cummings Collection* (exhibited as *Public Garden*), no. 25

Federal Reserve Board, Washington, D.C., on loan May 11, 1972–August 12, 1981

REPRODUCTIONS

Selections from the Nathan Cummings Collection (exh. cat.). Washington, D.C.: National Gallery of Art, 1970, p. 39.

Consolidated Foods Corporation's Nathan Cummings Collection. (Chicago): Consolidated Foods Corporation, 1983, p. 10, fig. 4 (color). See entry for Vuillard, *The Bay Window,* 1908.

SELECTED BIBLIOGRAPHY

Andre Chastel. *Vuillard, 1868–1940.* Paris: Floury, 1946.

Claude Roger-Marx. *Vuillard: His Life and Work.* Translated by E. B. D'Auvergne. London: P. Elek, 1946.

John Russell. *Édouard Vuillard, 1868–1940* (exh. cat.). Toronto: Art Gallery of Toronto, 1971.

Jacques Salomon. *Vuillard.* Paris: Gallimard, 1968.